The Tramways of Hong Kong
A History in Pictures

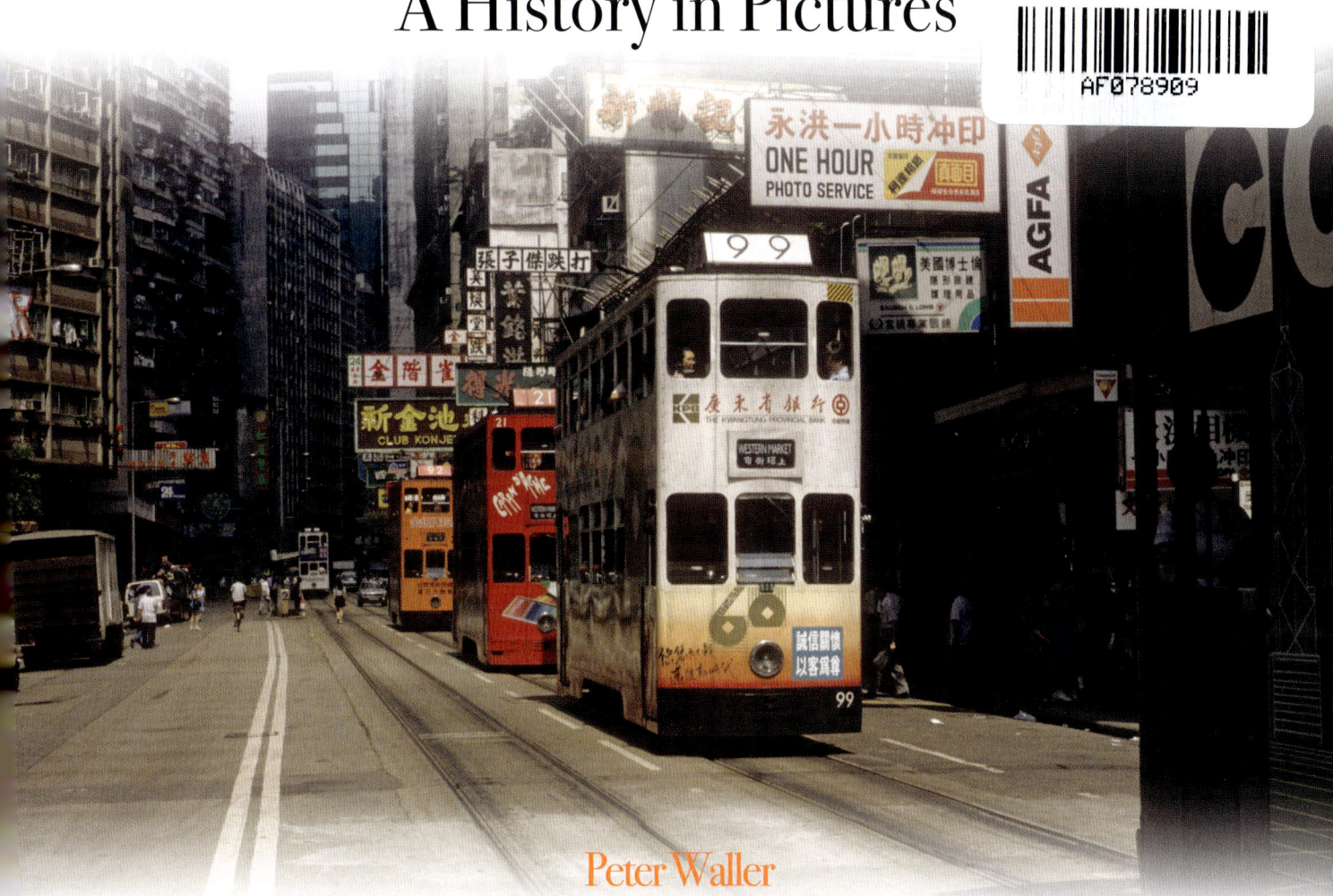

Peter Waller

UNIQUE BOOKS

Title page: On 16 September 1992 trams head westbound along Johnston Road. Leading the colourful trio is No 99 en route towards Western Market. This tram had originally entered service in February 1955 and had re-entered service, following rebuilding, in April 1990. One of the rebuilt cars to be scrapped, No 99 was finally broken up in August 2011. Behind are Nos 21 and 92; these re-entered service following rebuilding in April 1989 and April 1988 respectively. The rebuilding work resulted in the transfer of each vehicle's resistance bank to a pod above the front cab – as shown here – which incorporated a fleet number, this making identification much easier.
Author

First published in the United Kingdom by Unique Books 2018

© Text: Peter Waller 2018

© Photographs: As credited

ISBN: 978 0 9957493 2 0

All rights reserved. No part of this book may be reproduced or transmitted in any form or by any means electronic or mechanical, including photocopying, recording or by any information storage without permission from the Publisher in writing. All enquiries should be directed to the Publisher.

A CIP record for this book is available from the British Library

Unique Books is an imprint of Unique Publishing Services Ltd, 3 Merton Court, The Strand, Brighton Marina Village, Brighton BN2 5XY.

www.uniquepublishingservices.com

Published in Hong Kong by Blacksmith Books

Unit 26, 19/F, Block B, Wah Lok Industrial Centre, 37-41 Shan Mei Street, Fo Tan, Hong Kong

www.blacksmithbooks.com

Tel: (+852) 2877 7899

ISBN: 978 988 77928 5 7

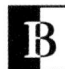

Printed in China

Dedication
This book is dedicated to my mother – Joan – who first introduced me to the delights of Hong Kong when she was working there with the British Council in the early 1990s and who sadly passed away whilst this book was in production.

Author's note
This book is primarily a pictorial account of the tramways on Hong Kong Island in the 20th century. The LRT scheme that serves Tuen Mun has been excluded as has been the development of the Mass Transit Railway.

A note on the photographs
The majority of the illustrations in this book have been drawn from the collection of the Online Transport Archive, a UK-registered charity that was set up to accommodate collections put together by transport enthusiasts who wished to see their precious images secured for the long-term. Further information about the archive can be found at: www.onlinetransportarchive.org or email secretary@onlinetransportarchive.org

INTRODUCTION

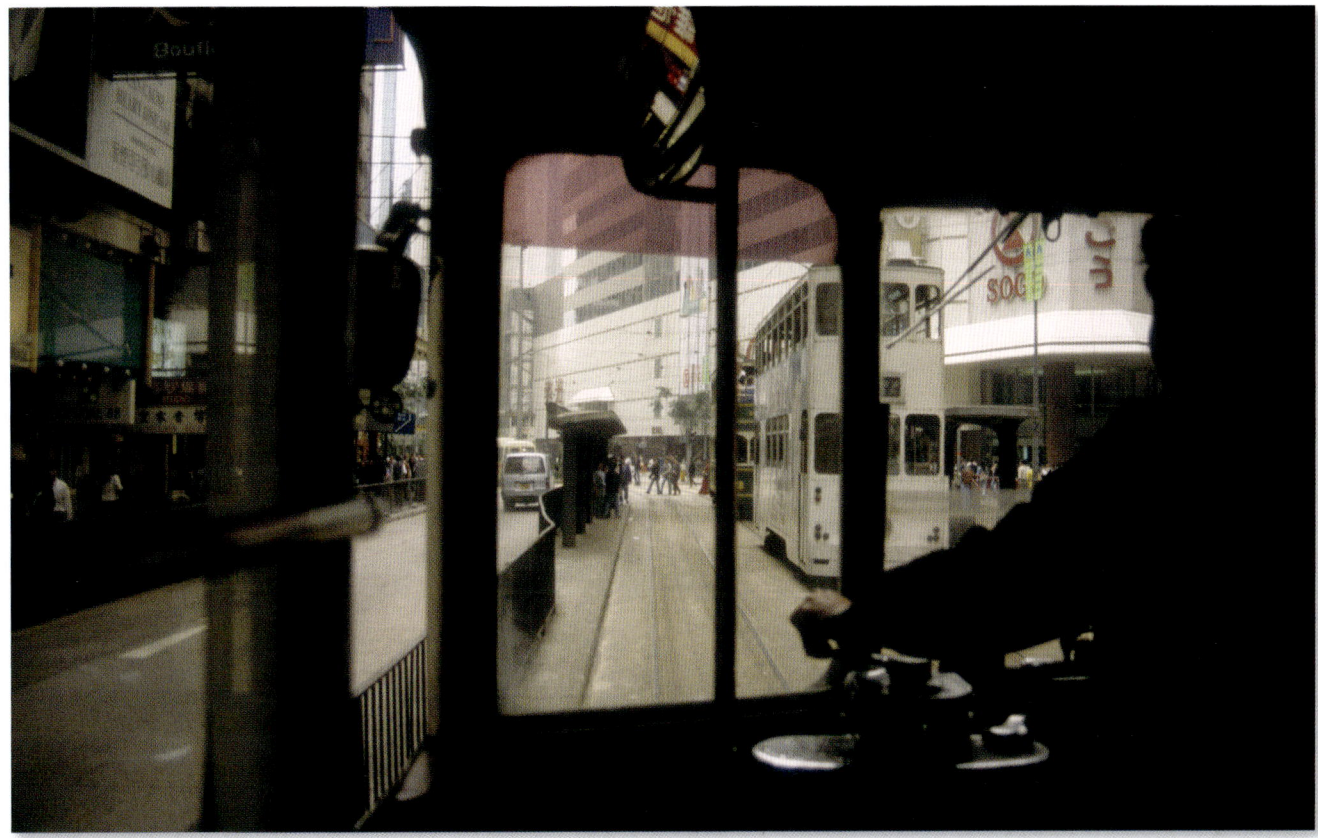

A driver's eye view from Hong Kong's famous trams taken in 1995; Hong Kong is now one of a handful of places in the world where it is possible to travel on traditional double-deck trams. Until comparatively recently, Hong Kong's tram utilised traditional-style controllers with drivers standing – a scene that would have been familiar to passengers from the early 20th century onwards.
Alan Pearce/Online Transport Archive

The first proposals for an electric tramway serving Hong Kong Island surfaced in the early 1880s. Although powers to construct the main route plus the funicular to Victoria Gap were obtained in 1884, an inability to raise the finance resulted in only the line to Victoria Gap – the future Peak Tramway – being completed. Further proposals for a tramway emerged early in the next decade, but it was not until the early years of the 20th century that real progress was made.

On 29 August 1901, renewed powers to construct a tramway were enshrined in Tramway Ordnance No 10. This was followed on 7 February 1902 by the registration in London of a new

company – the Hong Kong Tramway Electric Co Ltd – that was designed to complete the proposed tramway. A second company again registered in England – the British Corporation Ltd (a subsidiary of the United Exploration Co Ltd) – acquired all the shares of the earlier company on 1 December 1902. A further company – the Electric Traction Co of Hong Kong Ltd – was registered in England on 20 November 1902. Again on 1 December 1902 the latter company acquired the Hong Kong Tramway Electric Co Ltd from its owners (the British Corporation Ltd), in exchange for cash and shares, and the new owners proceeded to raise capital for the tramway's construction.

The authorised tram route ran from Kennedy Town to the junction of Shau Kei Wan Road and Chai Wan Road. The western section of the route, from Kennedy Town to Causeway Bay and the junction with Tai Hang Road, was effectively double track throughout but the eastern section was primarily single track with passing loops. There was also a branch – mainly double track – from Hennessy Road to the Happy Valley racecourse.

Work started on the 3ft 6in-gauge line's construction in May 1903. In all, the work involved the laying of some 14 miles of track. In order to provide the power, a new power station was constructed beside the Bowrington Canal whilst a depot capable of accommodating 35 trams was built on Russell Street. For the initial operation of the system, 26 single-deck trams were ordered from the Preston, England, based Electric Railway & Tramway Carriage Works Ltd. These comprised 10 combination and 16 crossbench cars; all were supplied in sections for completion in Hong Kong. A further 10 crossbench trams – Nos 27-36 – were constructed in 1906 and, the following year, three trams were rebuilt with fully-enclosed single-deck bodies. All the first 36 trams were initially fitted with Brush-built 6ft 6in trucks; however, all of these were replaced by Brill-type 6ft 6in trucks between 1910 and 1925.

The first tram to operate on test running – crossbench No 16 – operated on 2 July 1904 and, following an inspection later in the month, public services commenced on 30 July 1904 although the westernmost section, from Arsenal Street to Kennedy Town, was not yet complete; this section opened later in 1904.

In 1906 the Hong Kong Tramway Electric Co Ltd went into liquidation with its assets transferred to the Electric Traction Co of Hong Kong Ltd. This was to be retitled as the Hongkong Tramway Co Ltd on 5 August 1910.

The fleet was further expanded in 1912 with the acquisition of the first 10 double-deck cars; these were open top and were effectively operated as single-deckers in inclement weather until they were fitted with canvas roofs and side-screens the following year. In addition a further 18 older cars were also rebuilt as open-top double-deckers.

The first extension to the existing system occurred in

February 1914 when the existing Happy Valley route was extended 600 yards southwards. This section was constructed as single track as was the final extension to the loop – completed in 1922 – that saw the line run via Wong Nei Chong Road, Leighton Road and Canal Road East to Hennessy Road. The track along Bowrington Road was abandoned at that time whilst the original branch along Morrison Hill Road was converted to single track. Also in 1922 – on 26 May – the registration of the Hongkong Tramway Co Ltd was transferred from London to Hong Kong. The following year saw the company cease to generate its own power; henceforth electricity was supplied by the Hongkong Electric Co Ltd and its successors. The cessation of power generating enabled the existing depot to be increased, taking capacity to 90 trams. In 1924 work started on the doubling of the largely single-track section from Causeway Bay to Shau Kei Wan; this work also required the widening of the existing roads. Work was largely completed on this project in the early 1930s although the Causeway Road section and short sections in Shau Kei Wan were not completed until the post-war reconstruction. The final significant extension to the tramway occurred in 1929 when services to Shau Kei Wan were extended 360 yards from the original terminus to the loop at Kam Wa Street.

By the mid-1920s the fleet had expanded to some 80 cars; the vast majority were now double-deck. In 1925 the first fully-enclosed tram was constructed; this was fitted with a new style truck – the 8ft 6in wheelbase Peckham P35 – and the improved ride that this offered resulted in the decision to extend the length of the earlier trucks to 7ft 6in. Between 1925 and 1940, some 29 new fully-enclosed trams were delivered whilst the earlier double-deck cars were modified. Also introduced in the late 1920s was a predominantly dark green livery; this – in a modified form post-war – was to survive through until the advent of the advertising (this was first reintroduced in 1961 before the onset of the overall adverts later). By 1931 the fleet reached almost 100 trams and the existing depot at Russell Street was proving inadequate. The site of a second depot – capable of accommodating 30 trams eventually – was acquired off King's Road in North Point; this was opened in 1938. By the end of 1940 the tram fleet had reached a total of 109.

On 7 December 1941 Hong Kong came under attack from the Japanese; inevitably the tramway was to suffer damage and one crew member was killed when a tram was hit on Connaught Road West. Although a skeleton service was operated thereafter, this was suspended before Hong Kong's surrender on 25 December 1941. From January 1942 limited services were reintroduced, but it was not until June 1942 that operation over the entire system was again possible following repairs to damaged track and overhead. Services were again to be suspended in November 1944 – this time as a result of inadequate electricity supplied – but were to be partially reintroduced the following April.

Following the Japanese surrender and the British re-occupation, although all 109 trams were still extant, the vast majority were inoperable whilst the track and overhead were generally in poor condition. Work was undertaken to repair the fleet and improve the track and overhead with the result that services were restored in October 1945 with some 40 trams operational. In addition to restoring and maintaining the pre-war cars, a further 11 new trams were added to the fleet during 1948 and 1949. Although most were built to the pre-war design, the last – No 120 – was built to a new design; this was to form the basis of the post-war fleet with 161 similar bodies being supplied between 1950 and 1964.

During the 1950s there was some considerable work undertaken on the track. The enlargement of the original depot at Russell Street – renamed Sharp Street after enlargement – and the subsequent closure of the depot off King's Road resulted in the modification of the track serving the Happy Valley loop. The connection from Hennessy Road into Canal Road East was removed, as was the section linking Leighton Road with Canal Road East. In its place the link along Percival Street was extended to Leighton Hill Road and thus to Wong Nei Chong Road. In 1953 work started on the relocation of the loop from Causeway Bay to North Point. The introduction of loading islands resulted in the narrowing of track separation on a number of sections. In 1957 an enlarged loop at Whitty Street was completed.

The early 1960s witnessed a return to single-deck trams when, following modification to No 161, the first unpowered trailer car was introduced in August 1964. The success of this combination resulted in the purchase of a further 21 trailers between 1965 and 1967. The bulk of these were supplied in kit form from a manufacturer in England but the last – No 22 – was wholly constructed by the company itself.

A decade on from the removal of the loop at Causeway Bay a new loop was constructed in order to reduce the number of

trams using the emergency crossover to reverse and thus running effectively backwards (although the post-war design included doors on the offside and were capable of reverse operation, they were designed primarily to operate in one direction, using the turning loops at the various termini). The new loop opened on 20 March 1967.

At the end of 1973 ownership of the tramway changed, with it becoming a subsidiary of the Hongkong & Kowloon Wharf & Godown Co (Wharf [Holdings] Ltd from 1986). The construction of Queensway resulted in the tramway's original route along Naval Terrace being abandoned in favour of a central reservation along the new road in 1975. The installation of pay on exit equipment allied to the end of the two-class fare structure – abolished in July 1972 – saw most trams one-person operated by the end of 1977 with conductors retained only for the trailer cars until the operation of these ceased. Between 1978 and 1982 the western end of the loop via Happy Valley was slightly aligned as part of the project to extend the Canal Road flyover. Further trackwork was carried out at Western Market between September 1985 and January 1987 in connection with the construction of the Sheung Wan MTR station and other improvements; the completed work included the construction of a scissors crossover although this was relatively short-lived. In 1986 a section of steeply graded track along King's Road was replaced by an alignment along Kornhill Road. In 1989 Sharp Street depot was closed and the site redeveloped; the fleet was transferred to new depots at Sai Wan Ho and Whitty Street.

By the mid-1980s the standard cars developed after World War 2 and constructed until 1963 were starting to show their age. Work started on their rebuilding with the first of the rebuilt cars – No 143 – re-entering service in February 1986. Initially the early rebuilt cars – Nos 6, 36, 39, 41, 46, 80, 88 (later 30), 89, 121, 127, 139, 141, 143, 144 (later 166) and 159 – simply received replacement aluminium panelling on their original frames; from mid-1987 onwards the work on the remaining rebuilds was much more significant and included new frames as well. With the completion of work on the remaining cars, the original 15 cars were also fully rebuilt. The work on rebuilding the fleet was completed during 1992. For almost a century the tram drivers controlled the vehicles using traditional controllers; however, from the late 1990s more modern equipment replaced this. From 1998 equipment supplied by Siemens was utilised on a number of trams with a transistor-based system being introduced in 2008. The majority of the fleet is now fitted with variants of the 2008 system although four cars – the two tourist cars (Nos 28 and 128), the sightseeing car (No 68) and the replica of the prototype post-war car (No 120) – retain Dick Kerr controllers.

The 1990s witnessed further slight track modifications. These included the installation of a siding at the Happy Valley terminus, which was commissioned in March 1995, and the realignment of the track along Catchick Street completed the same year. More radical change might have been in the offing, as No 88 was temporarily fitted with a home-built pantograph in 1994. Although some overhead modifications were made, the idea of conversion to pantograph operation was not pursued despite the potential operational benefits that pantograph use might have brought. Towards the end of the decade work commenced on the construction of three new trams – Nos 168-70 – which became known as the 'Millennium' class as they entered service in 2000 and 2001; a fourth – No 171 (which was fitted with air-conditioning to improve passenger comfort as lack of ventilation was a serious problem with the original three cars) – was constructed in 2002 but never entered service.

In 2009 a 50% stake in Hong Kong Tramways Ltd was acquired from Wharf (Holdings) Ltd by a French consortium comprising RATP and Veolia Transport; in February 2010 the French consortium acquired the other 50% of the business. In October the same year, the new owners launched the prototype for a new standard tram. Retaining the overall external design of the rebuilt cars from 1986-92, the new body featured aluminium – rather than teak – frames and improved seating and passenger displays.

More than a century after the tramway commenced operation, the fleet – which now comprises some 164 passenger cars along with three works trams – continues to provide an essential service through one of the most vibrant cities in the world. Long may it continue to do so – the only tramway in the world now operated exclusively by double-deck trams.

THE EARLY YEARS

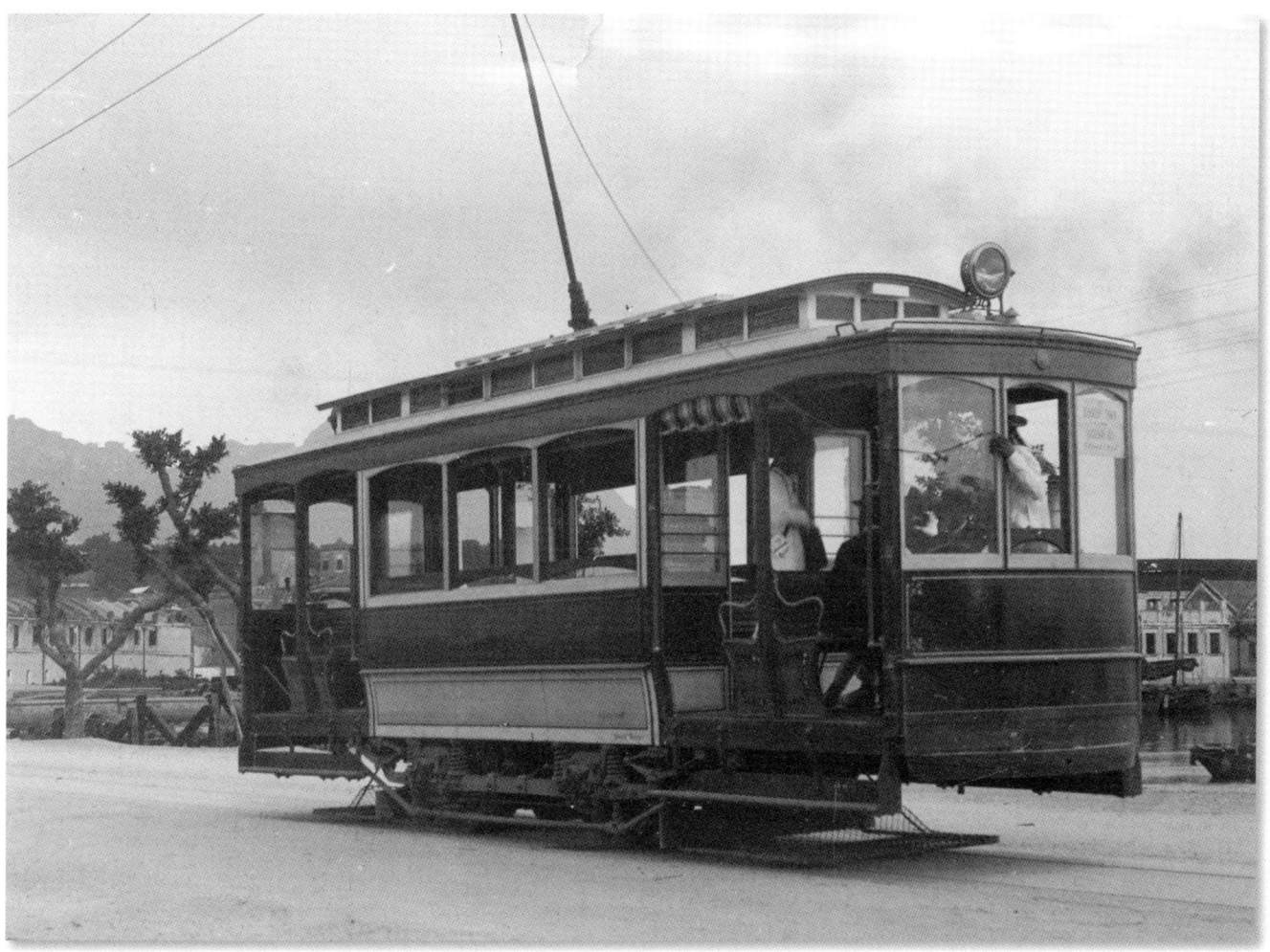

The initial tramway fleet comprised a total of 26 single-deck cars, all of which were supplied by the Electric Railway & Tramway Carriage Works Ltd of Preston in England. Nos 1-16 were crossbench cars, whilst Nos 17-26 were combination cars. One of the latter is seen in this view. Initially, the crossbench cars were designated for third-class use and the combination cars for first-class; however, the heat and stuffiness – despite the provision of electric fans – was such that the rules were soon amended.
Barry Cross Collection/Online Transport Archive

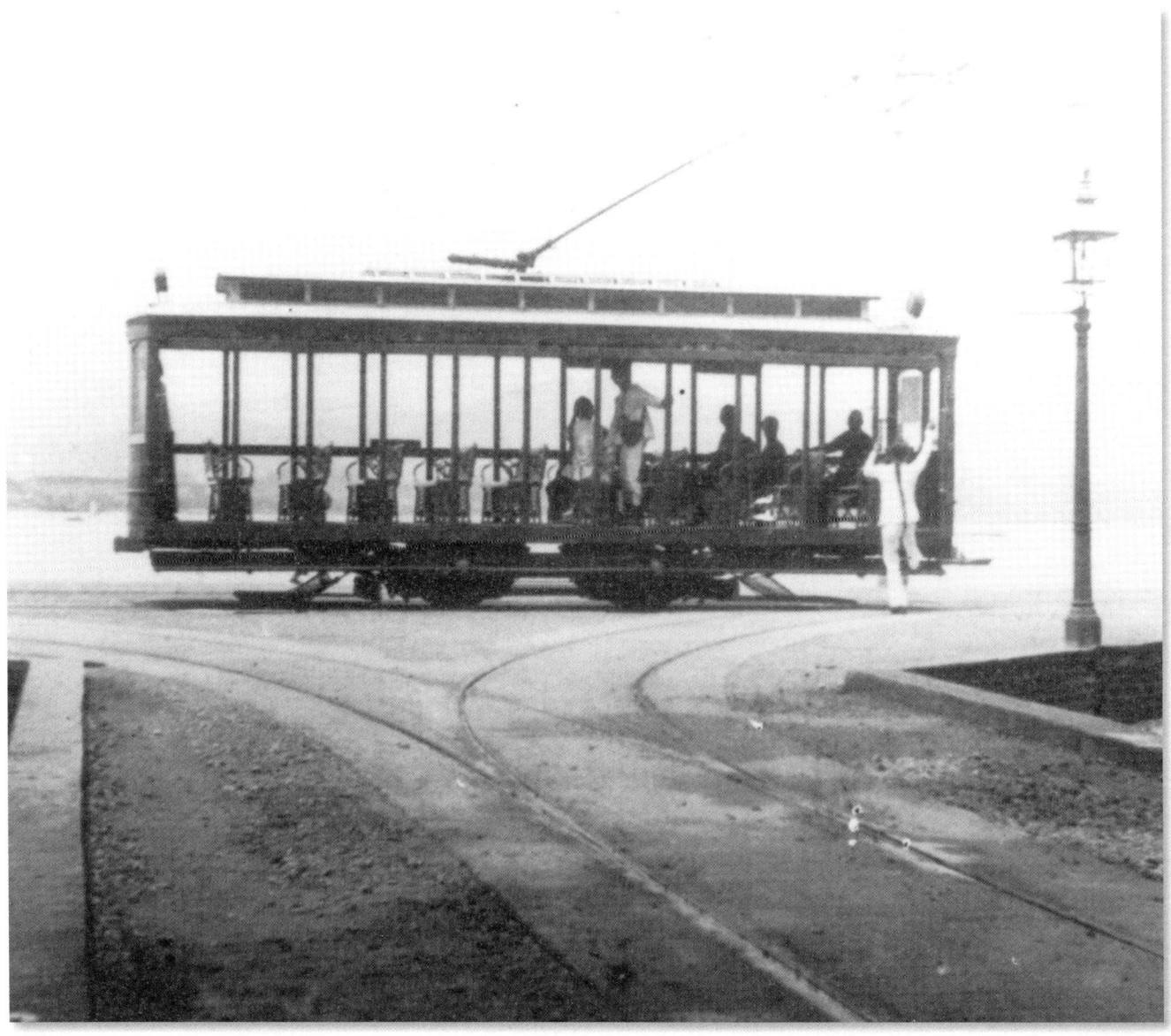

A side view of one of the open crossbench cars that were supplied by the Electric Railway & Tramway Carriage Works Ltd. In all, 26 of this type were acquired: the first 16 for the tramway's opening in 1904 and a further 10 the following year. All of the trams – these and the combination cars – were shipped out from England in sections and assembled in the company's depot.

Barry Cross Collection/Online Transport Archive

A single-deck crossbench car pictured in front of the Alexandra Building. The building, which was situated on the intersection of Chater Road and Des Voeux Road was completed in 1904 following the acquisition of the site by Hong Kong Land three years earlier. It was originally known as Alexandra Buildings – named after Queen Alexandra, the wife of King Edward VII – but the 's' was soon dropped. Designed by Palmer & Turner, the building was nicknamed the 'Flat Iron' as a result of its shape. The impressive structure was to be demolished in 1952 and a new building constructed; this itself was demolished in 1974 and replaced by the current structure.
Barry Cross Collection/Online Transport Archive

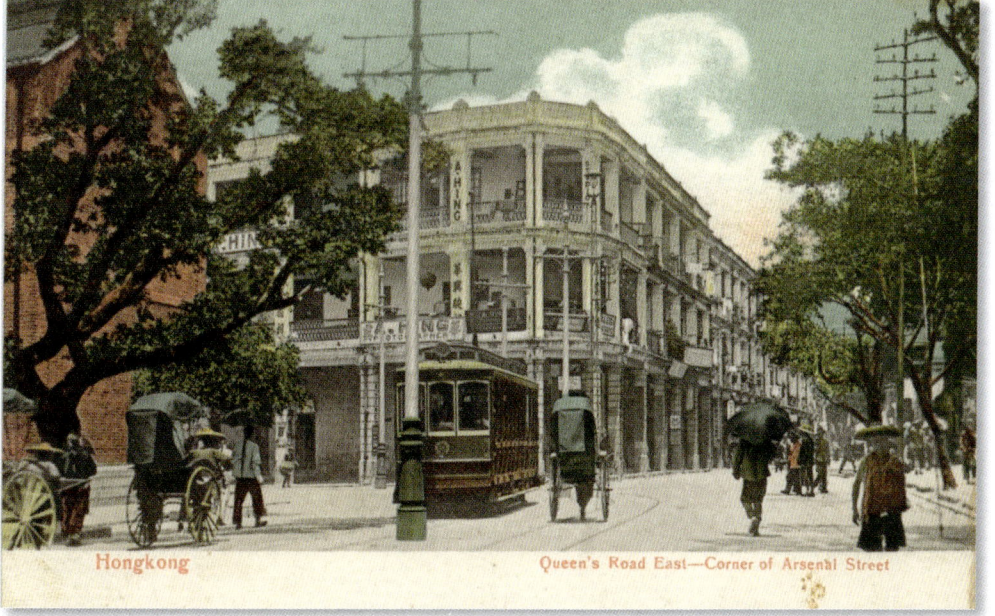

Pictured looking towards the east in about 1909, one of the crossbench cars heads into Queen's Road East at its junction with Arsenal Street. This streetscape was radically altered in 1939 when Hennessy Road was constructed and the adjacent roads were realigned.
Barry Cross Collection/Online Transport Archive

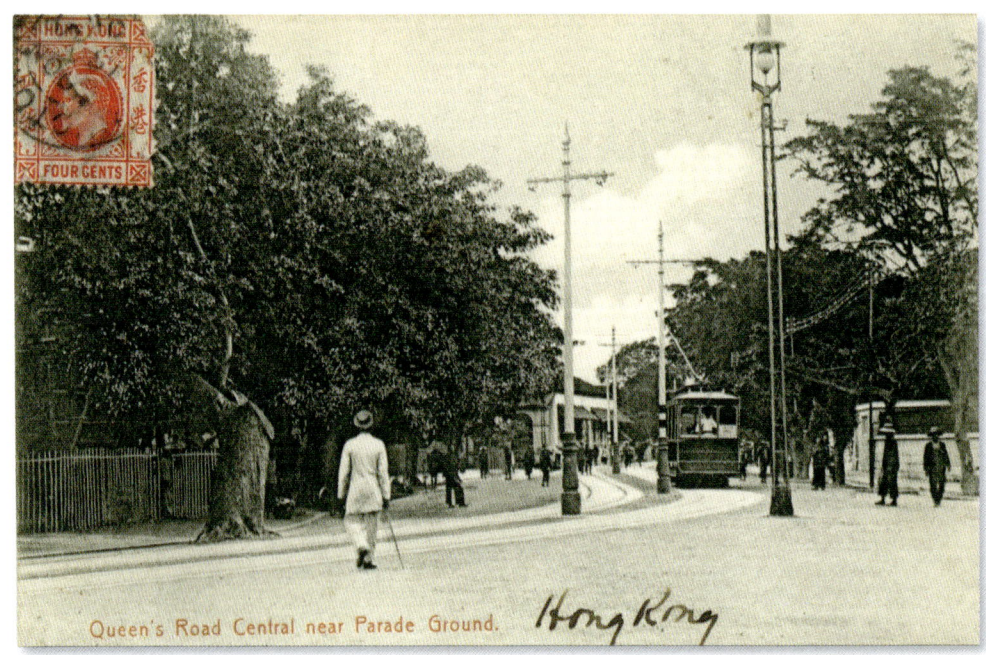

One of the 16 crossbench cars heads westbound along Queen's Road Central near the Parade Ground. Originally known as Main Street, Queen's Road was the first street to be constructed by the British following their occupation of Hong Kong Island. Work started in 1841 and much of the road ran parallel to the original coastline until reclamation extended the land northwards into Victoria Harbour.
Barry Cross Collection/Online Transport Archive

A single-deck tram makes its way eastbound along Des Voeux Road with the spire of St Peter's Church, Praya West, in the background. This church, situated on the corner of Des Voeux Road West and Western Street, was completed in 1871 but was only to survive until 1933, when it was demolished. Adjacent to the church, but set back from the road and shielded from it by the line of bushes, was the Sailor's Home. The top of the building's pediment is visible behind the trees. The Sailor's Home was built in 1864 to provide temporary accommodation for sailors visiting Hong Kong. This building was to survive until demolition in 1955. Today the site of the home and church is occupied by the Western Police Station.
Barry Cross Collection/Online Transport Archive

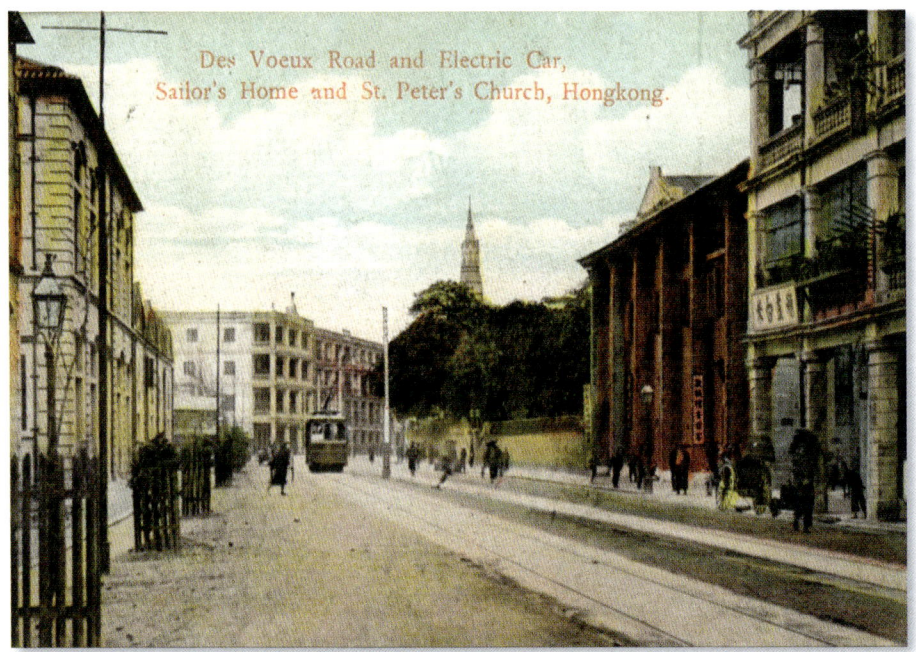

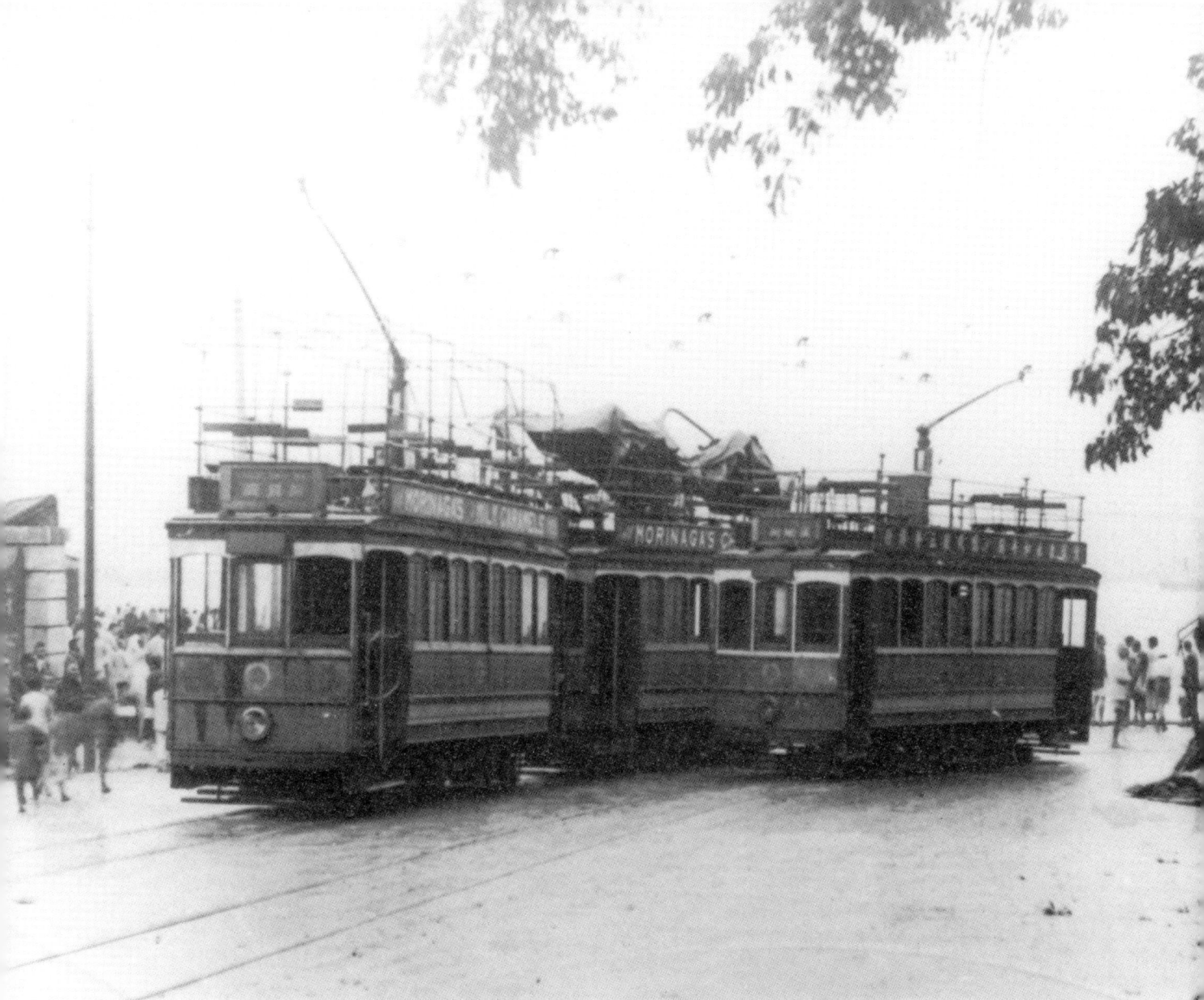

Following complaints from first-class passengers that the open-top double-deck trams were unusable in bad weather, canvas roofs and roll-down side screens were fitted for protection. These were not wholly satisfactory, however as this view of three trams taken in the late 1920 demonstrates. The effect of a typhoon has been to severely damage or remove the canvas fittings.
Hong Kong Tramways/Barry Cross Collection/Online Transport Archive

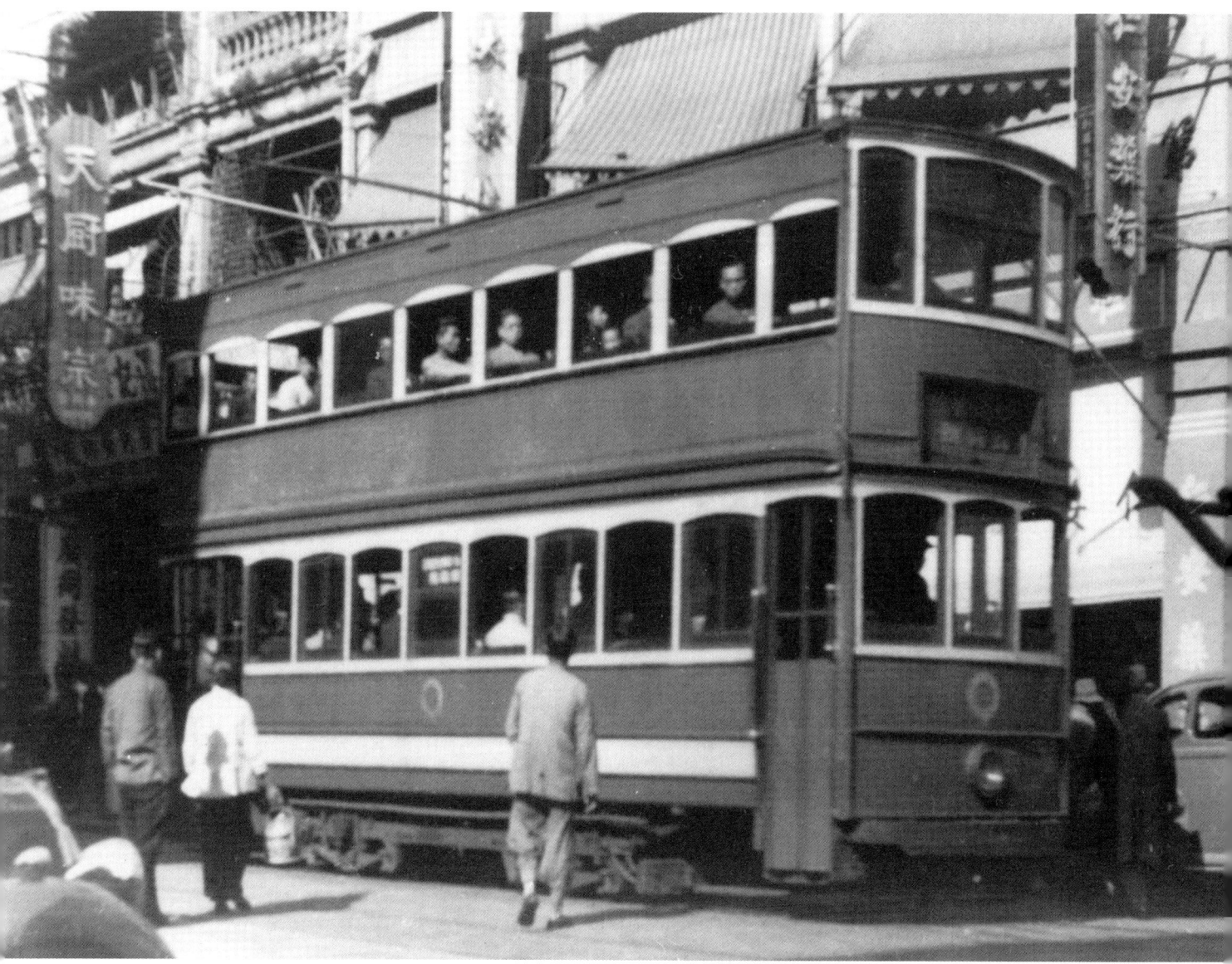

In 1925 Hong Kong Tramways introduced a new style of fully-enclosed double-deck tram – such as this example – which was to set the standard for the fleet through until late 1949 when No 120 introduced the new post-war design that was to dominate operation for almost 40 years. Note the platform gates – rather than doors – on the rear platform.
Barry Cross Collection/Online Transport Archive

A JOURNEY FROM EAST TO WEST

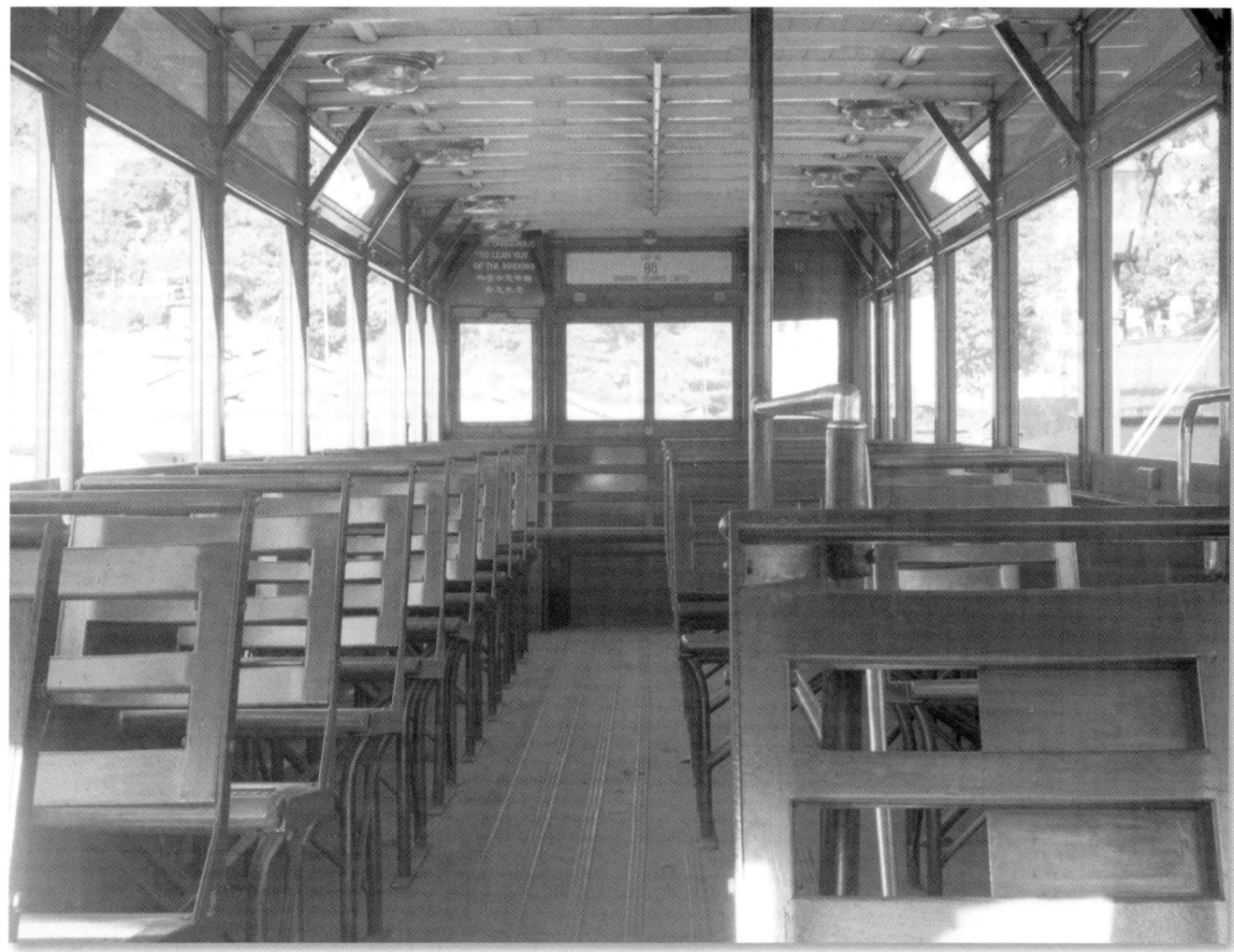

Before the journey starts, let's look at the accommodation that the passengers were offered in the mid-1950s. This is the top deck of No 86 – built by the Taikoo Dockyard & Engineering Co – which entered service in May 1951. At the time the upper deck was reserved for first class passengers who entered the tram at the front; third class passengers travelled on the lower deck and entered via the rear platform. Wooden seating, even for first class passengers, was the norm until the fleet was modernised during the second half of the 1980s onwards.

Douglas Beath/Online Transport Archive

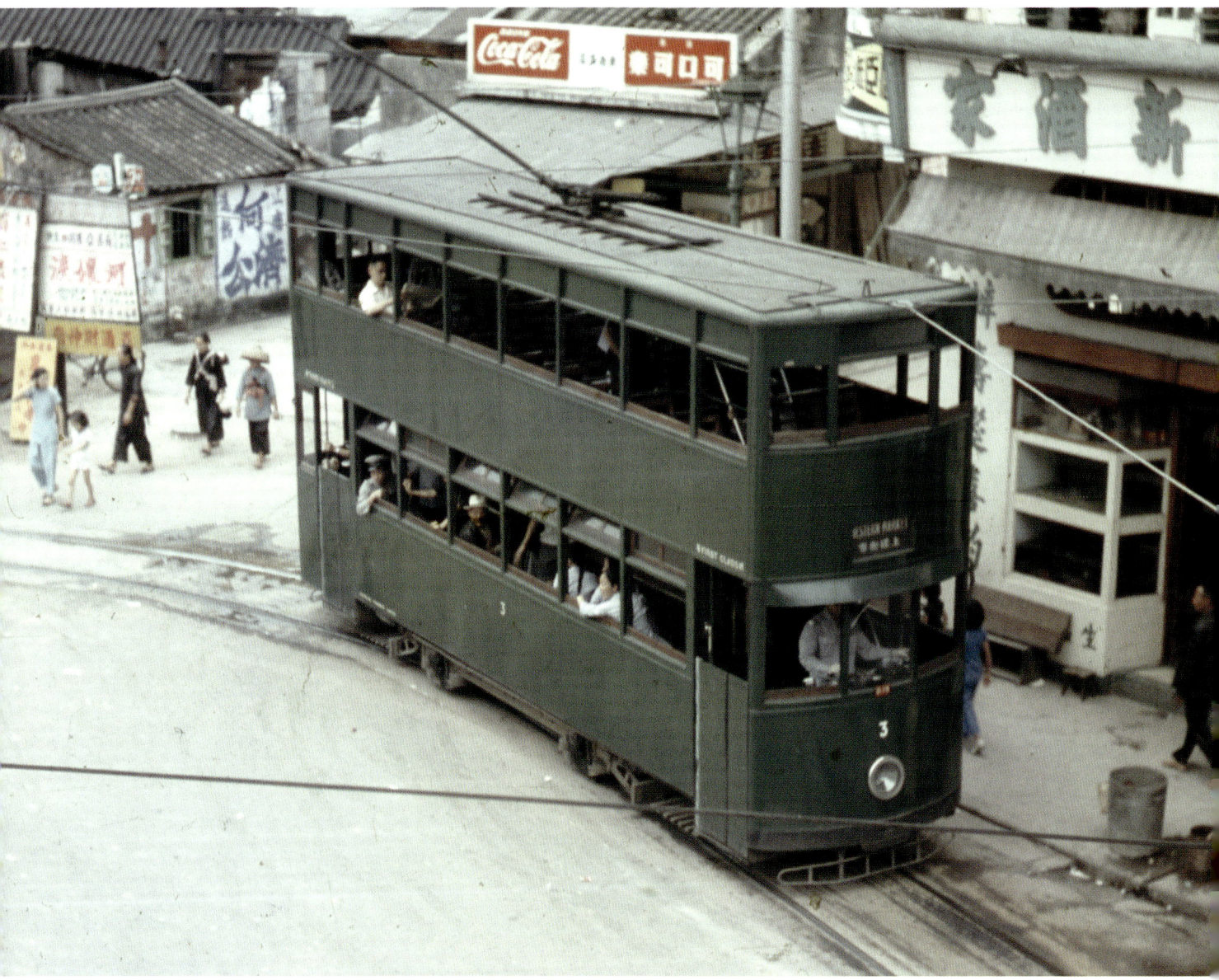

The easternmost terminus of the tramway is at Shau Kei Wan. The tramway was extended to this point from the original 1904 terminus in 1929. This 1956 view sees No 3 – a tram that had been built by the Taikoo Dockyard & Engineering Co, entering service in March 1952 – departing with a service towards Western Market.
Douglas Beath/Online Transport Archive

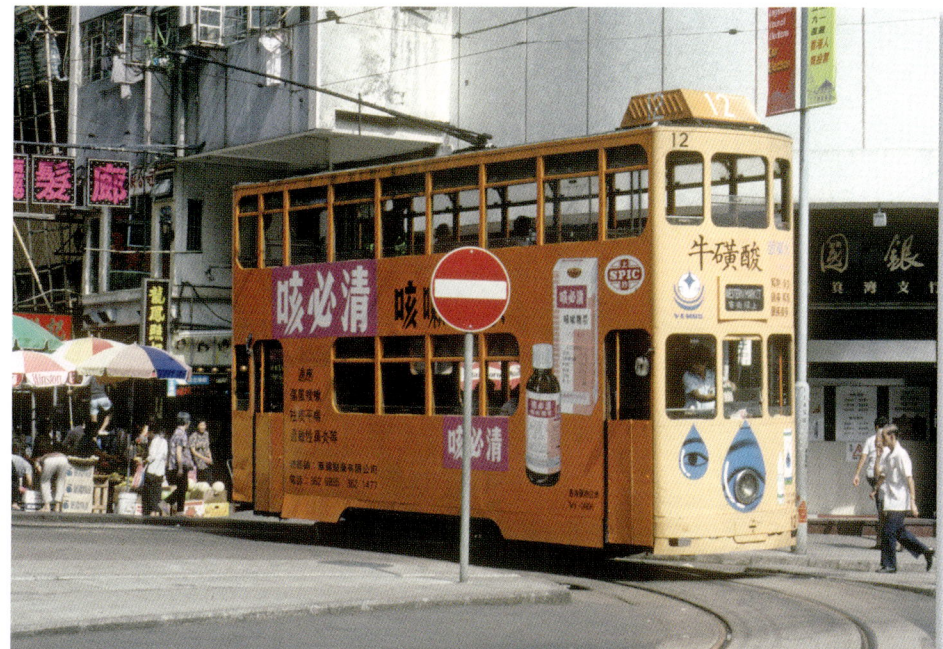

On 13 September 1991, No 12 turns on the terminal loop at Shau Kei Wan into Shau Kei Wan Main Street East with a service heading towards Western Market. In the late 1980s, most of the existing tram fleet was rebuilt or rebodied using the original trucks. The story of No 12 was more complicated; its original body, dating back to August 1952, was removed and shipped to Vancouver, in Canada, where it was used as an exhibit as part of the Hong Kong display for Expo 86. Its truck then received the rebuilt body from No 30.
Harry Luff/Online Transport Archive

A busy scene on 23 October 1981 sees No 15 entering the terminal loop at Shau Kei Wan whilst No 135 emerges from the loop with a westbound service. No 15 was built by Hongkong Tramways and entered service in August 1952 whilst No 135 was constructed by the Taikoo Dockyard & Engineering Co; it entered service in September 1955.
Alan Murray Rust/Online Transport Archive

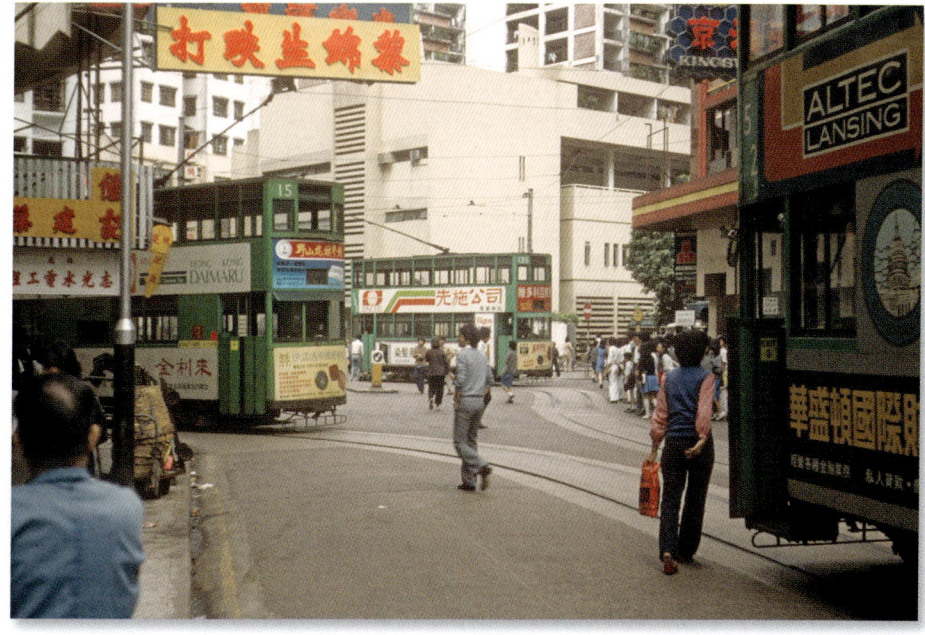

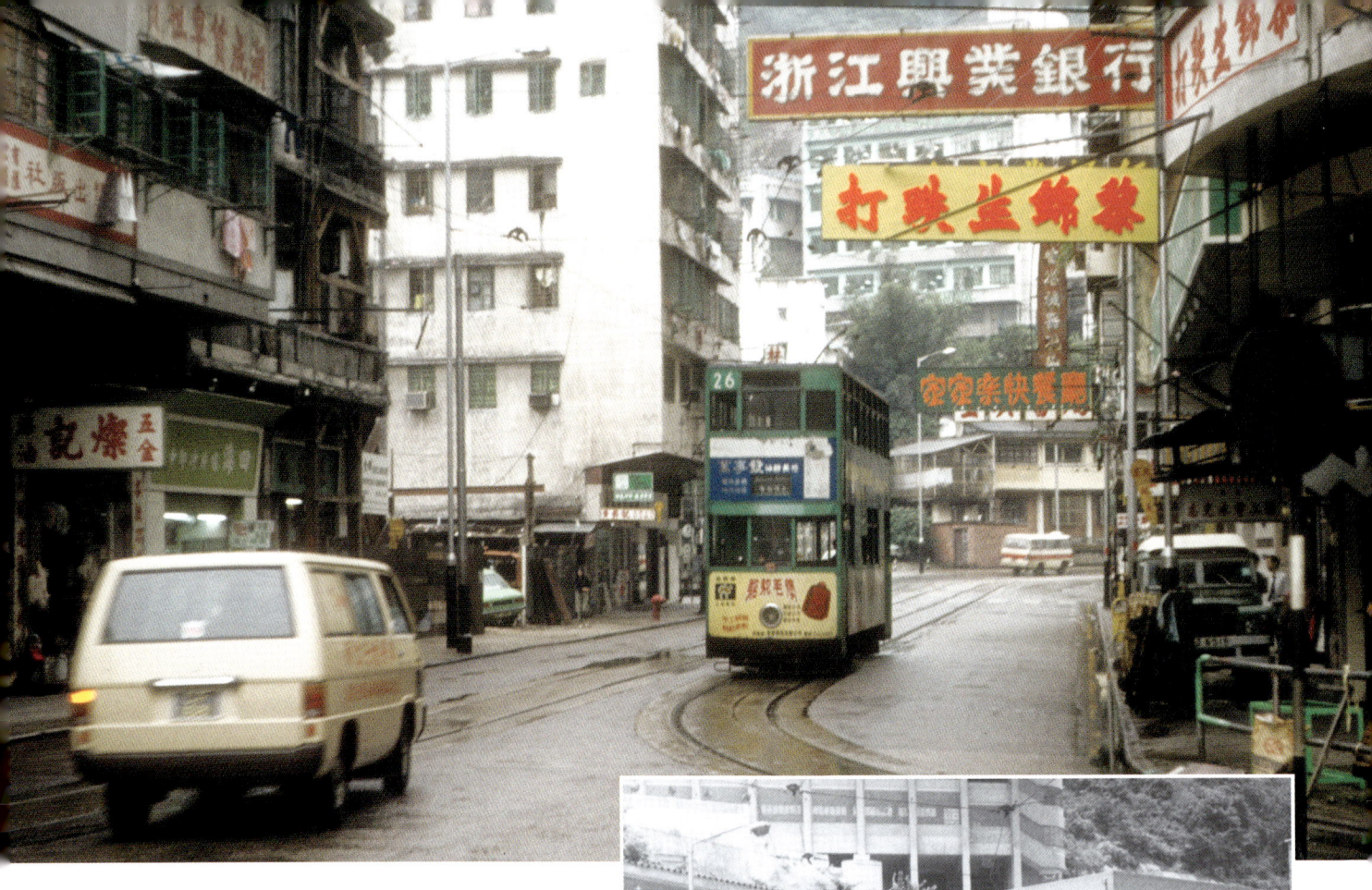

Above: On 20 October 1981 No 26 approaches the loop at Shau Kei Wan along Shau Kei Wan Main Street. Although much has changed over the past 40 years, this scene is still recognisable with the two-storey building at the far end still extant. No 26 was built by the Taikoo Dockyard & Engineering Co and entered service in March 1954.
Alan Murray-Rust/Online Transport Archive

Right: On 23 July 1978 No 64 – one of the trams built by the Taikoo Dockyard & Engineering Co and new in September 1954 – heads out from Shau Kei Wan Main Street into Shau Kei Wan Road with a service towards Happy Valley.
Barry Cross Collection/Online Transport Archive

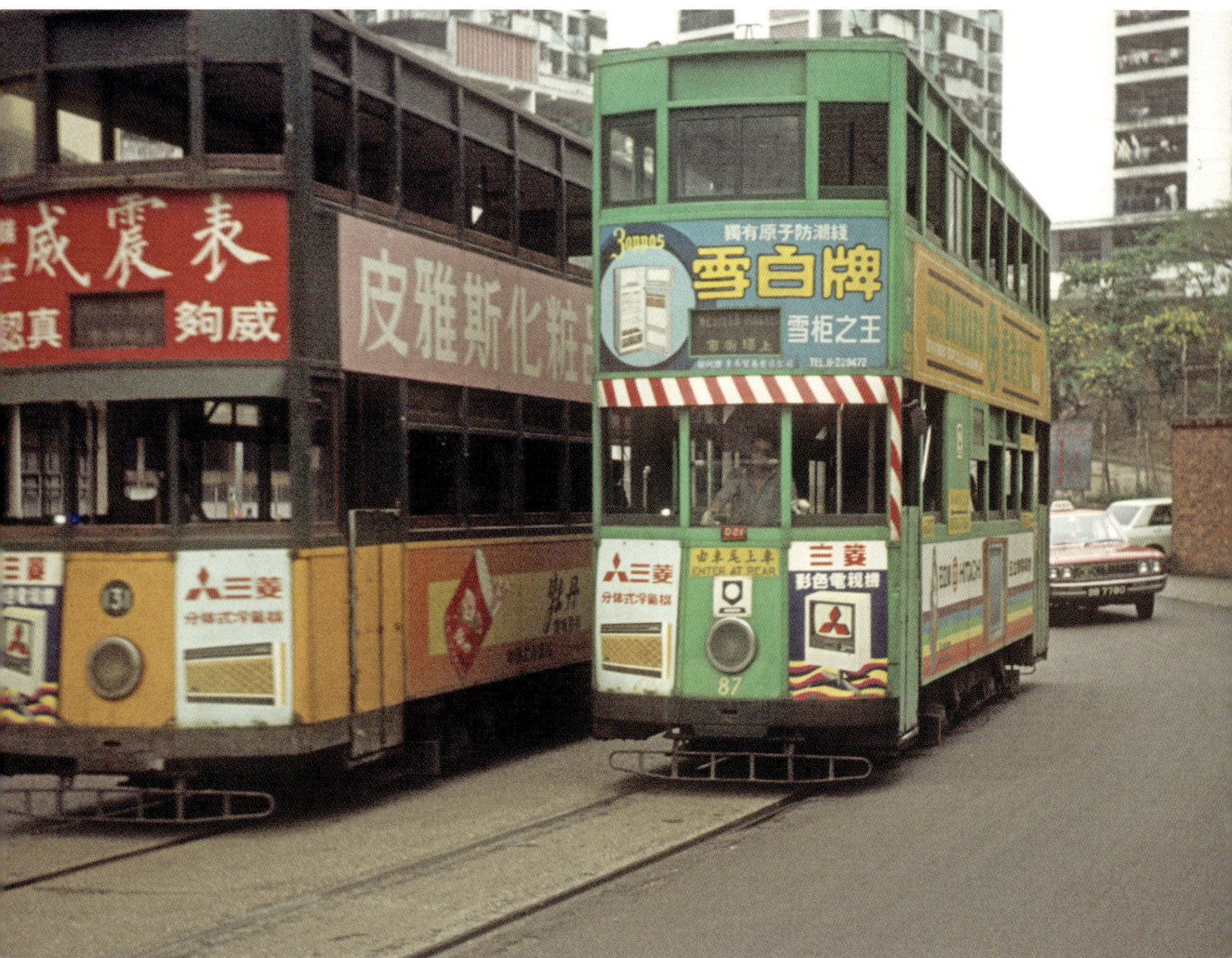

In this 1973 view, Nos 131 and 87 are seen on the approach to the terminus at Shau Kei Wan. The former – with its destination already amended to read Kennedy Town – is heading towards the terminus whilst the the latter is heading westbound towards Western Market.

Both trams dated to the early 1950s: No 87 entered service on 3 July 1953 and No 131 on 30 April 1954.
Paul de Beer/Online Transport Archive

A Journey from East to West • 17

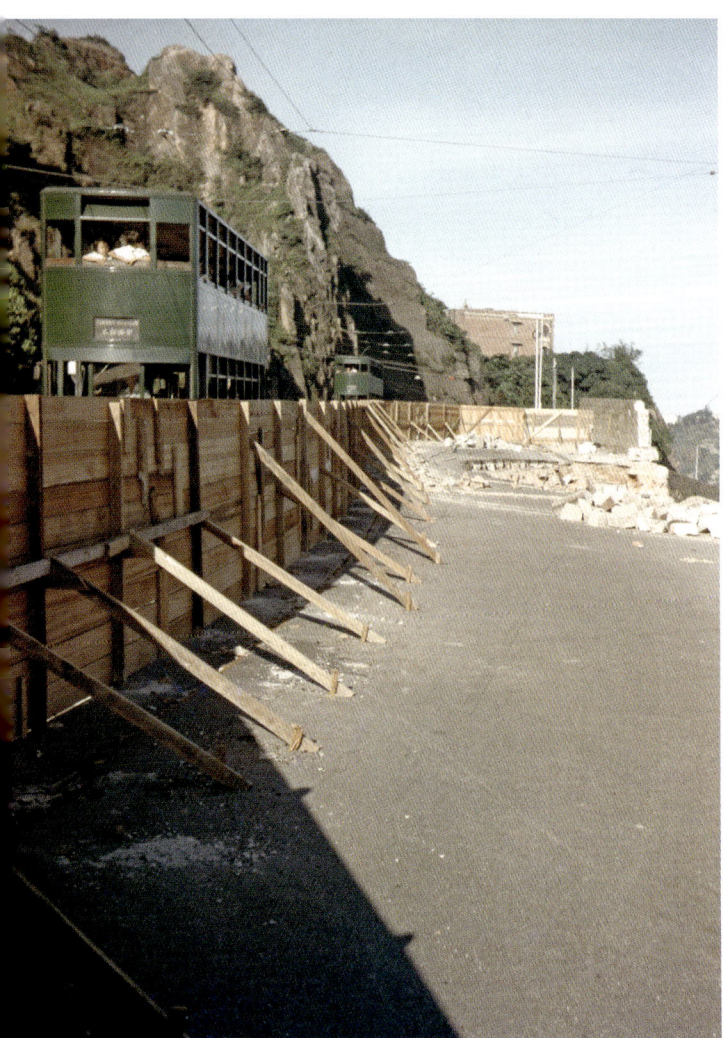 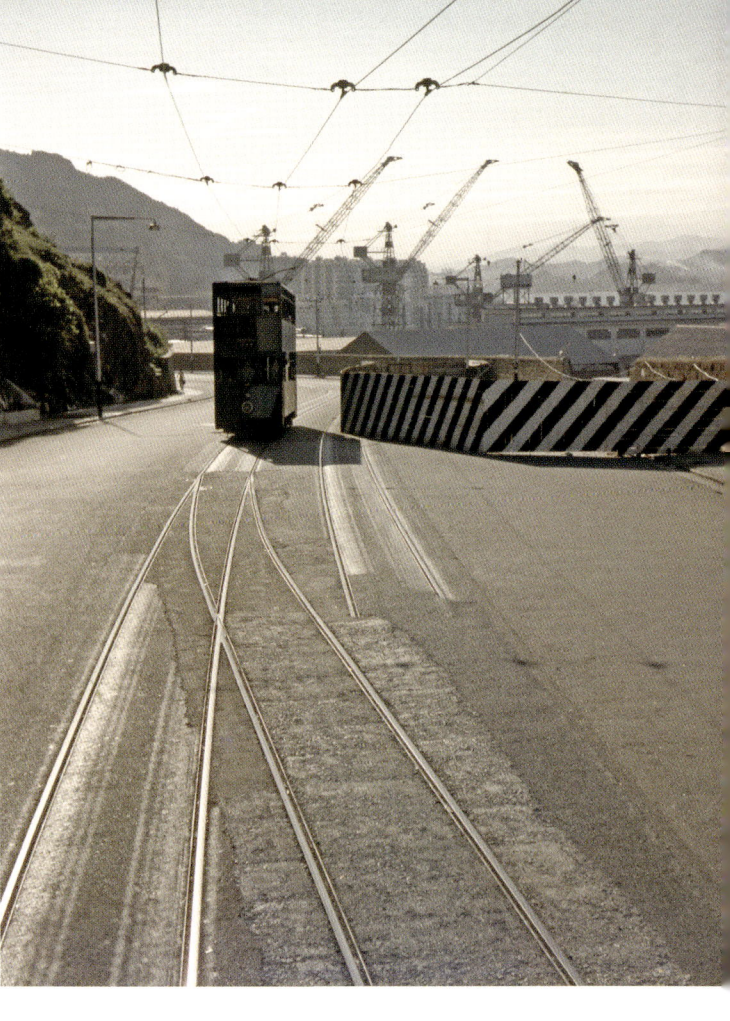

Above: In May 1957 there was a major subsidence on King's Road, Quarry Bay, that resulted in the tramway being disrupted as the eastbound track was deemed unusable. This view, taken looking towards the west, shows the result of the landslip and the temporary barrier erected to prevent access whilst the damage was repaired.
Dennis Beath/Online Transport Archive

Above: In order to maintain its services whilst the King's Road landslip was repaired, Hong Kong Tramways inserted a temporary points and revised overhead to permit single-track operation past the obstruction. This view of No 16 heading eastwards shows to good effect the temporary pointwork and overhead as well as the disconnected eastbound running line at this point. It was not until November 1957 that the road and track was fully repaired.
Dennis Beath/Online Transport Archive

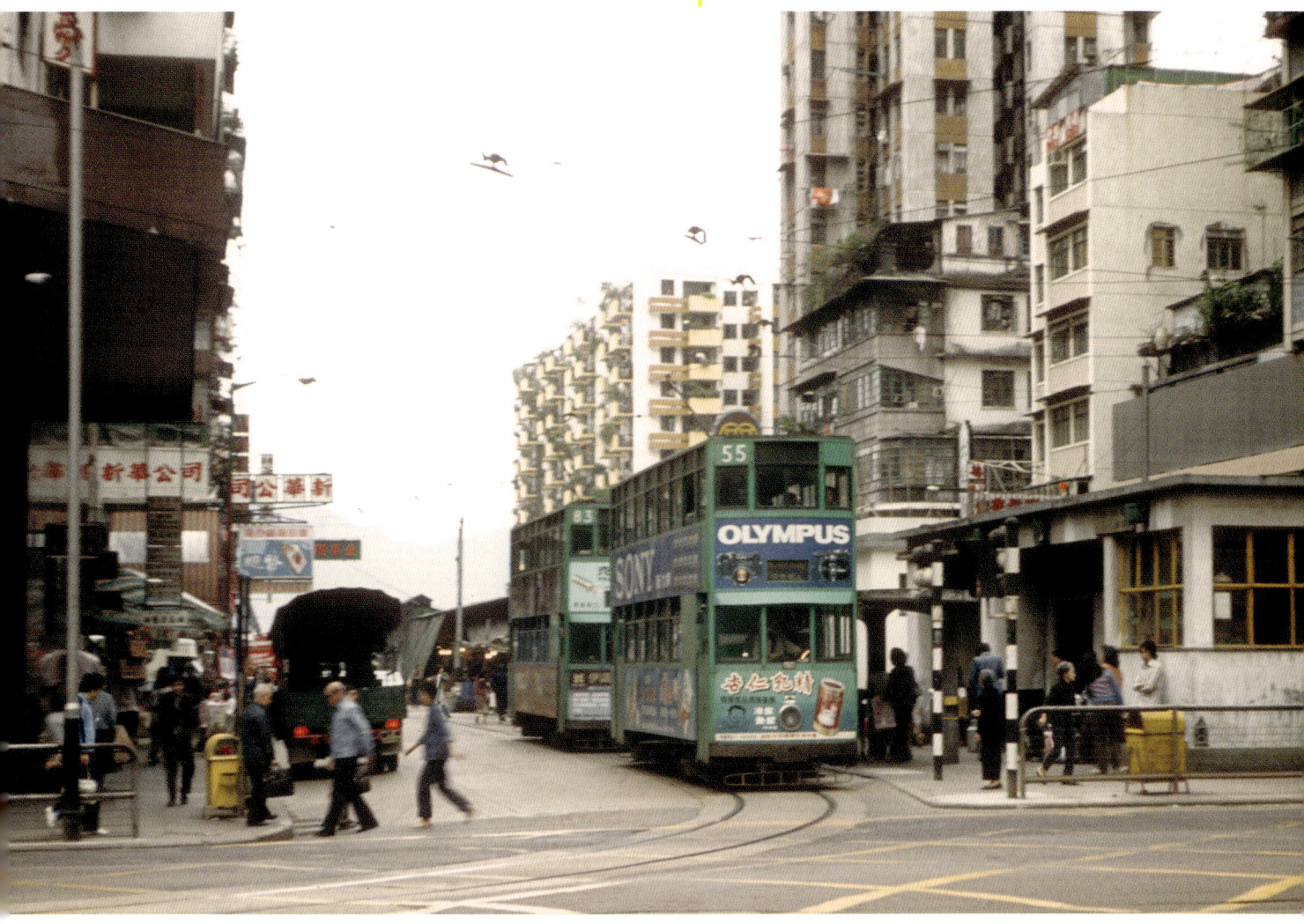

Pictured emerging into King's Road on 23 October 1981 from the loop at North Point are Nos 55 and 83. The original depot on King's Road, which opened in 1932 and could accommodate 30 trams, was situated slightly to the east of this location on the south side of King's Road; this was to close in 1951 when the Sharp Street depot was enlarged. No 55, which was built by Hongkong Tramways, and No 83, which was built by the Taikoo Dockyard & Engineering Co both entered service in April 1953.
Ian Murray-Rust/Online Transport Archive

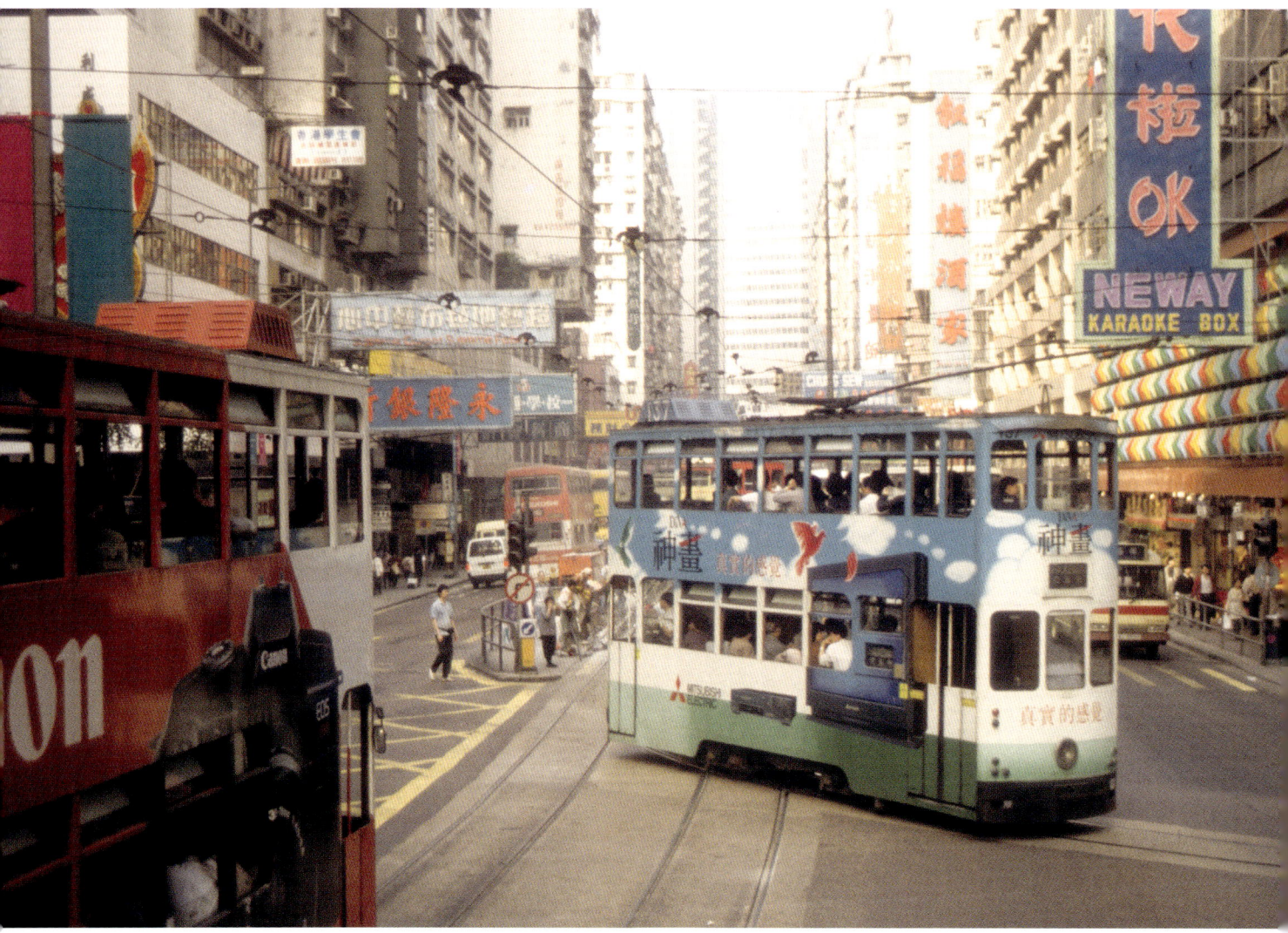

Above: As a second tram waits to proceed past the junction, No 137 emerges from the North Point loop into King's Road. No 137 was rebuilt from a car originally new in 1956 and re-entered service in February 1990. Unlike the majority of the rebuilt cars, No 137 was never fitted with a 2008-style controller and was to be scrapped in June 2013.
Alan Pearce/Online Transport Archive

Opposite: Recorded from the top deck of a following tram in 1956 at the junction of Shau Kei Wan Road and Chai Wan Road, No 18 heads westbound with a service towards Kennedy Town.
Douglas Beath/Online Transport Archive

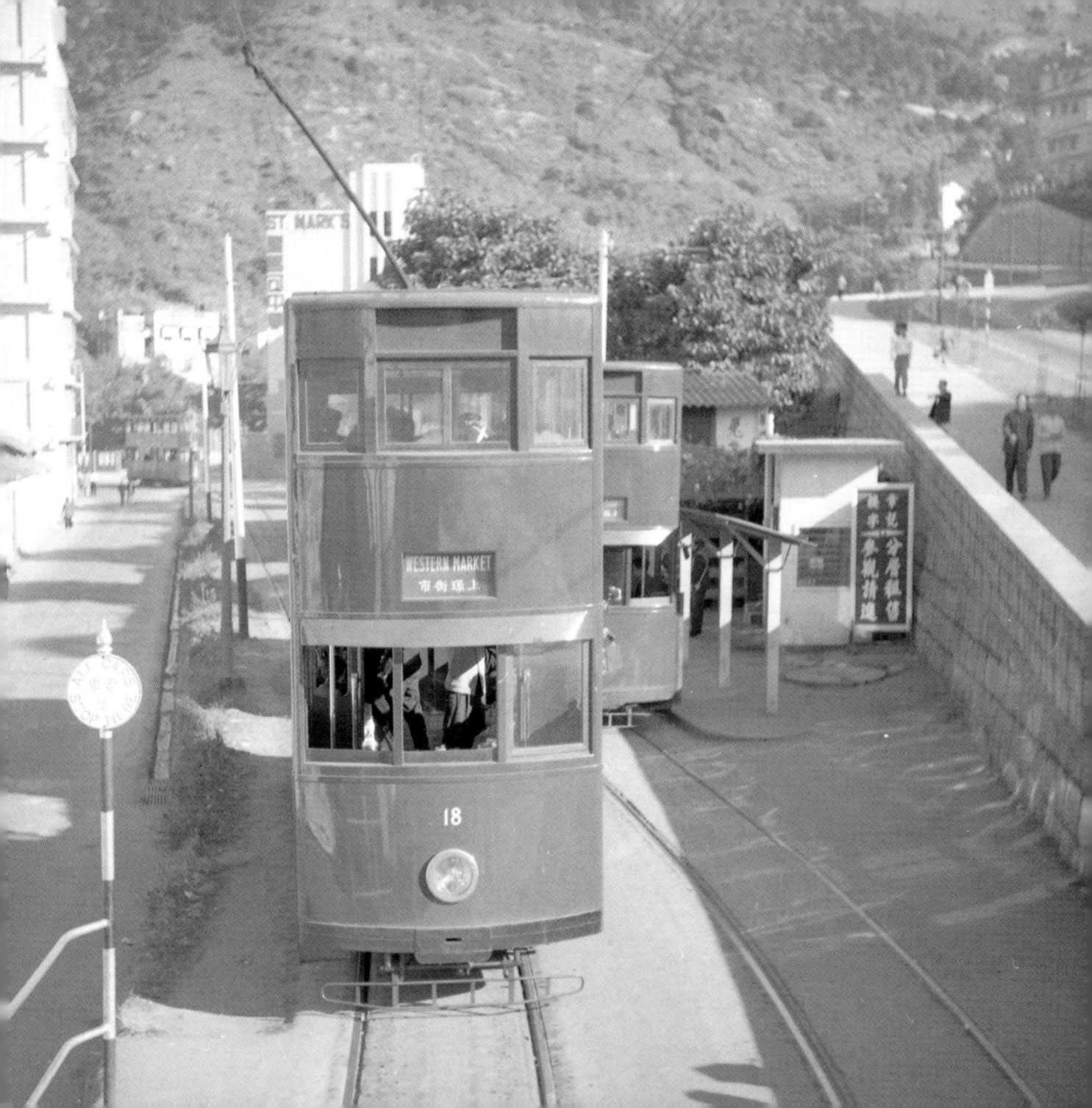

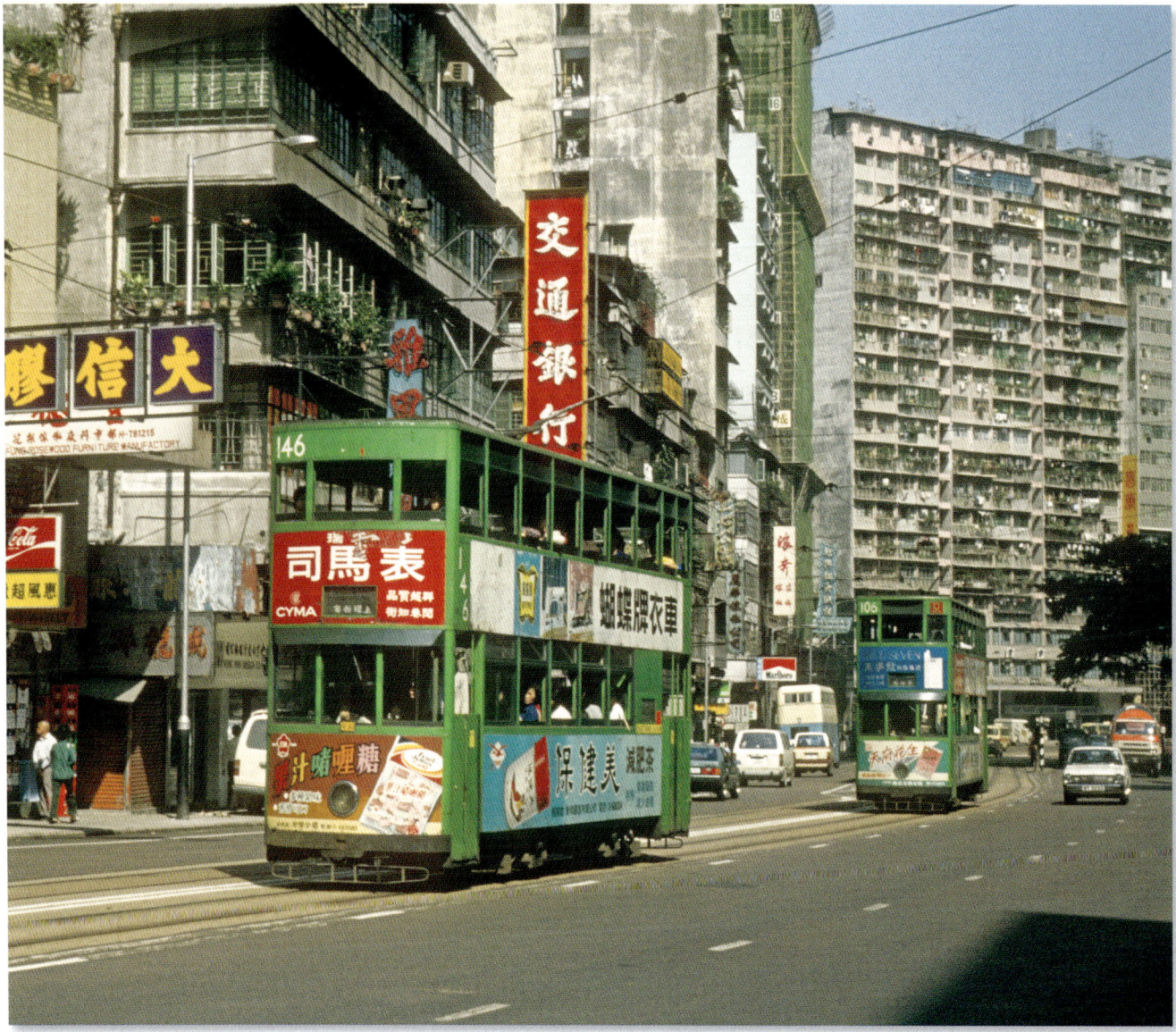

Pictured on 28 October 1981 close to the junction of King's Road with Wing Hing Street, two trams – Nos 146 and 105 – head southbound with services heading towards Western Market. Both trams were built by the Taikoo Dockyard & Engineering Co: No 146 entered service in July 1956 whilst No 105 was completed in March the previous year.
Alan Murray-Rust/Online Transport Archive

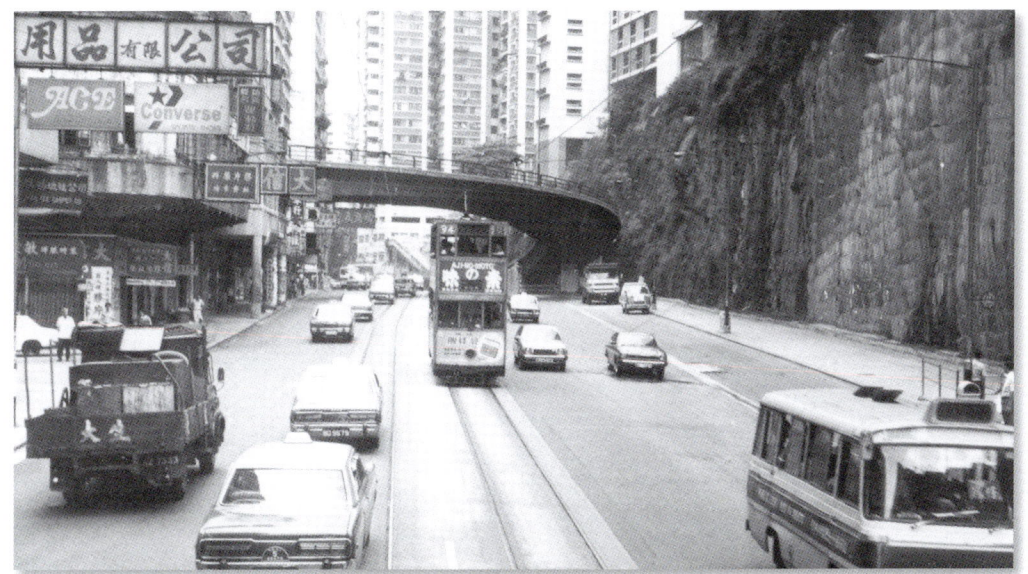

Taken from the top deck of a tram heading northbound, No 94 descends King's Road, near Ngan Mok Street, on 23 July 1978 having just passed under the road overbridge that links King's Road with Route 4 immediately to the north of Victoria Park. Entering service in March 1955, No 94 was built by the Taikoo Dockyard & Engineering Co.
Barry Cross Collection/Online Transport Archive

Recorded at the junction of King's Road and Lau Li Street on 28 October 1981, looking towards the south with the road overbridge in the distance, No 145 heads northbound with a service towards North Point whilst No 134 heads inbound with a service towards Western Market. Both trams were again built by the Taikoo Dockyard & Engineering Co; the older of the two was No 134, completed in September 1955, whilst No 145 was delivered nine months later.
Alan Murray-Rust/Online Transport Archive

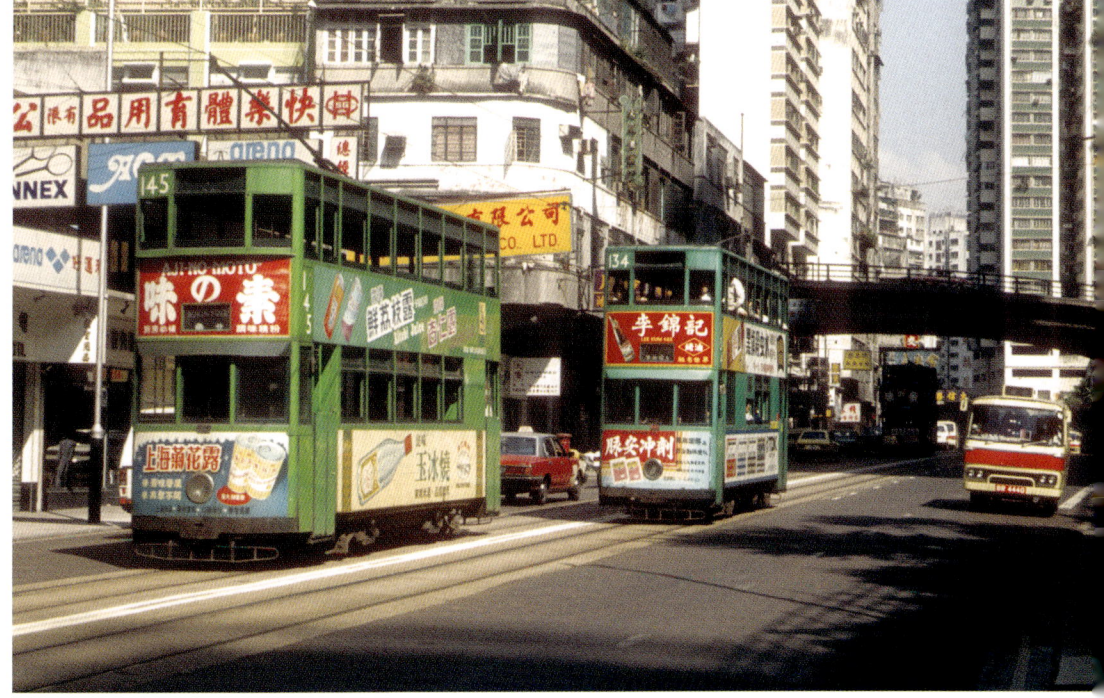

A Journey from East to West • 23

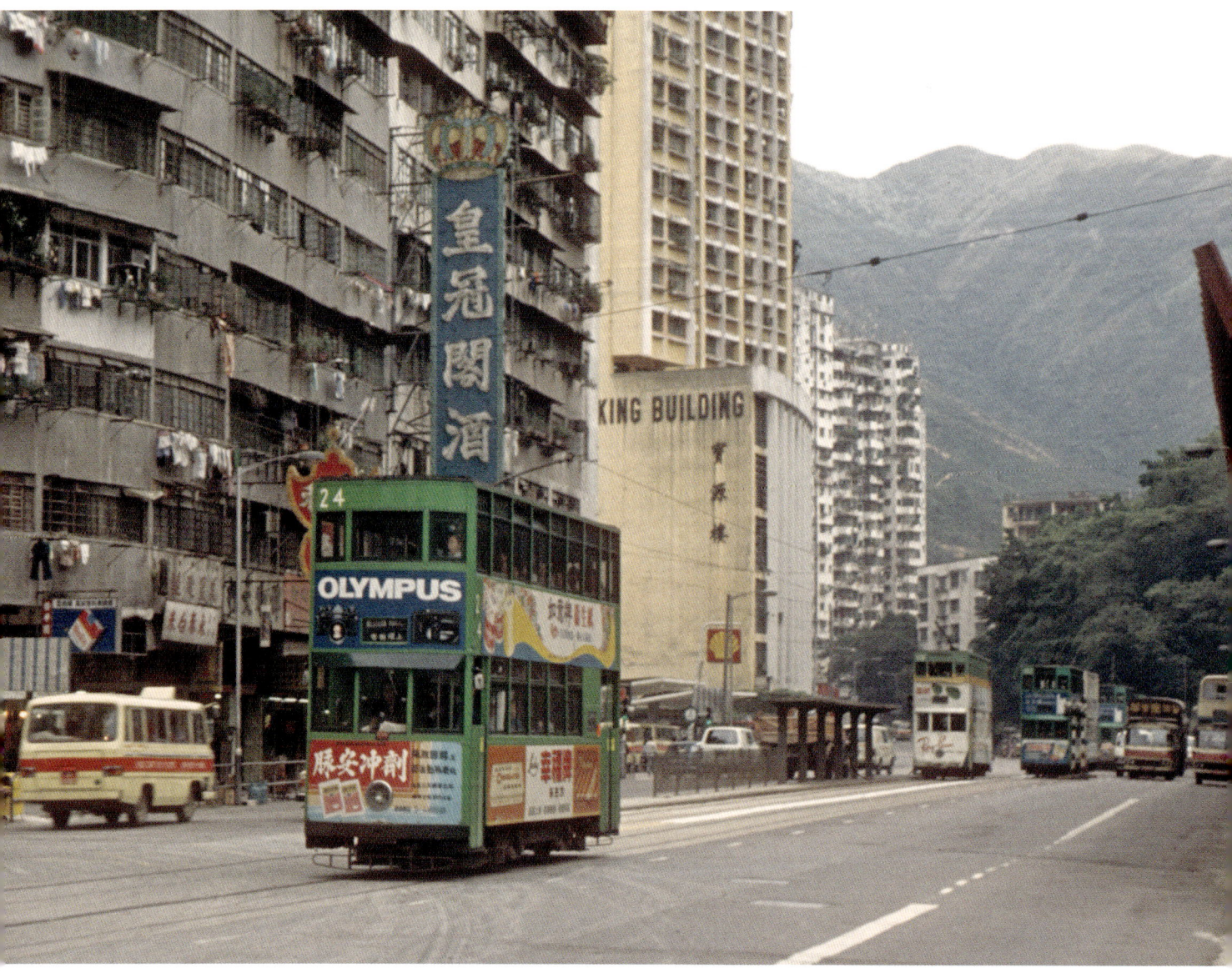

On 23 October 1981, No 24 heads eastbound on King's Road with a service towards Shau Kei Wan. The tram was one of those constructed by the Hongkong & Whampoa (Kowloon) Docks and entered service in February 1952.
Alan Murray-Rust/Online Transport Archive

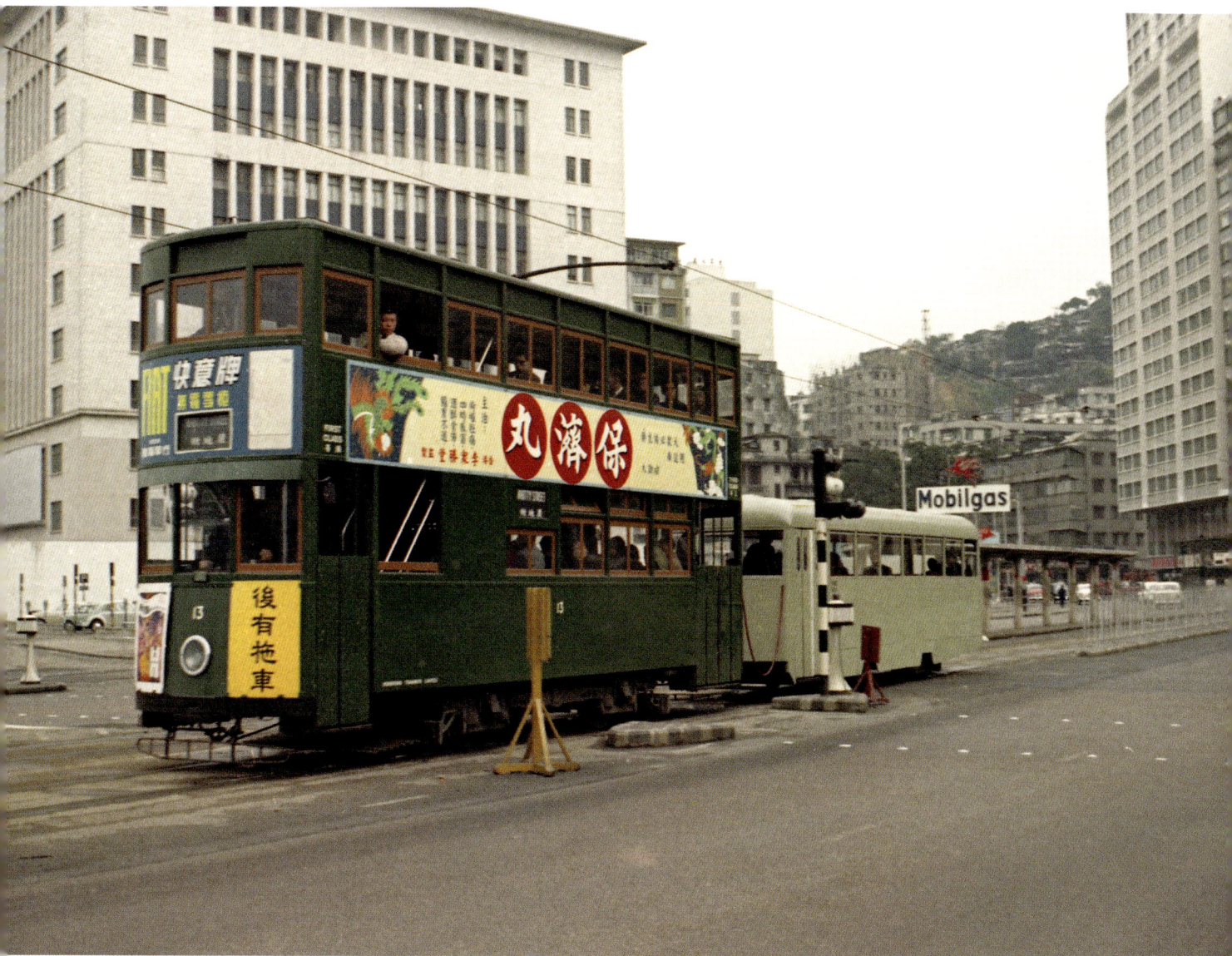

In December 1965 No 13 is pictured with one of the then new trailer cars at the junction of King's Road, Causeway Road and Hing Fat Street. In the background are the buildings of the Causeway Bay Magistracy and the Tai Hang bus station. These have now been demolished and replaced by the Tin Hau MTR station and the Park Tower building. The Magistracy was completed originally in about 1960 and demolished in the late 1980s.
Douglas Beath/Online Transport Archive

Right: Pictured in 1967 whilst work was in progress on the turning circle at Causeway Bay – the completion of which would reduce the need to use the emergency crossover on Causeway Road – No 129 reverses over the crossover, making use of the trolley reverser overhead to switch the pole's direction. Note the crewman on the right carrying the tool for switching the manual points.
Douglas Beath/Online Transport Archive

Opposite: Viewed looking towards the east and with Victoria Park on the left, No 17 can be seen heading towards Shau Kei Wan whilst No 19 heads inbound towards the photographer along Causeway Road in late 1965. On the right are the premises of Johnson, one of Hong Kong's best known tailoring businesses. Today the scene is radically different with the Gloucester Road flyover passing overhead. Nos 17 and 19 were both built by the Taikoo Dockyard & Engineering Co and entered service on 9 November 1953 and 15 April 1951 respectively. The two maroon and cream buses visible belong to the China Motor Bus fleet and are Guy Arab UFs, the 'UF' standing for underfloor as in the location of the engine. Bodywork was by Duple Midland/Metal Sections. Between 1967 and 1969 these vehicles were fitted with an additional radiator front mounted, the radiators being recovered from scrap Tilling Stevens buses.
Harry Luff/Online Transport Archive

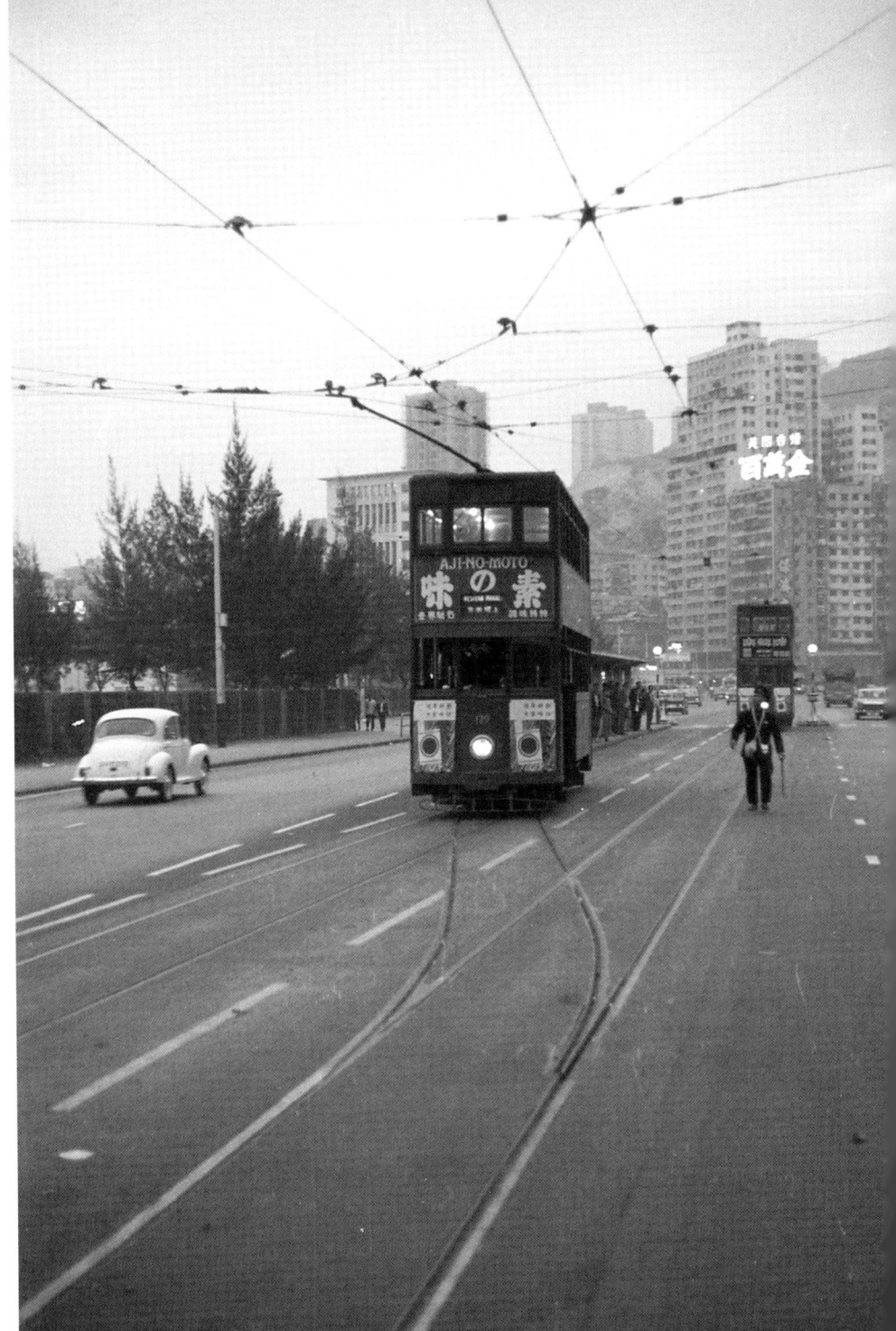

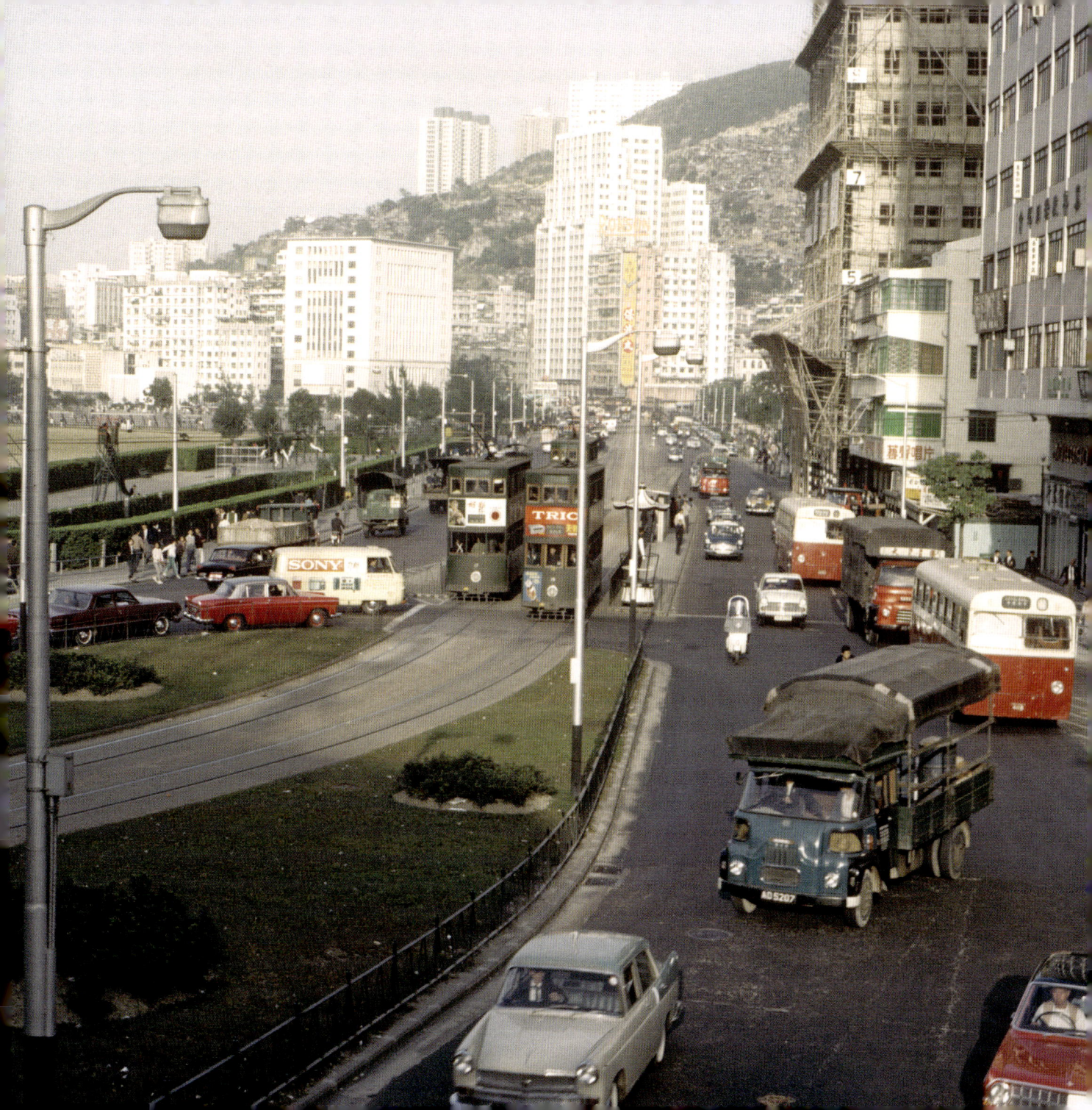

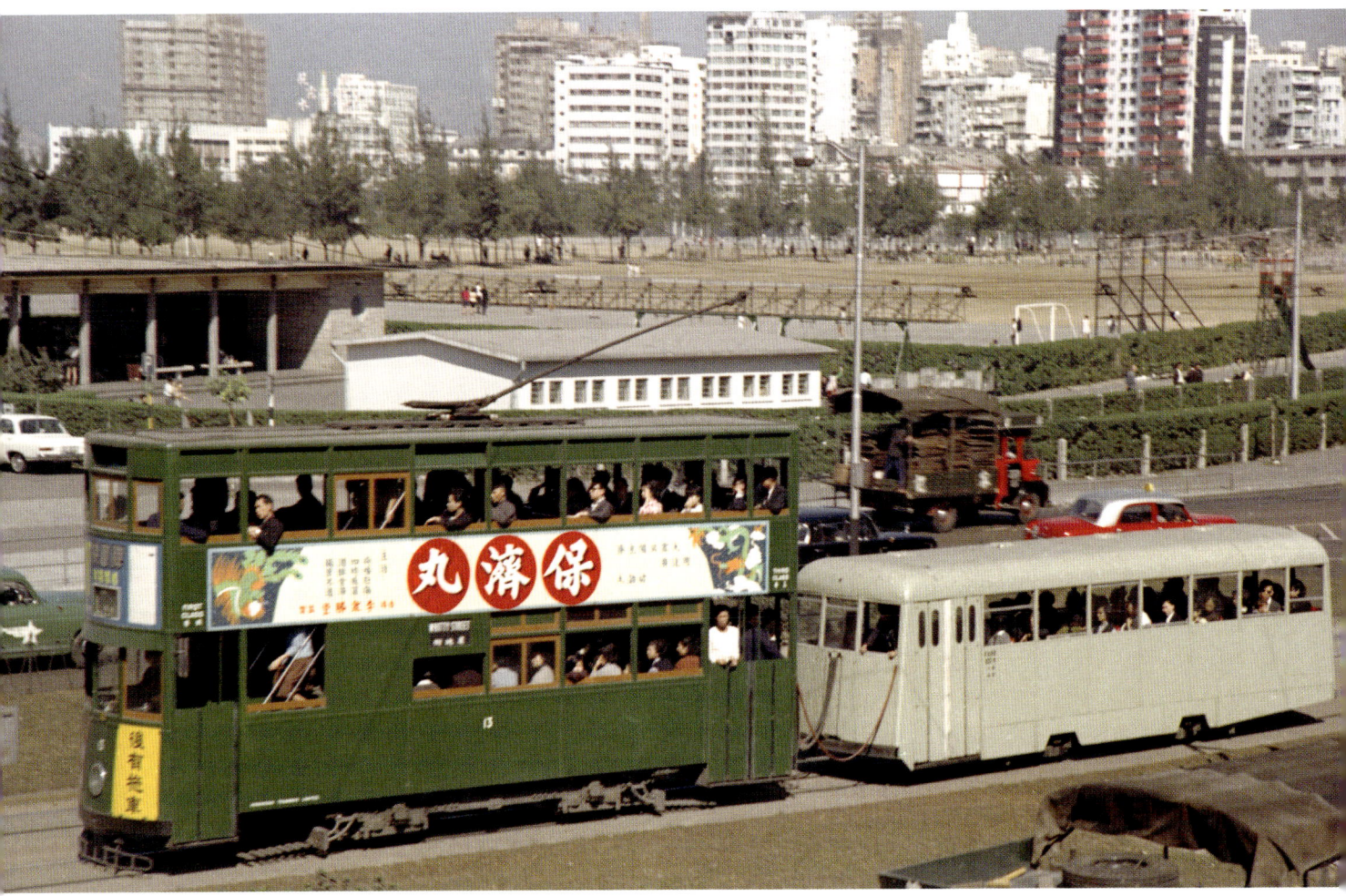

Above: With Victoria Park in the background, No 13 heads westbound towards Whitty Street towing one of the then new trailer cars during 1966.
Douglas Beath/Online Transport Archive

Opposite: Pictured in 1956 – the year after the completion of the New York Theatre seen in the background – No 68 heads eastbound at Causeway Bay on Hennessy Road. The New York opened on 23 January 1955 and was to survive until closure on 1 May 1982. Subsequently demolished, the site of the building was used for the construction of Causeway Bay Plaza. No 68 was also relatively new when recorded in this view; it entered service on 28 May 1952.
Douglas Beath/Online Transport Archive

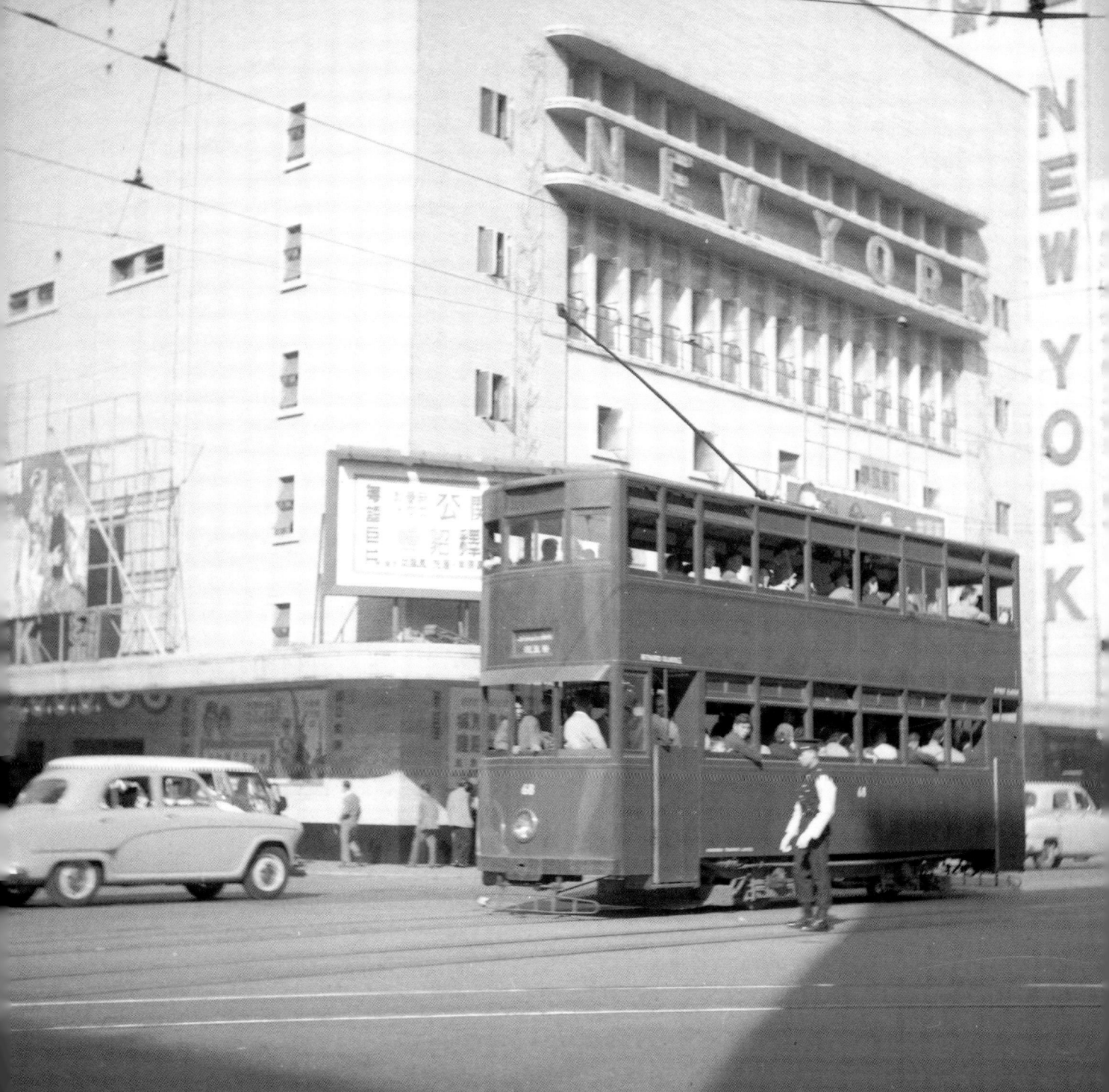

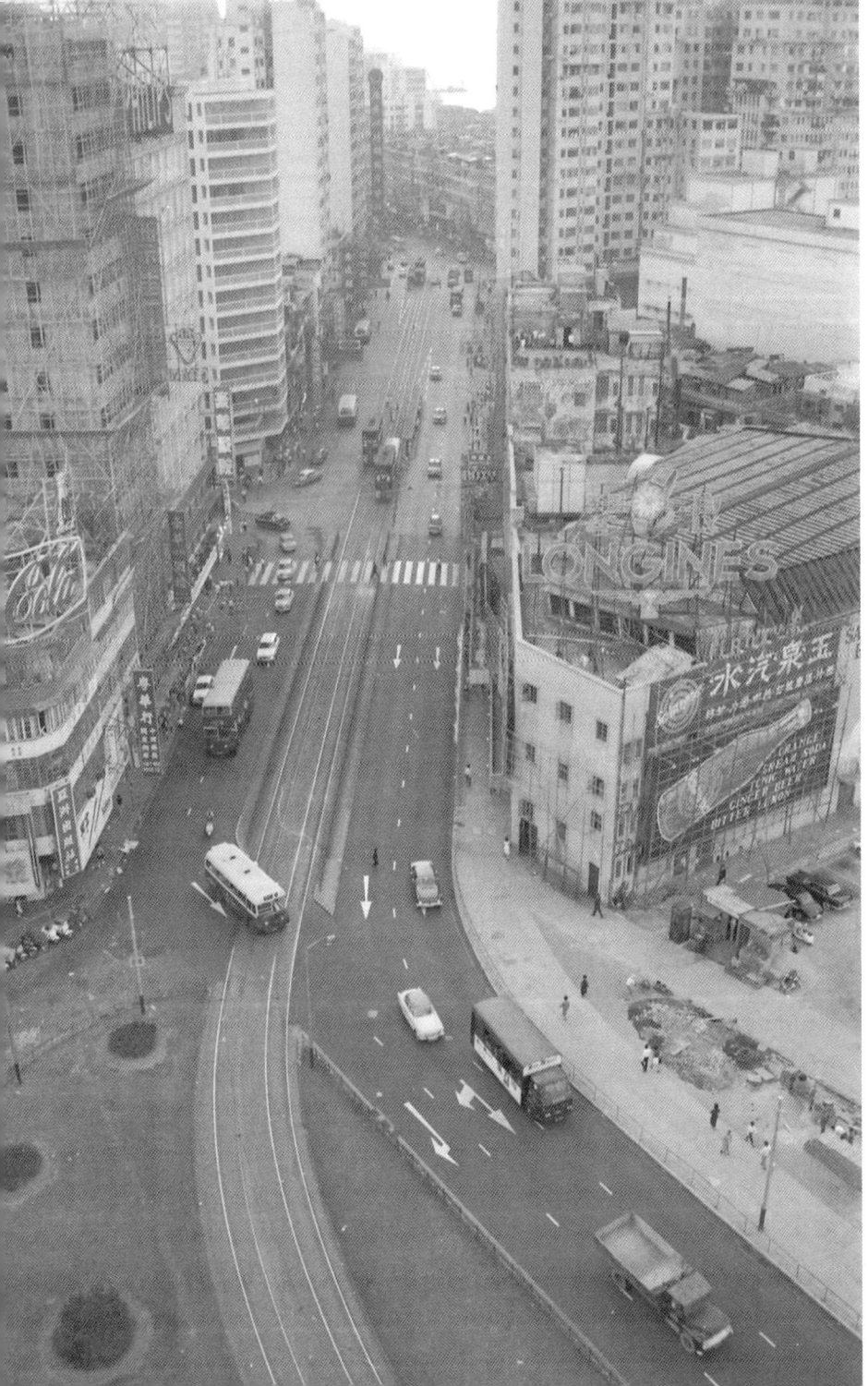

Left: With both east- and westbound trams visible in the distance, Yee Wo Street stretches towards Hennessy Road in this view taken in 1966 before work was undertaken on the construction of the loop at Causeway Bay. There had previously been a loop at this point but this had been removed in 1953.
Douglas Beath/Online Transport Archive

Opposite: Work in progress to install the new loop at Causeway Bay as trams, one with a trailer, head westbound into Yee Wo Street. The construction of the loop, part of a broader project to improve the traffic flow at the intersection, was designed to reduce the use of the emergency crossover and thus minimise the number of trams operating in reverse.
Douglas Beath/Online Transport Archive

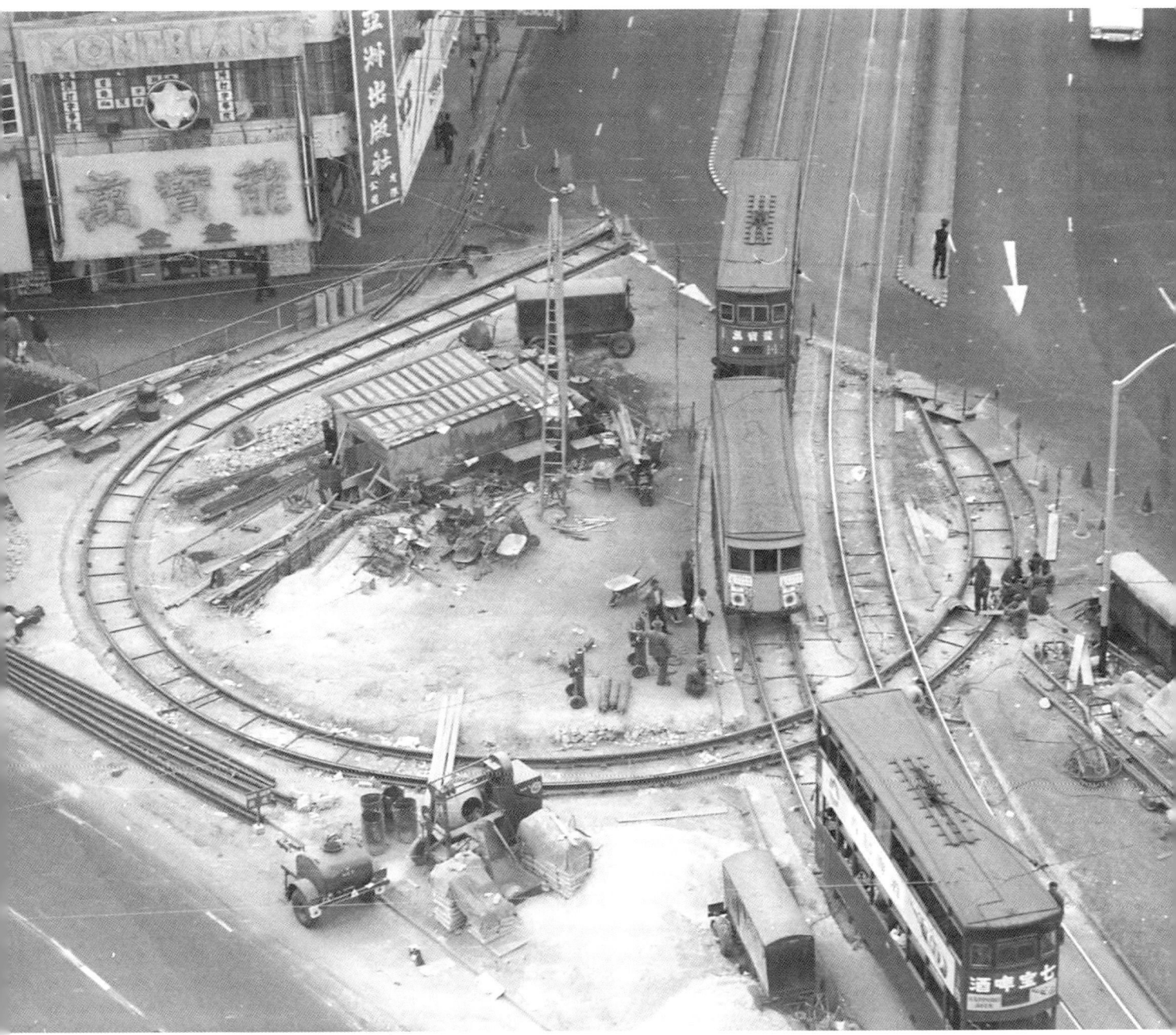

A Journey from East to West • 31

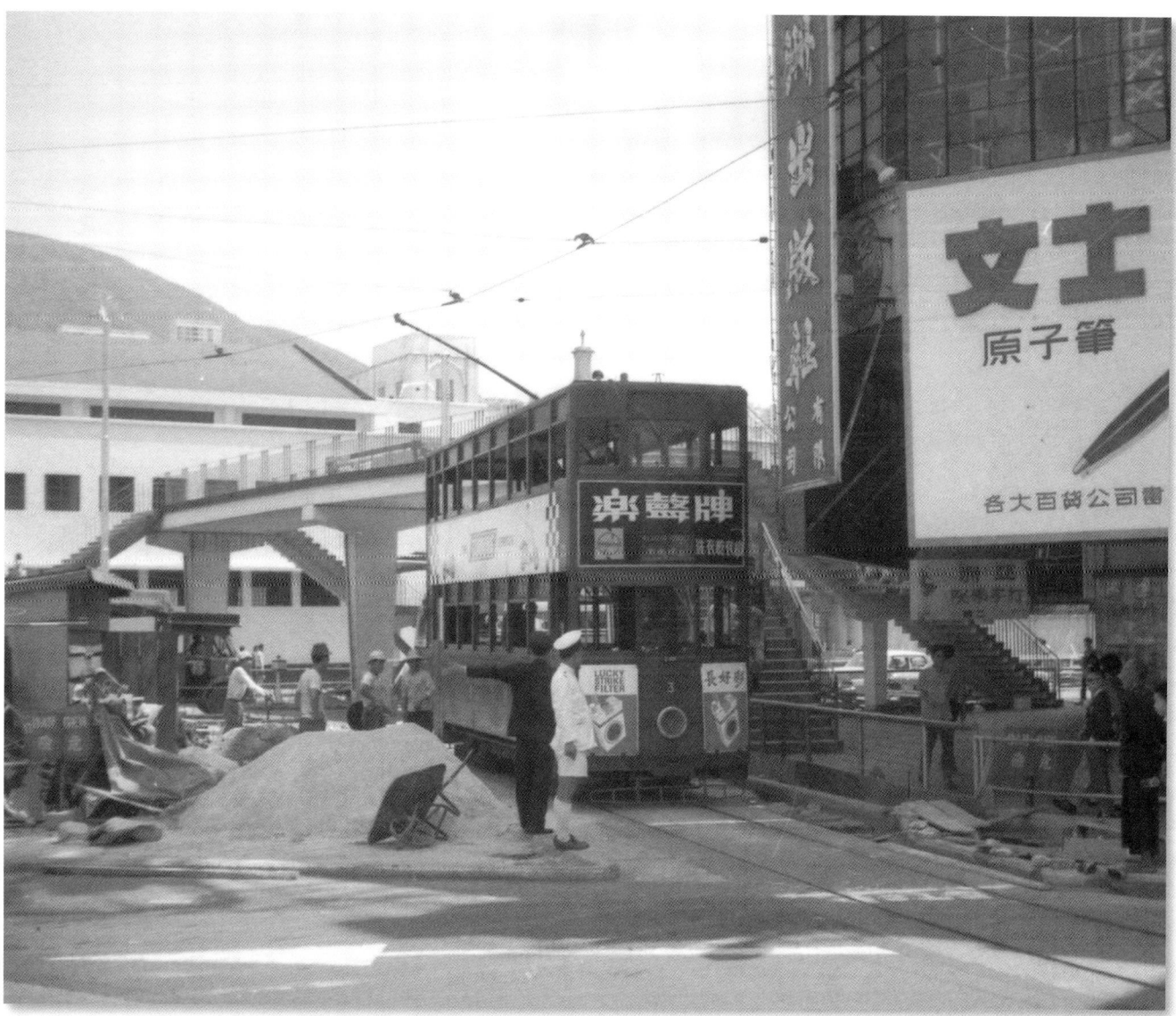

Pictured using the new Causeway Bay loop in 1967 shortly after its completion is No 3. The tram was built by the Taikoo Dockyard & Engineering Co and entered service in March 1952. The loop was opened on 20 March 1967 and permitted the recasting of the service pattern, permitting effectively a three-minute headway on services westbound towards Western Market and Whitty Street.
Douglas Beath/Online Transport Archive

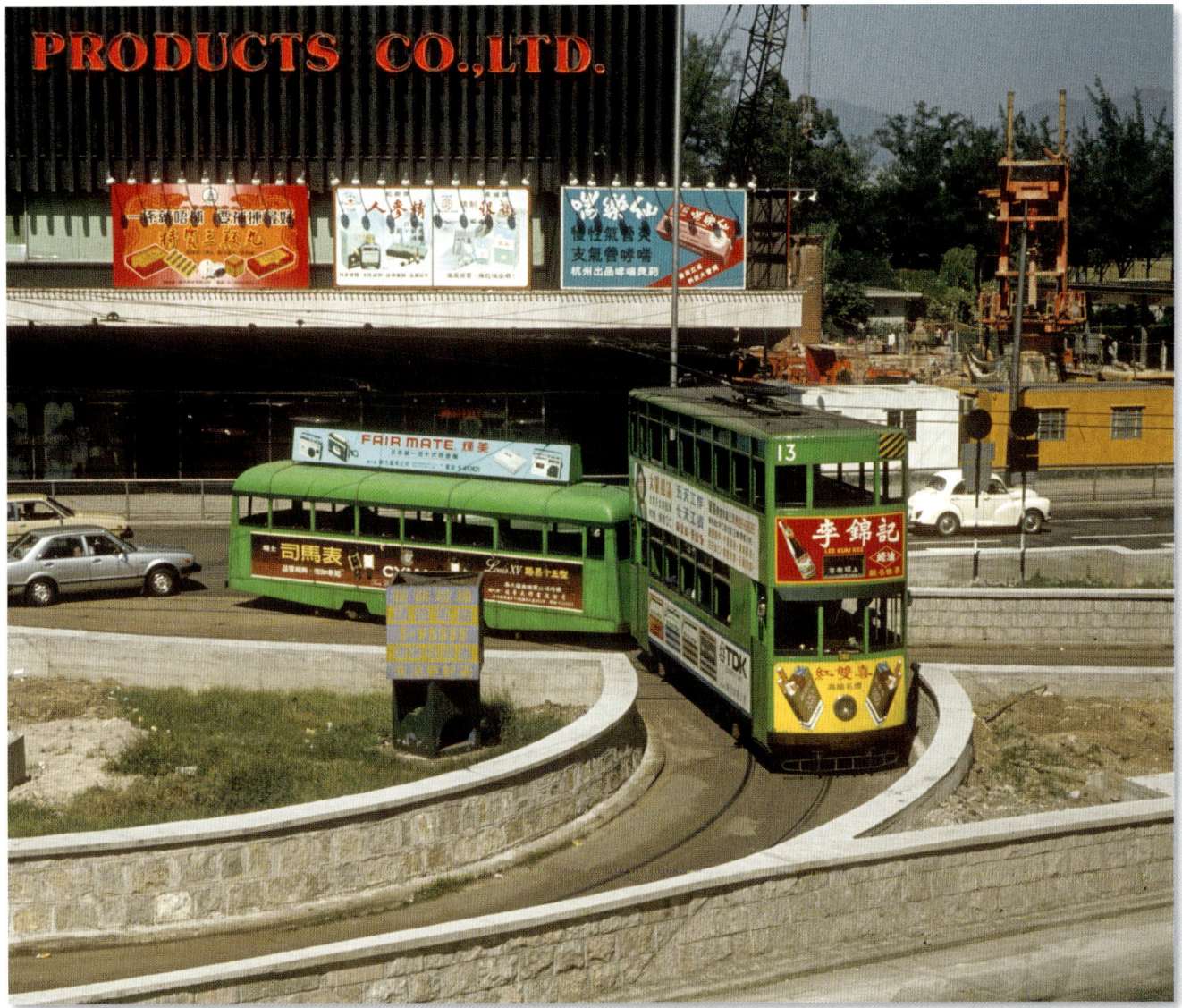

On 28 October 1981 No 13, built by the Taikoo Dock & Engineering Co and new originally in August 1952, enters the loop at Causeway Bay towing one of the 20 trailers built by Metal Sections Ltd. The trailers all entered service between December 1965 and February 1967. By this date the operation of trailers was drawing to a close; all were withdrawn in April 1982 and scrapped three months later.
Alan Murray-Rust/Online Transport Archive

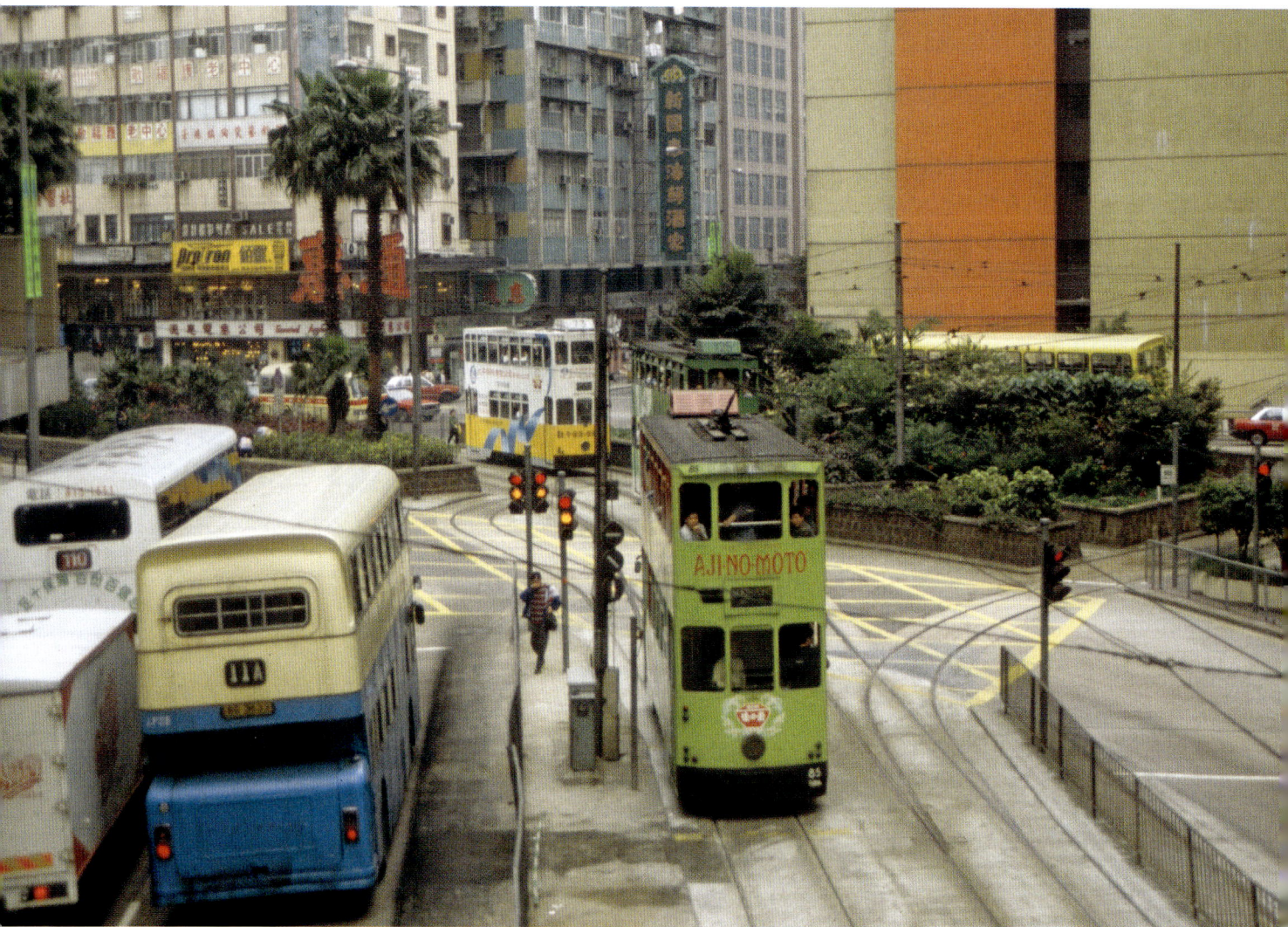

A busy scene at the Causeway Bay loop in 1995 sees No 85 heading eastbound with a service towards North Point whilst Nos 175 and 73 head inbound.
Alan Pearce/Online Transport Archive

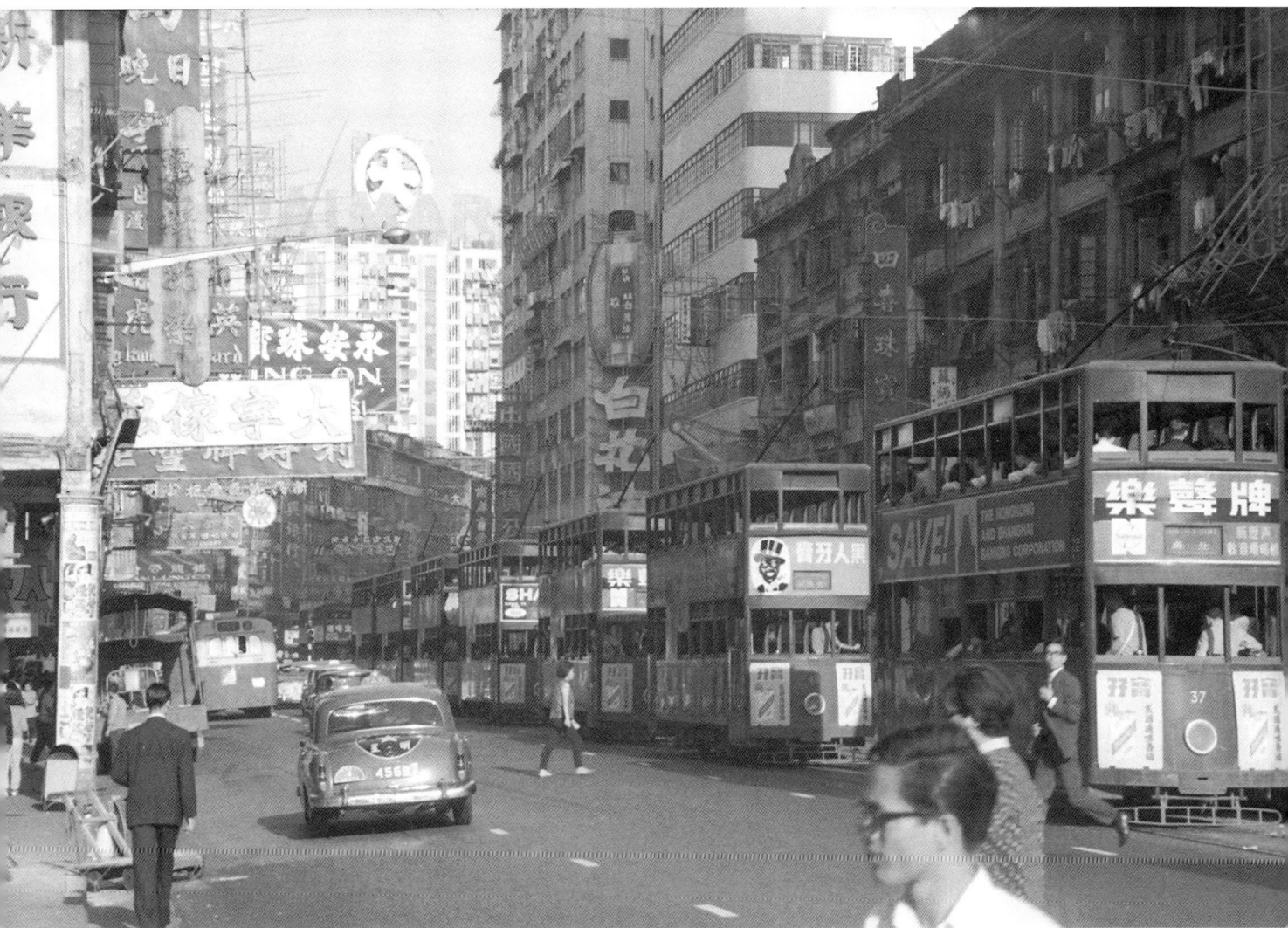

No fewer than 10 trams – with No 37 (a product of the Taikoo Dockyard & Engineering Co and new in August 1952) closest to the camera – can be seen in this view of Hennessy Road, Causeway Bay, close to the Wan Chai fire station in 1966.
Douglas Beath/Online Transport Archive

A Journey from East to West • 35

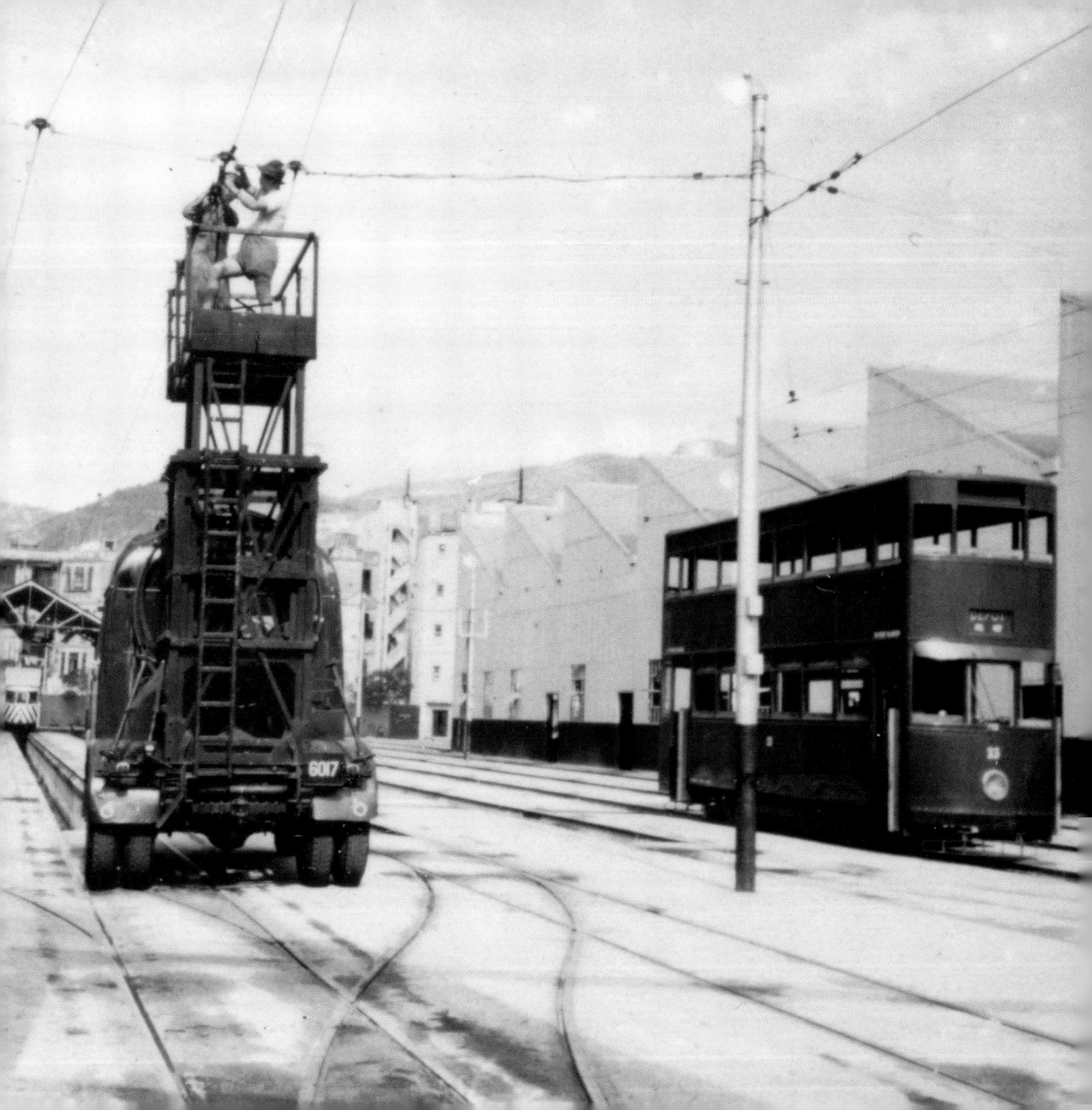

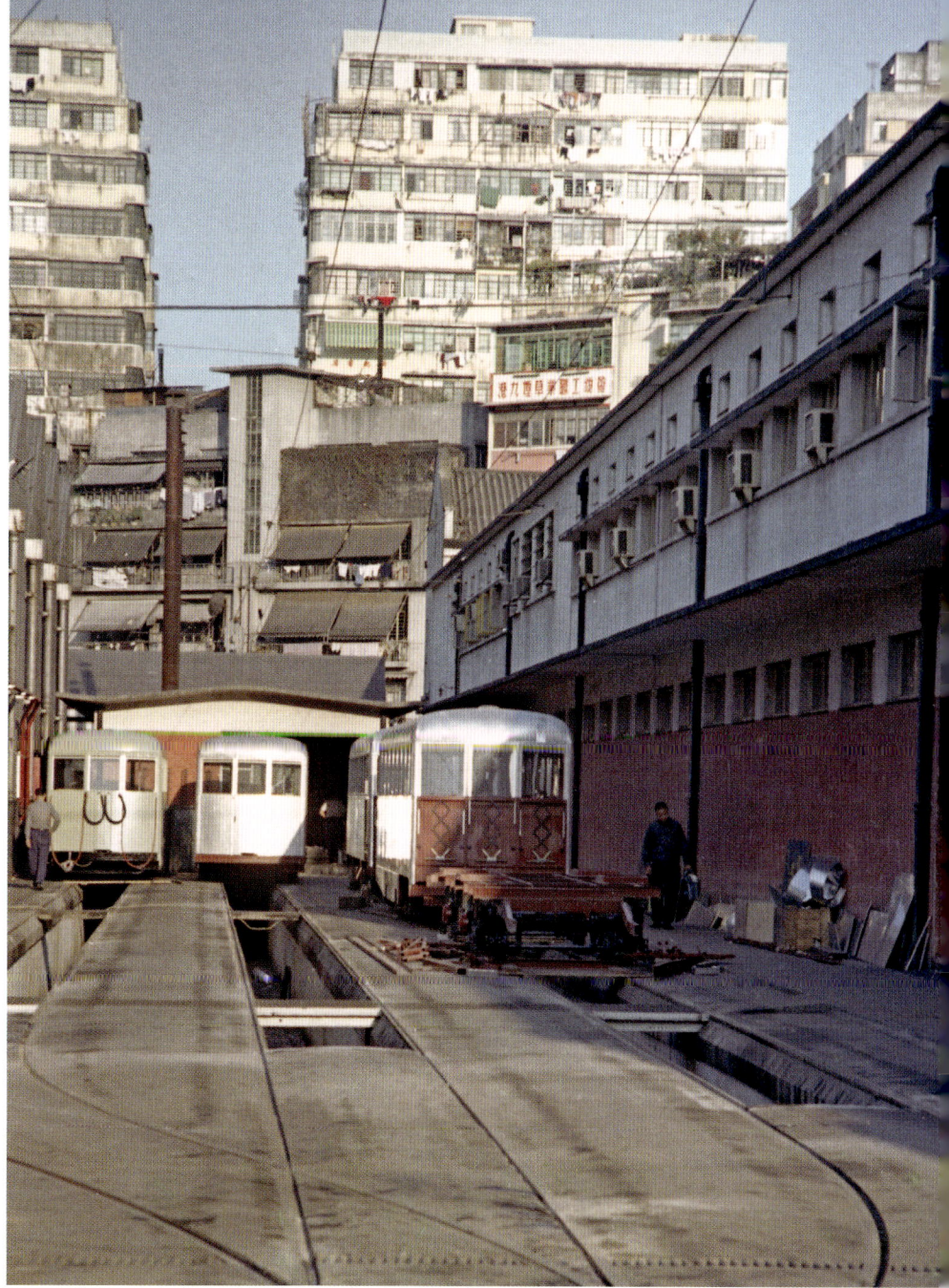

Left: The depot in Russell Street, which dated originally to 1904 and was enlarged in the early 1920s, was supplemented in 1932 by the construction of a second depot at North Point. This was designed to accommodate 30 trams but, by the late 1940s, the existing depot accommodation was proving inadequate and it was decided to close the North Point depot and expand Russell Street in order to accommodate the entire fleet. North Point depot closed in 1951 and the new depot – renamed Sharp Street – was finally completed in 1955. This view, taken the following year, shows tower wagon No 6017; this was one of two acquired from the Scottish-based manufacturer Albion, both of which entered service in February 1955.
Douglas Beath/Online Transport Archive

Right: Pictured in the depot at Sharp Street in 1966 are four of the company's 22 trailer cars under construction. A fifth truck – one of 20 constructed by the Taikoo Dockyard & Engineering Co for use on the trailers – can be seen on the right. Initially 10 trailers were ordered from the Oldbury, England, based Metal Sections Ltd following the success of a prototype constructed locally by Taikoo. These were delivered in sections and completed in Hong Kong; entering service between December 1965 and March 1966, the success of the trailers resulted in a further order for 10 more. The second batch, again manufactured in England and shipped to Hong Kong for completion, entered service during January and February 1967. The final one, No 22, was completed locally in September 1967.
Douglas Beath/Online Transport Archive

A Journey from East to West • 37

Left: Viewed from above, a tram emerges into Hennessy Road from Percival Street with a westbound service. Although the trams remain much else has changed in this scene; in particular, a footbridge now spans Hennessy Road immediately to the east of Percival Street.
Douglas Beath/Online Transport Archive

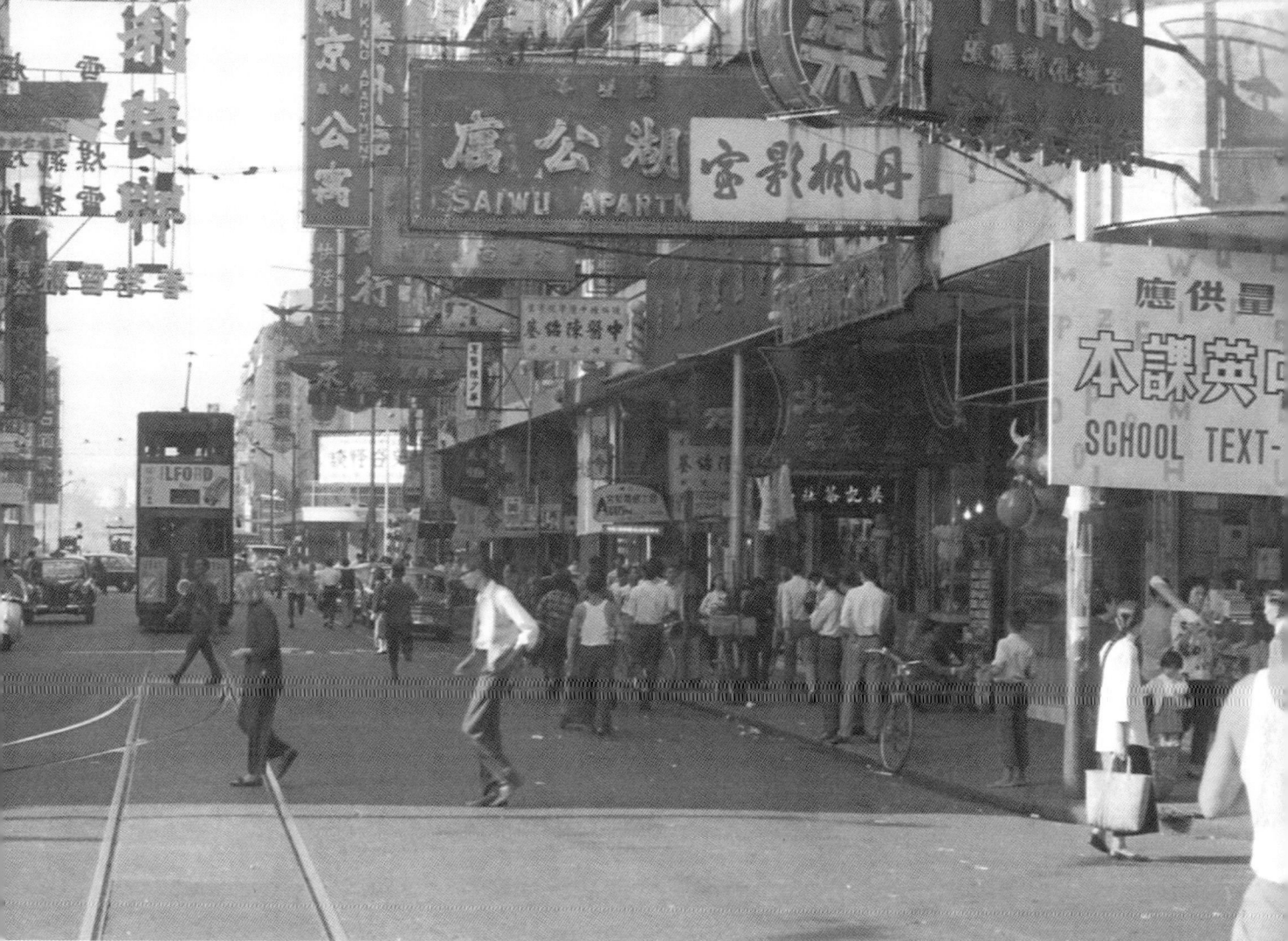

Above: A tram is pictured heading southbound along Percival Street with a service via Happy Valley in 1966. The track heading off to the left is the connection to Sharp Street depot. Originally access to Wong Nei Chong Road was via Canal Street East and Leighton Road; the track south of the junction illustrated here was installed in the early 1950s as part of the programme that saw the enlargement of Sharp Street depot. The track along the middle section of Leighton Road was closed at the same time.
Douglas Beath/Online Transport Archive

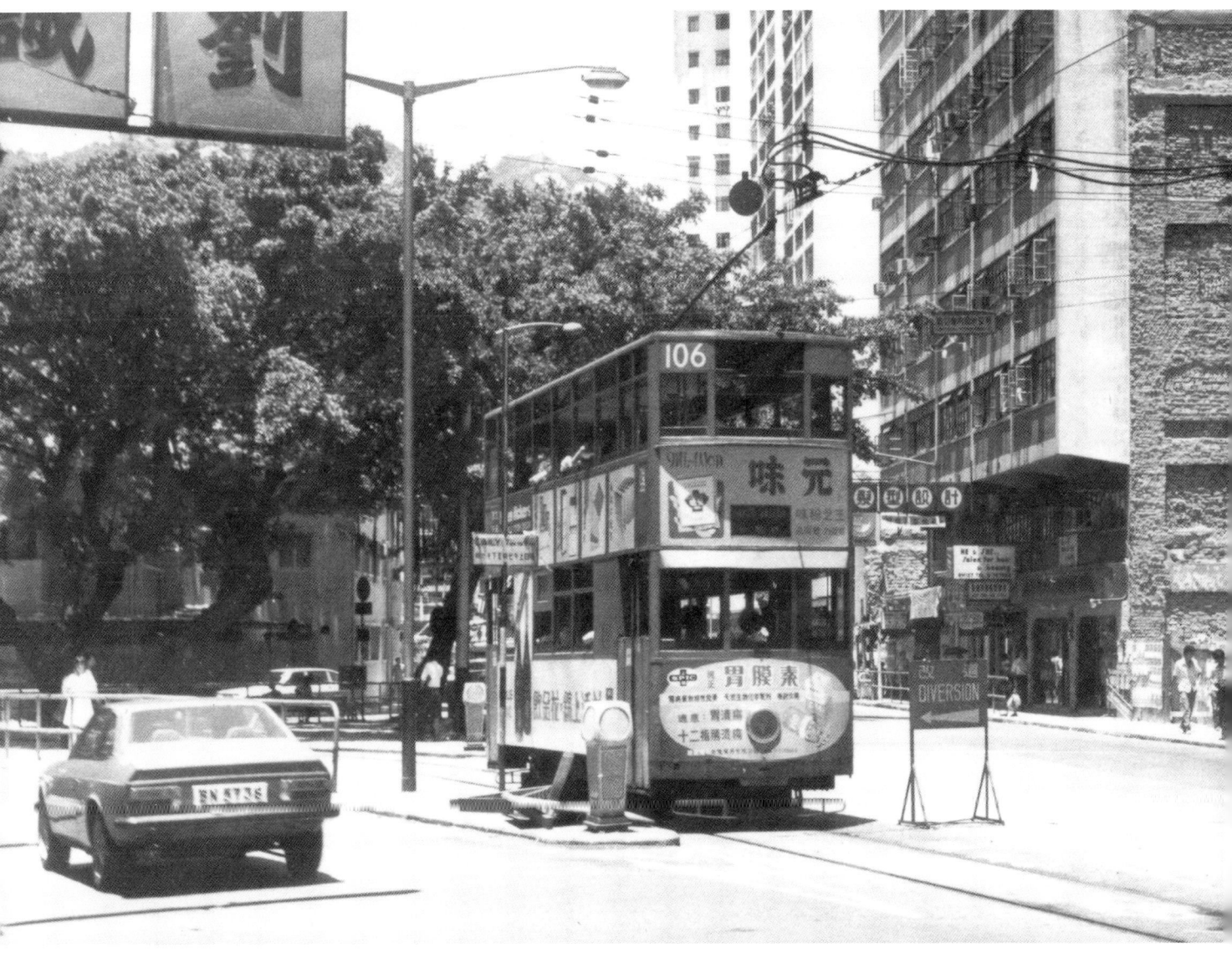

As part of the work associated with the construction of the enlarged Sharp Street depot in the early 1950s, trams serving Happy Valley were diverted away from Canal Road East and the western section of Leighton Road to operate south along Percival Street and then the central section of Leighton Road. Viewed on 20 July 1978, No 106 makes its way from Leighton Road into Wong Nai Chung Road. The tram was built by the Taikoo Dockyard & Engineering Co and entered service in June 1955.

Barry Cross/Online Transport Archive

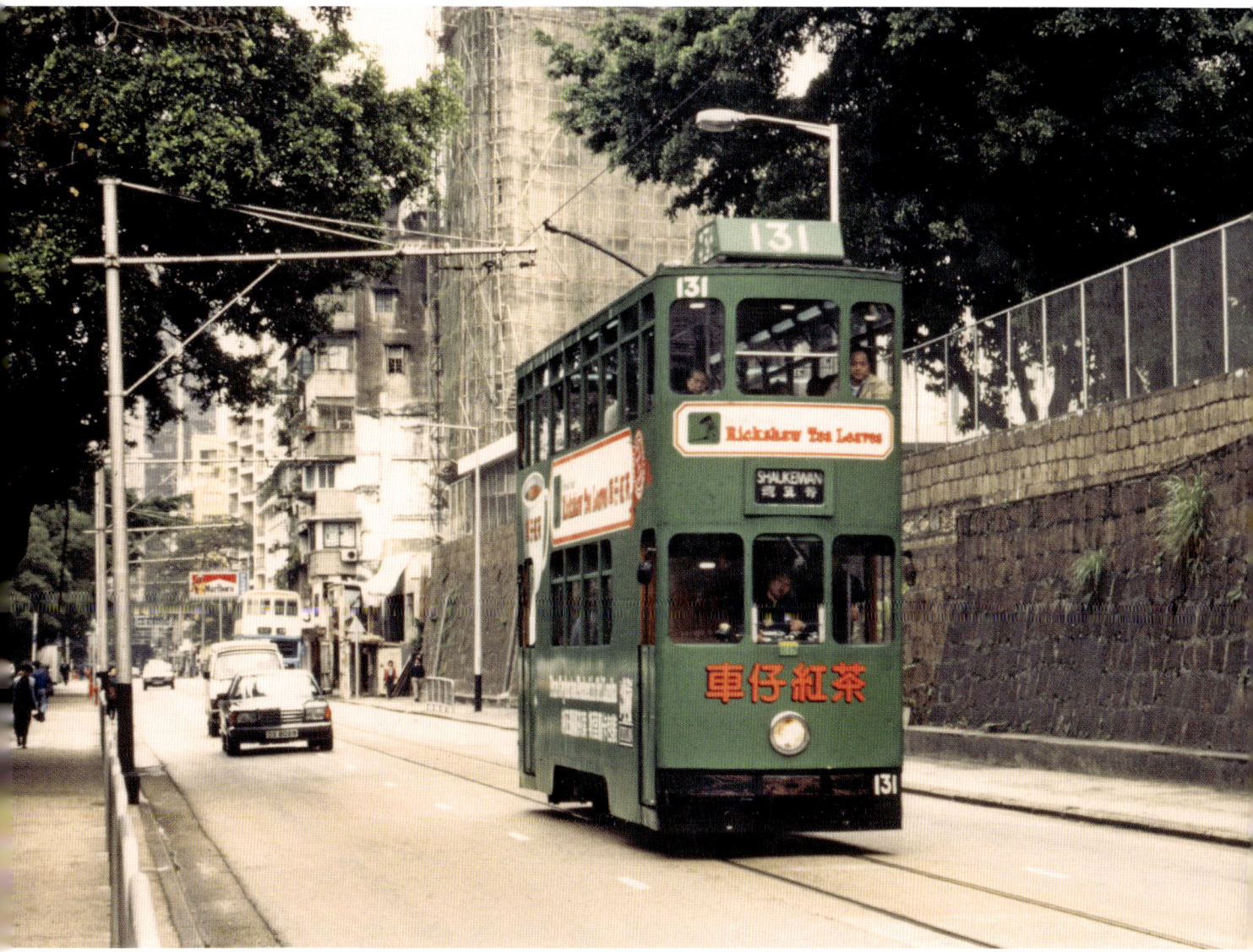

No 131 is pictured on the long single-track section along Wong Nai Chung Road heading southbound on 12 February 1990.
Barry Cross/Online Transport Archive

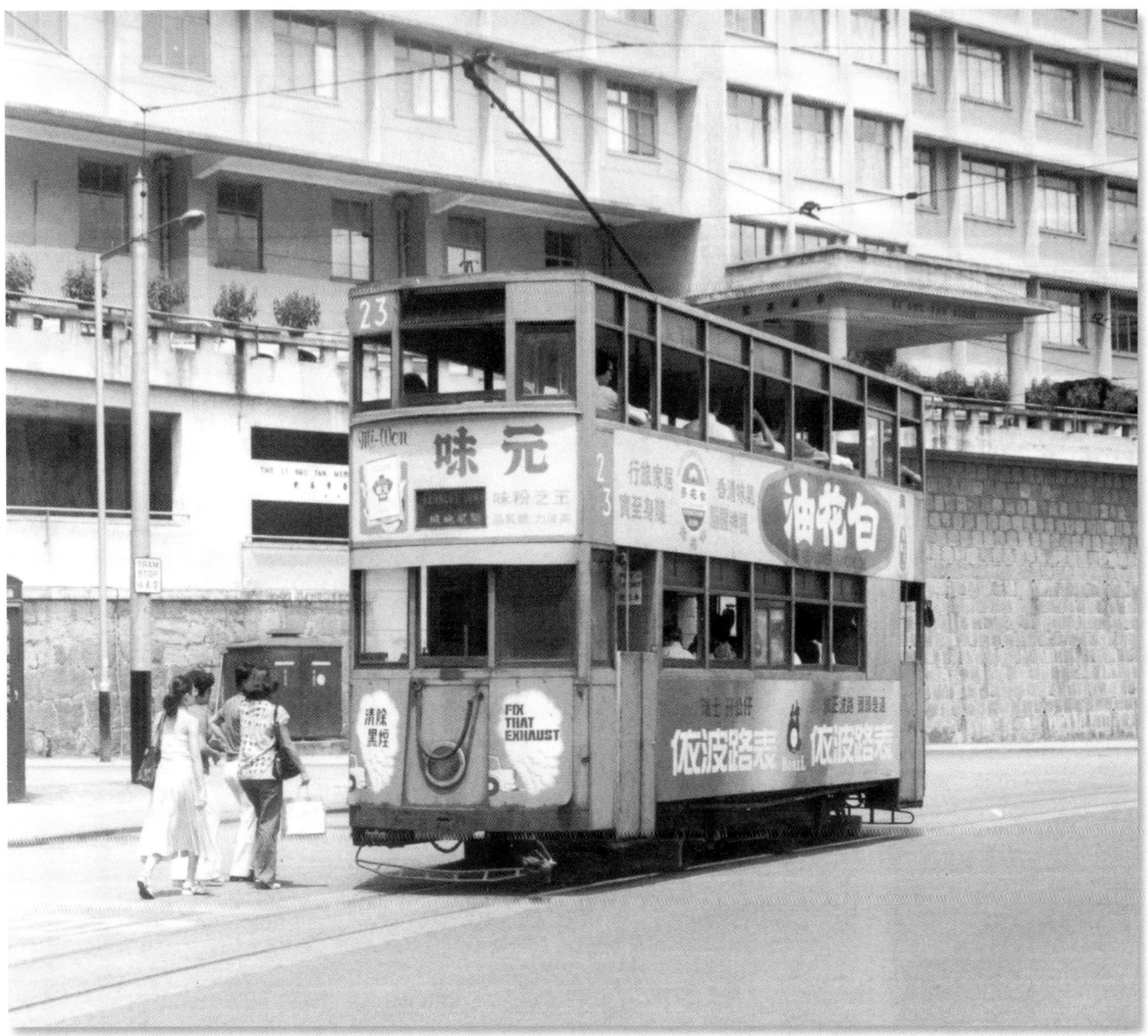

With the Li Shu Fan Block of the Hong Kong Sanatorium and Hospital on Wong Nai Chung Road in the background, No 23 heads back towards Hennessy Road with a service to Kennedy Town on 20 July 1978. No 23 was built by the Taikoo Dockyard & Engineering Co and originally entered service in November 1952.
Barry Cross/Online Transport Archive

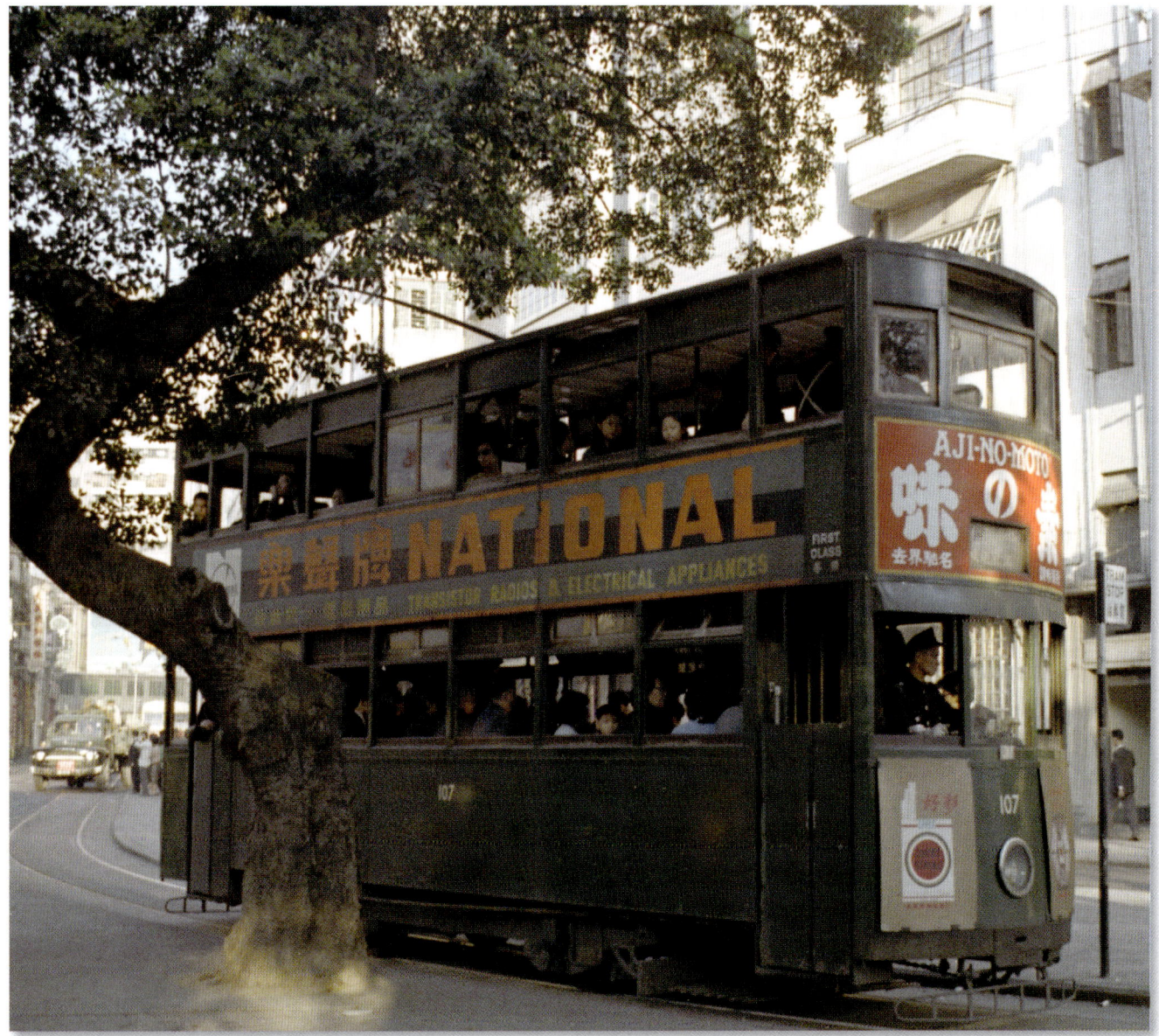

In 1966 No 107 is seen at the junction of Leighton Road and Wong Nai Chung Road with a service via Happy Valley. The destination blind on the tram – which was built by Taikoo Dockyard & Engineering Co and entered service in April 1955 – has already been changed to indicate that the tram will be heading on to Kennedy Town.
Douglas Beath/Online Transport Archive

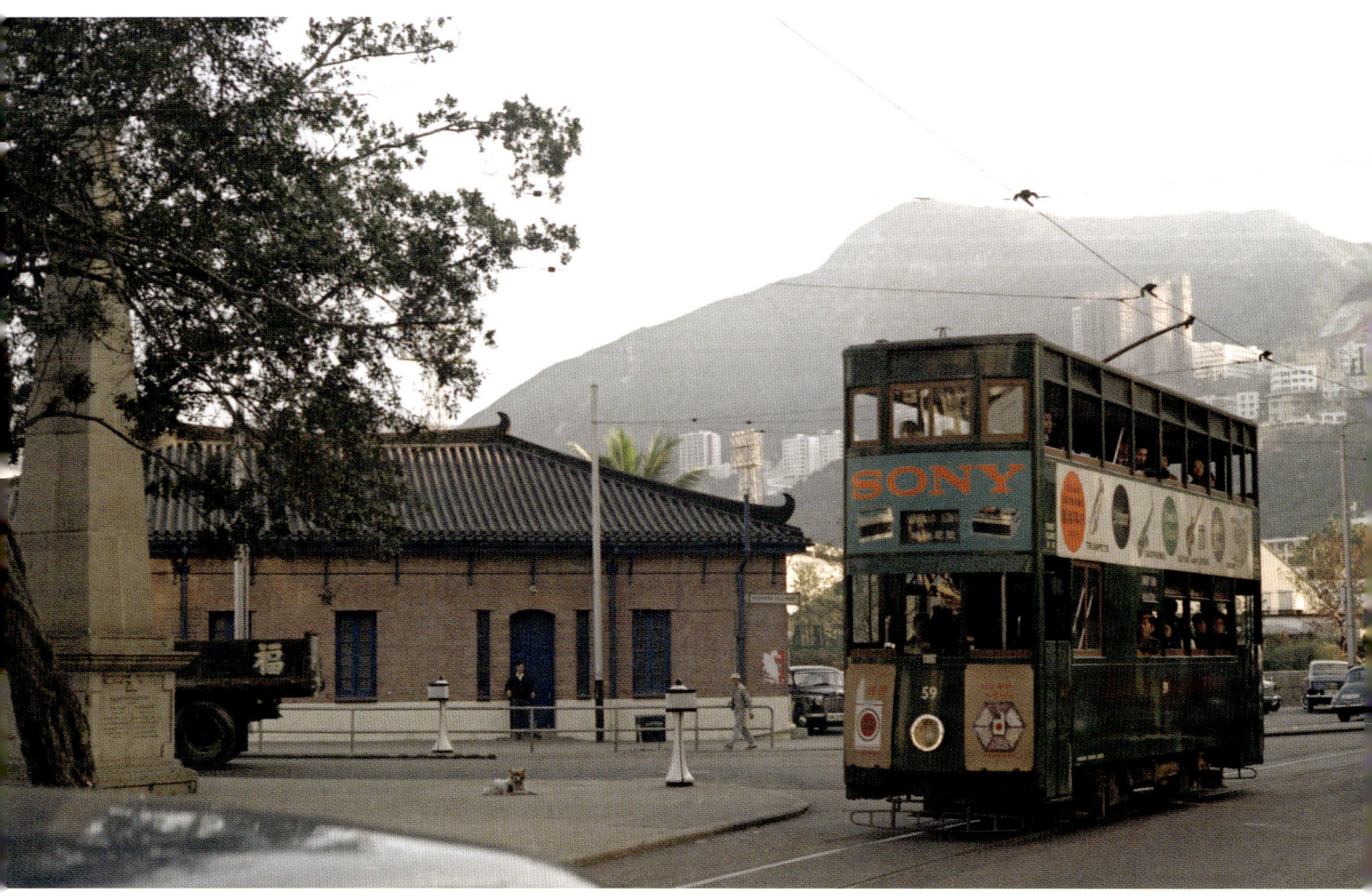

In 1966, No 59 is pictured alongside the Happy Valley racecourse with Morrison Hill Road in the background. The tram was new originally in August 1954 and was built by the Taikoo Dockyard & Engineering Co. On the extreme left can be seen the obelisk that once celebrated the life of Robert Morrison (1782-1834), an Anglo-Scottish missionary based in Macao who, amongst other work, translated the Bible into Chinese and who is also commemorated in the district and street name. He died in Guangzhou (Canton) and was buried in the Protestant cemetery in Macao.

Douglas Beath/Online Transport Archive

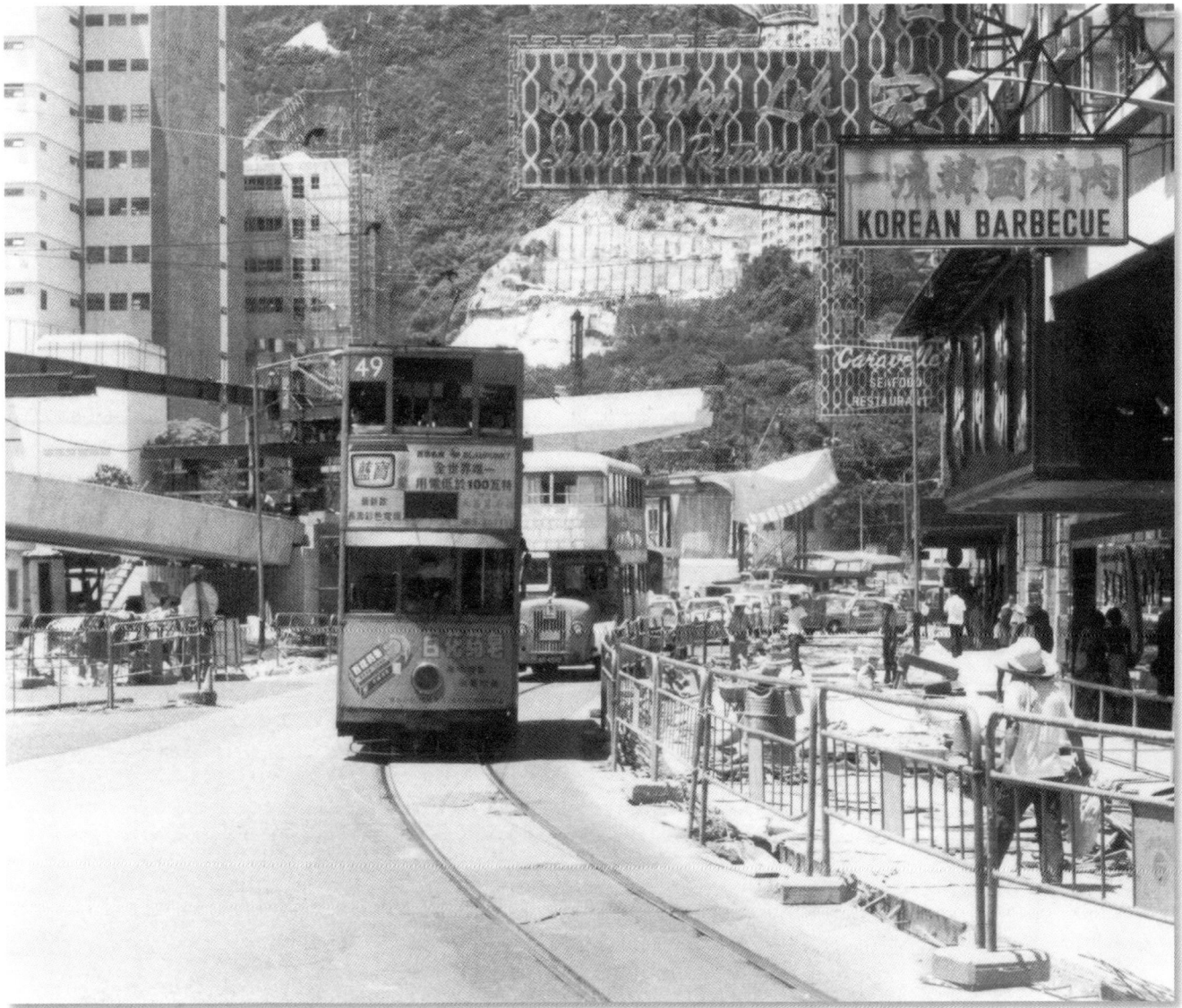

From Wong Nai Chung Road, trams via the Happy Valley loop head north towards Tin Lok Lane and Hennessy Road via Morrison Hill Road. On 20 July 1978, No 49 – built by the Hongkong & Whampoa (Kowloon) Docks and new in March 1952 – is seen heading northbound. The section of the route from Hennessy Road south to the junction of Morrison Hill Road and Wong Nai Chung Road was originally built as double track but was singled in 1928.
Barry Cross/Online Transport Archive

Trams that have taken the single-track loop via Happy Valley enter Hennessy Road via Tin Lok Lane. On 23 September 1992, No 15 – which had re-entered service after rebuilding in June 1990 – emerges from Tin Lok Lane to head eastwards along Hennessy Road to Shau Kei Wan.
Author

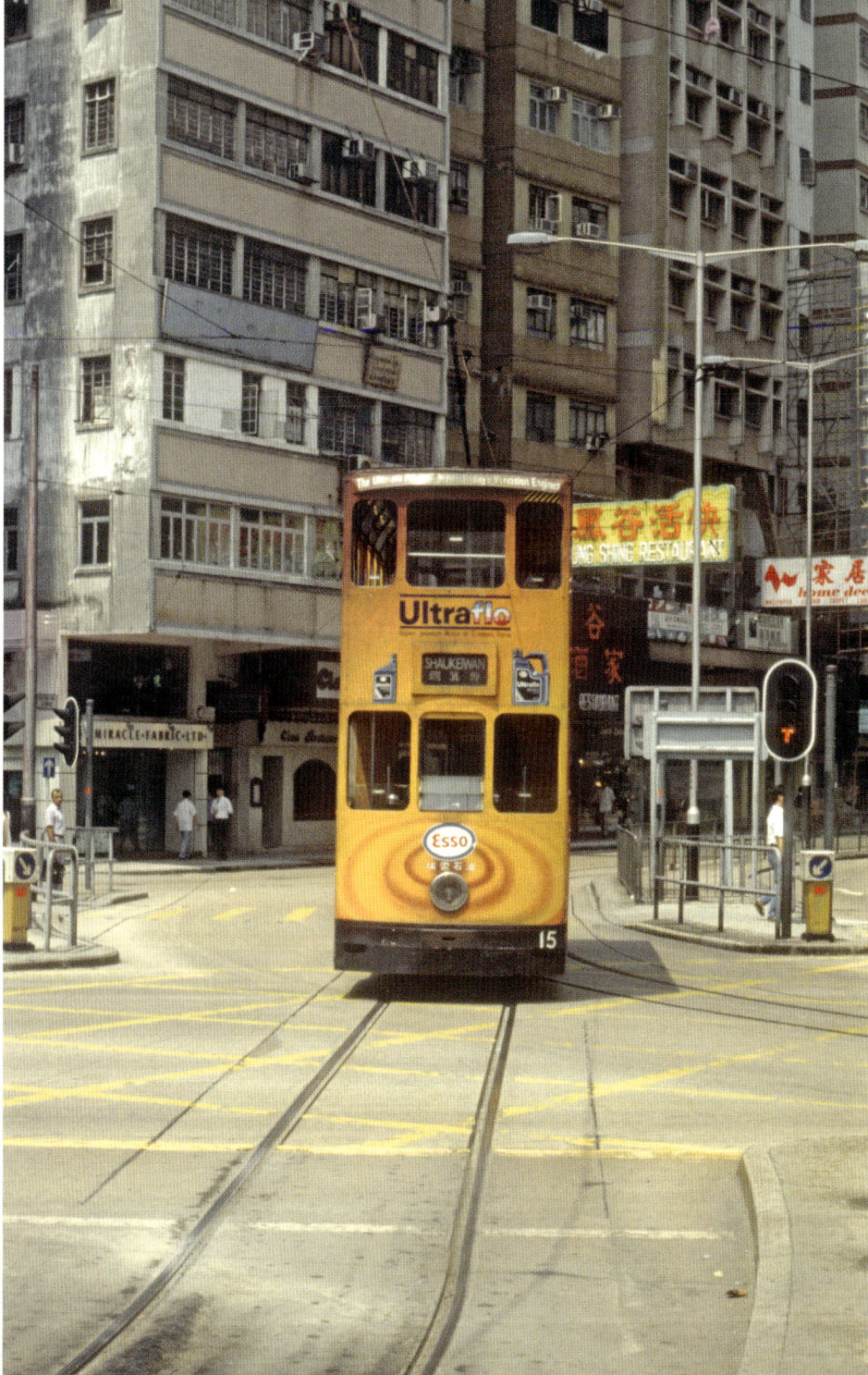

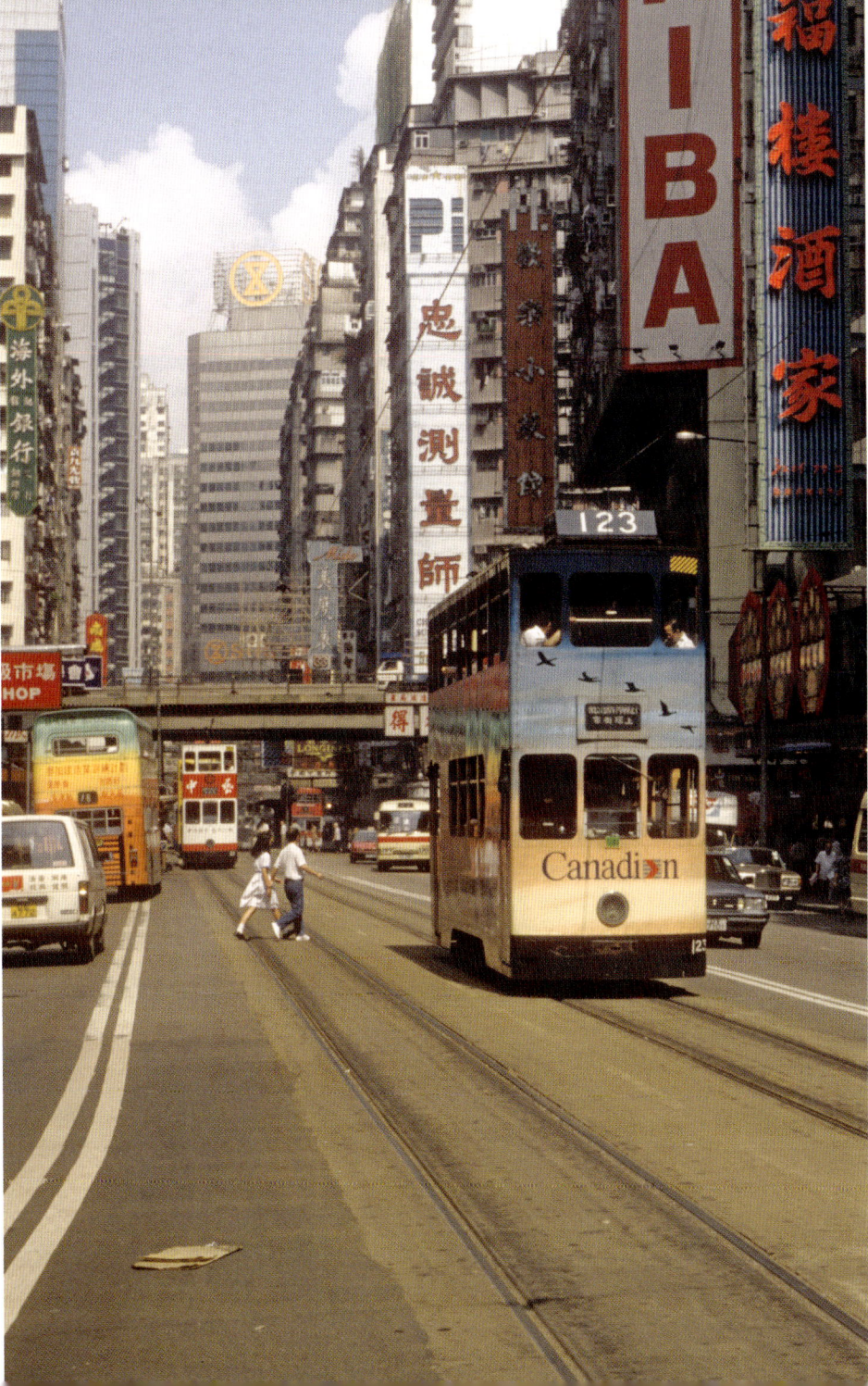

Pictured heading west along Hennessy Road on 16 September 1992 is No 123 with a service towards Western Market. This tram was one of those originally constructed by the tramway itself; it entered service in January 1951 but had been rebuilt in 1990, re-entering service in September that year.
Author

A Journey from East to West • 47

Turning left from Hennessy Road into Johnston Road on 16 September 1992 is No 47 with a service heading towards Whitty Street. This tram had originally entered service on Christmas Eve in 1951 but, following its rebuild, had reappeared in September 1988.
Author

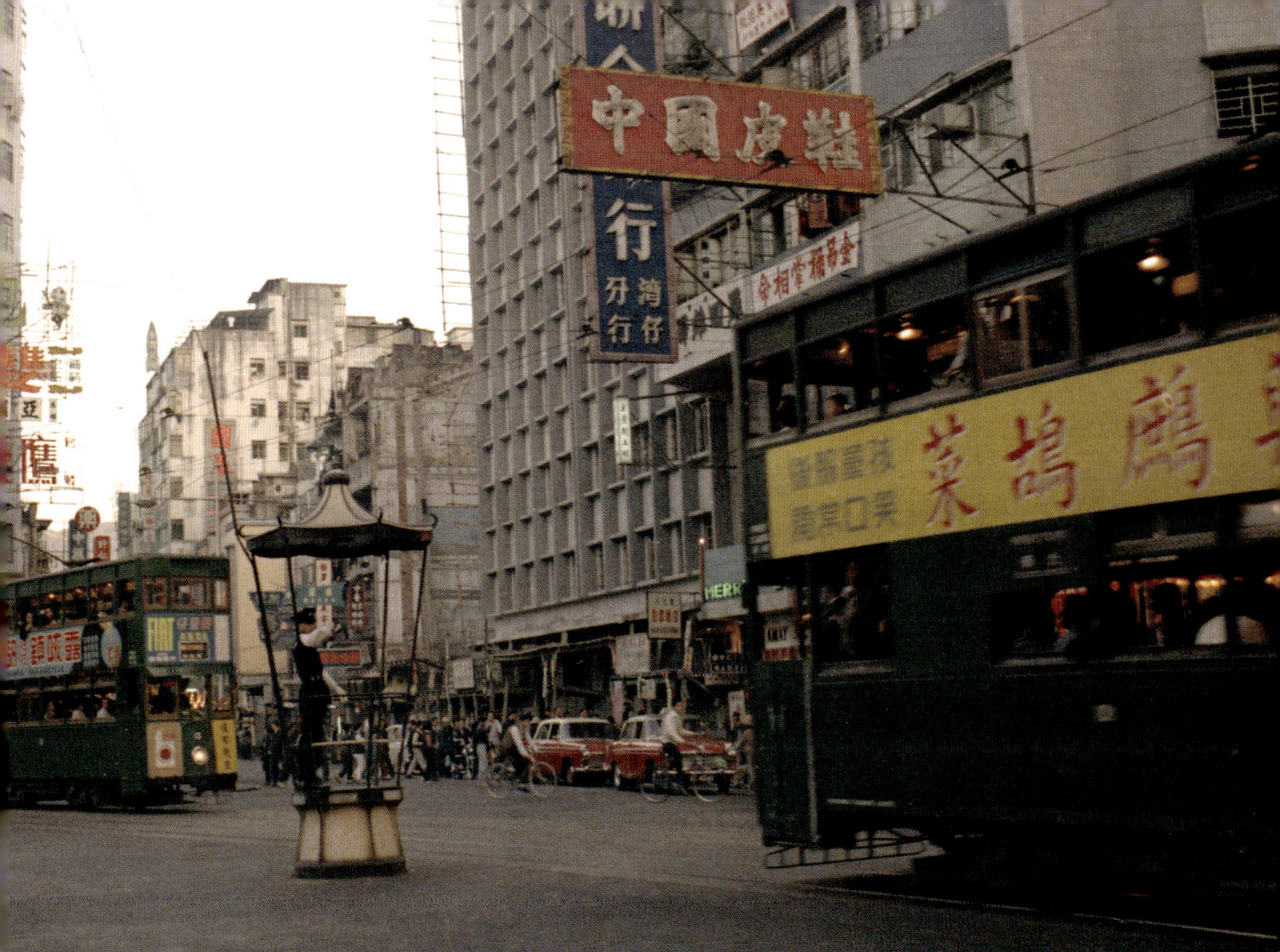

Tram No 13 with its trailer are pictured again, this time in 1966 heading westbound at the junction of Johnston Road, Fleming Road and Wan Chai Road. Although the once familiar police pagoda is no more, the distinctive round-fronted building on the corner has been modernised, extended and incorporated into the Tai Yau Plaza.
Douglas Beath/Online Transport Archive

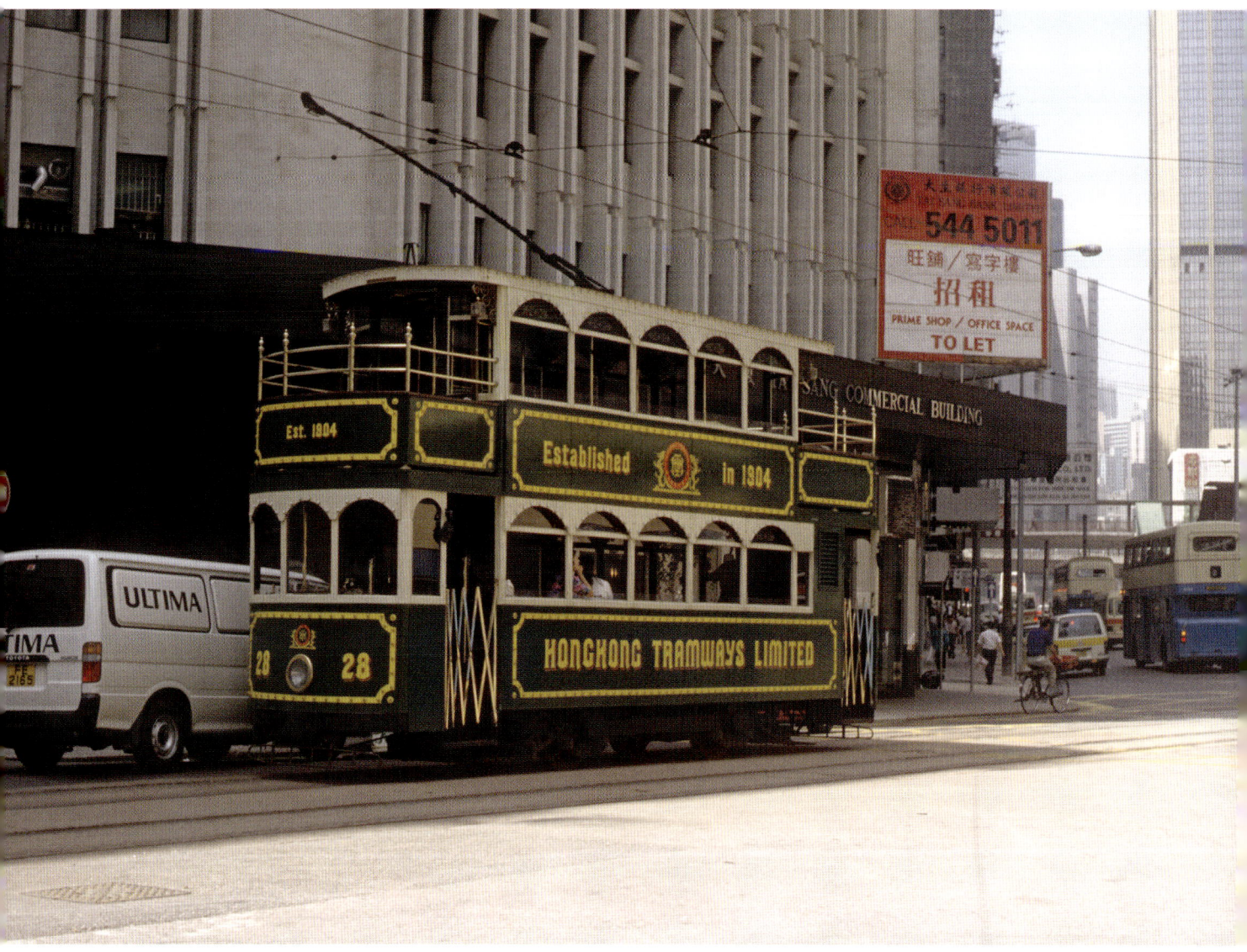

No 28 – seen here in Johnston Road on 22 September 1992 – was originally built as No 119 by the Taikoo Dockyard & Engineering Co and entered service in July 1955. During the 1980s, when the majority of the tramcars built in the 1950s were being rebuilt, two, now Nos 28 and 128, were rebuilt into antique style cars with open top-deck balconies in 1986 and 1987 respectively. The two trams remain in service in this guise and are generally now used for private hire work. Unusually the two cars retain traditional-style Dick Kerr-built controllers, as do sightseeing car No 68 and No 120 (the replica prototype post-war car). *Author*

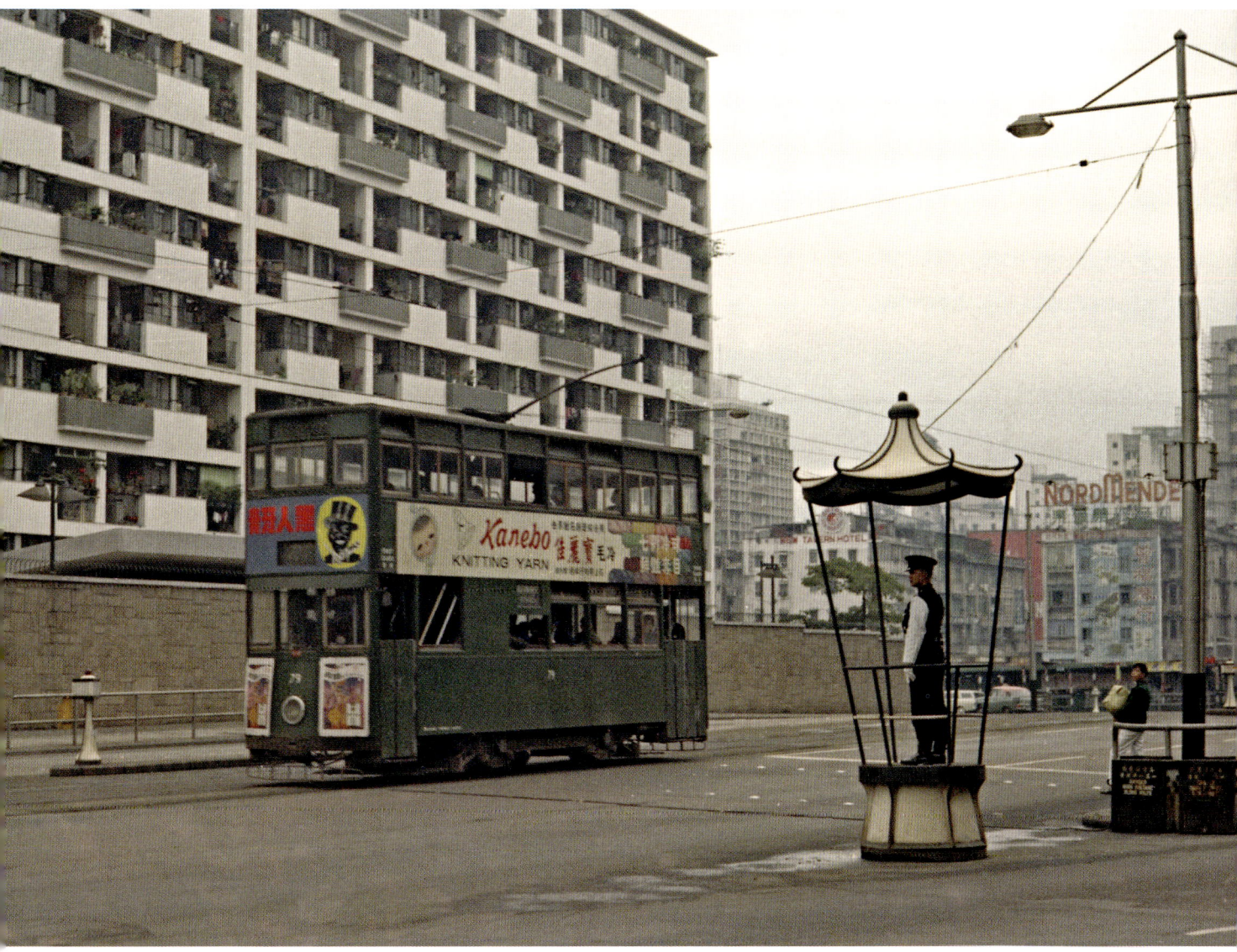

With one of the once familiar traffic pagodas in the foreground, No 79 heads west during December 1965. In the background are the now demolished Police married quarters that were situated in the compound of the Arsenal Street police headquarters. No 79 was built by the company itself and entered service in June 1951.
Douglas Beath/Online Transport Archive

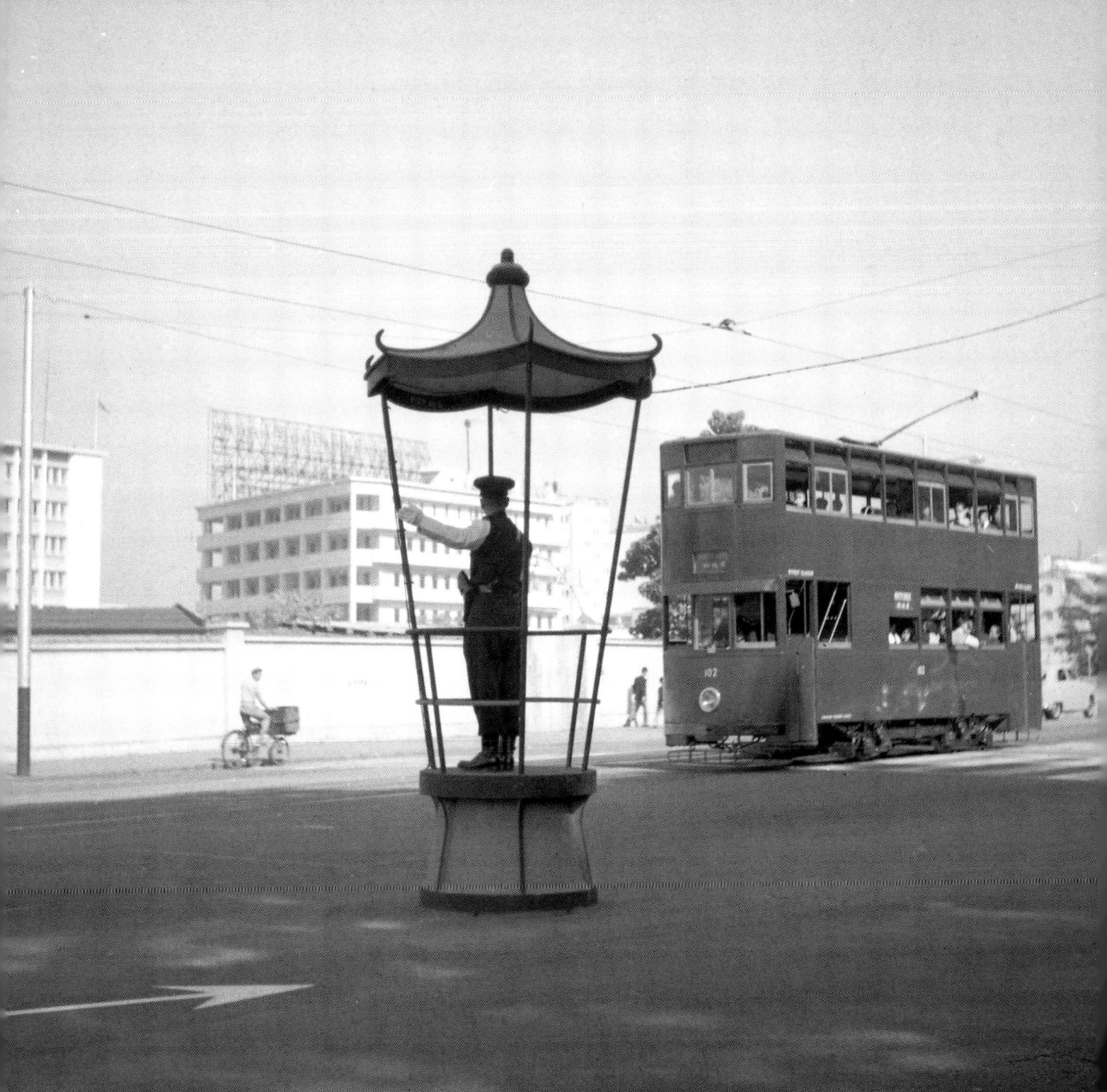

Left: Queen's Road East – with Caine House (the headquarters of Hong Kong Police) and the China Fleet Club visible in the background – seen in 1956 as No 102 – a product of the Taikoo Dockyard & Engineering Co and new in June 1955 – heads west with a service towards Whitty Street. At the date of the photograph, Caine House, which is still standing, was relatively new, having been completed in 1954. The foundation stone for the China Fleet Club was laid by the then Commander-in-Chief of the China Station of the Royal Navy, Admiral Sir Howard Kelly, on 11 January 1933 and was formally opened on 21 March 1934. The building was to survive almost 50 years before being demolished in 1982 and replaced by Fleet House.
Douglas Beath/Online Transport Archive

Above: Pictured heading eastbound along Queensway – formerly Queen's Road East – are No 119 and 132 on 23 October 1981. On the extreme right in the background is the site of HMS *Tamar* and the building that was named at the time after the Prince of Wales. The building was completed in 1979 and is 113m in height. Since the handover on 1 July 1997, the building has been officially known as the Chinese People's Liberation Army Forces Hong Kong Building. Nos 119 and 132 were both built by the Taikoo Dockyard & Engineering Co and entered service in July 1955 and June 1955 respectively.
Alan Murray-Rust/Online Transport Archive

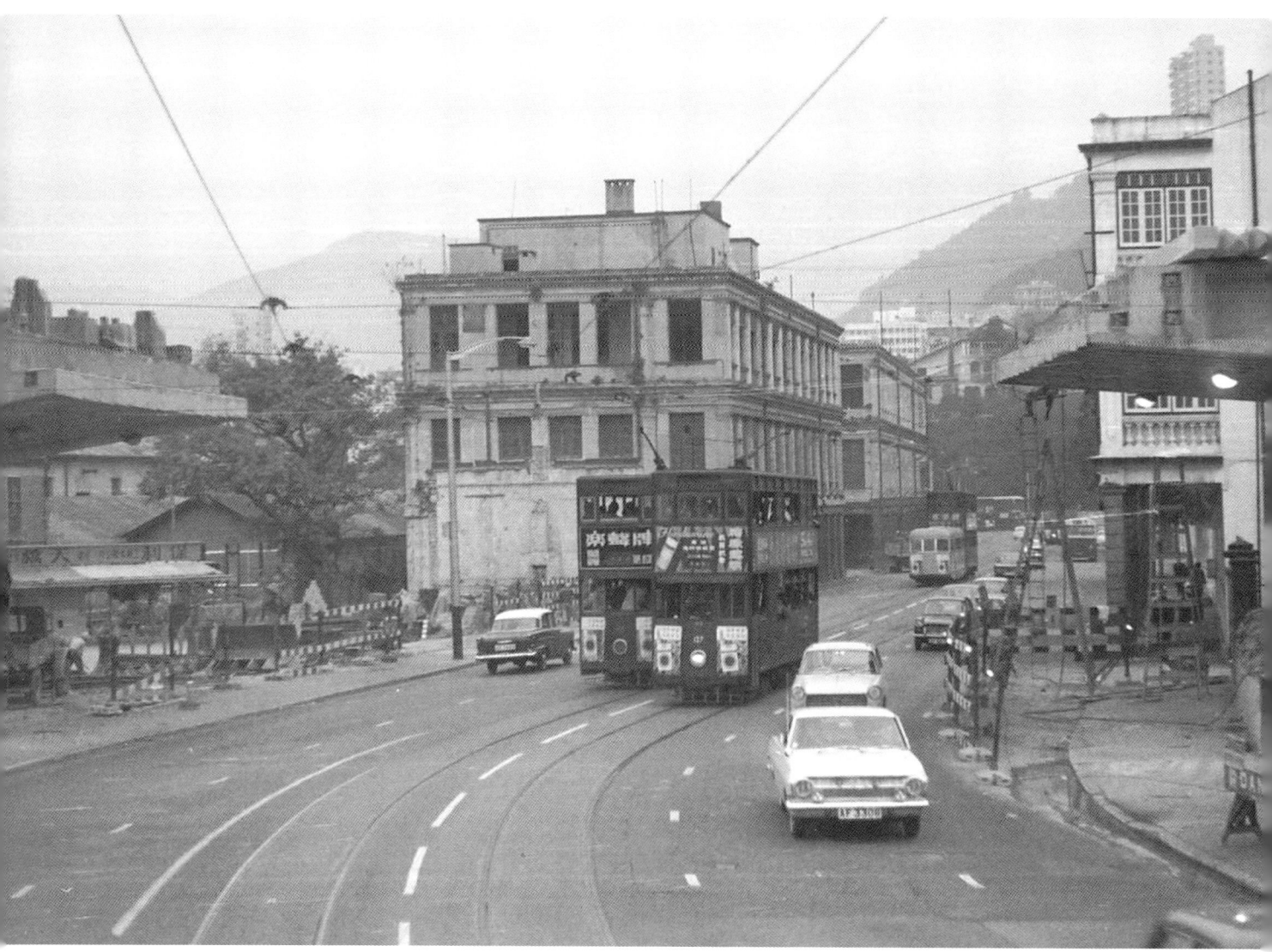

It's 1967 and work is in progress on the construction of the Cotton Tree Drive flyover on Queensway as No 127 – a product of the company itself and new in November 1953 – heads westbound with a service towards Western Market.
Douglas Beath/Online Transport Archive

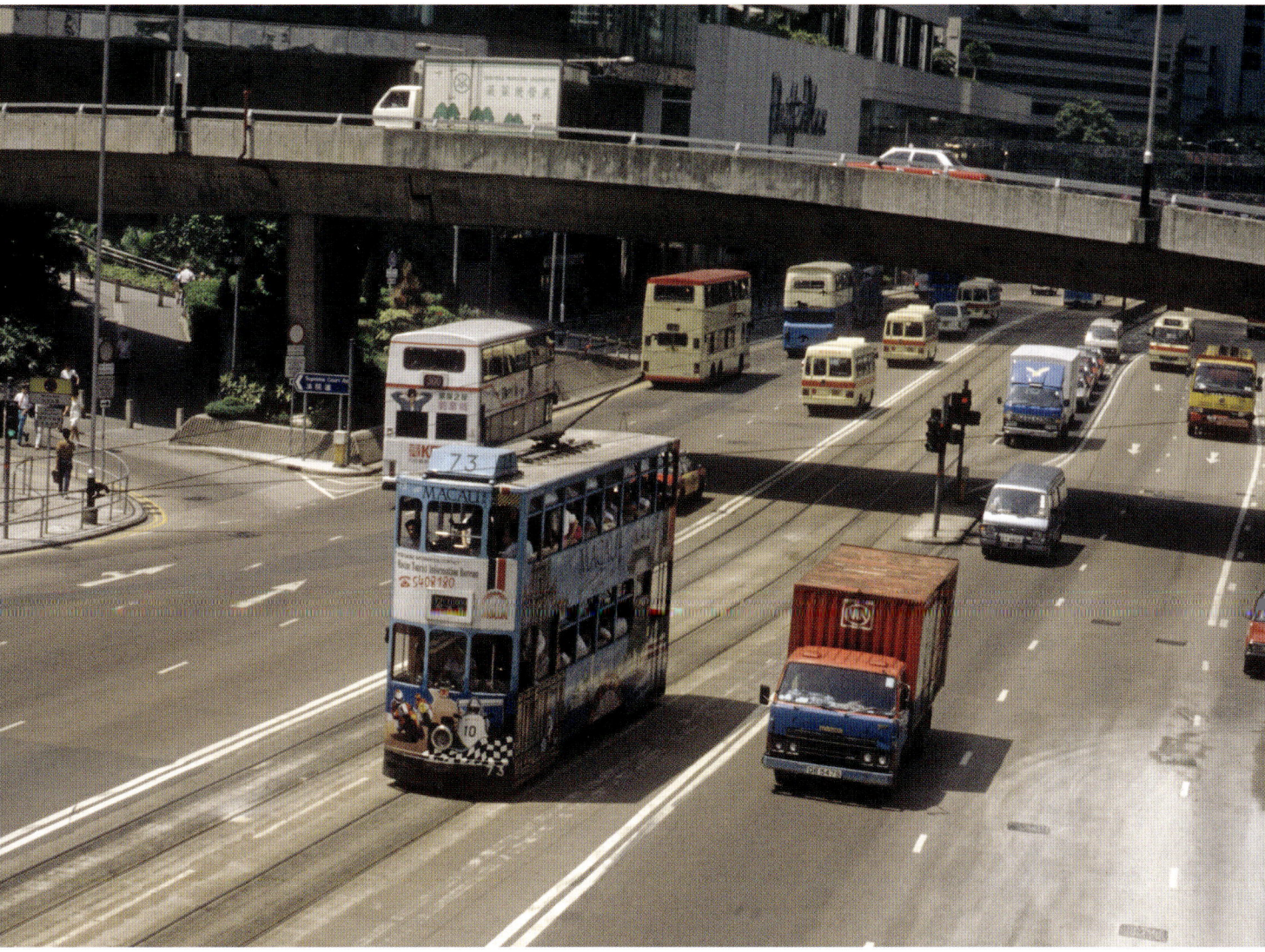

Heading eastbound along Queensway, having just passed under the Justice Drive overbridge, on 22 September 1992 is No 73; new originally in May 1951, the tram re-entered service after rebuilding on 10 October 1990. The white double-decker in the background is one of the early air-conditioned buses in the KMB fleet. After various experiments with varying degrees of success, KMB commenced delivery of production aircon double-deck buses in late 1990. It would take almost 26 years before the first, and only, aircon tram entered service in Hong Kong (on 6 June 2016).
Author

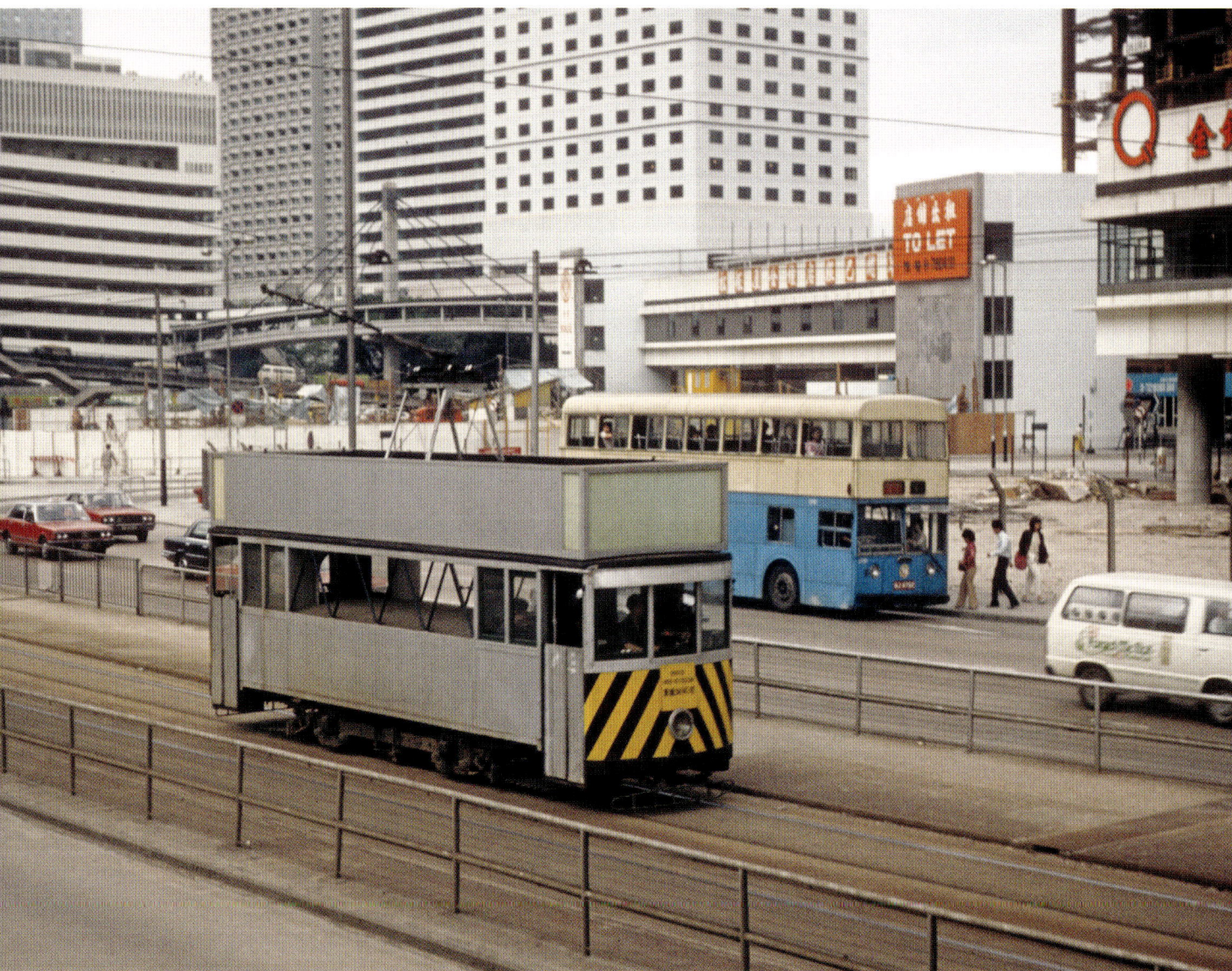

In 1956 Hongkong Tramways constructed a dedicated single-deck works car – No 200 – which was fitted with a water tank and air-operated carborundum blocks to act as a rail grinder. The tram is seen here heading along Queensway on 23 October 1981. By this date the tram was approaching the end of its career; it was scrapped in February 1984.

Alan Murray-Rust/Online Transport Archive

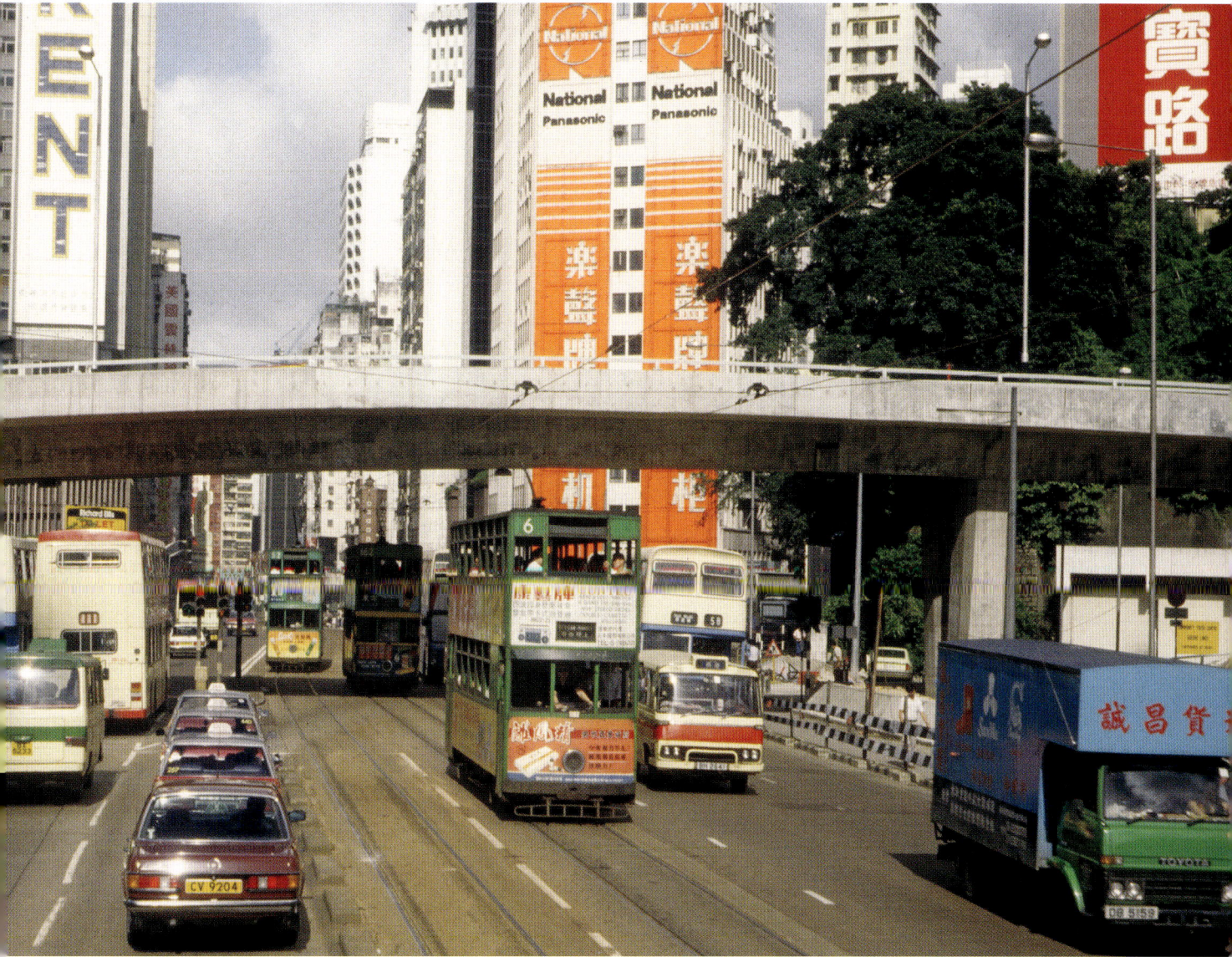

Viewed looking towards the east close to Harcourt Garden, this view records Nos 6 and 162 heading westwards whilst No 52 heads east towards North Point along Queensway. This view is radically different today; apart from the surviving trams – themselves now modernised – the only reference point is effectively the road overbridge, which carries Justice Drive over the main road.
Alan Murray-Rust/Online Transport Archive

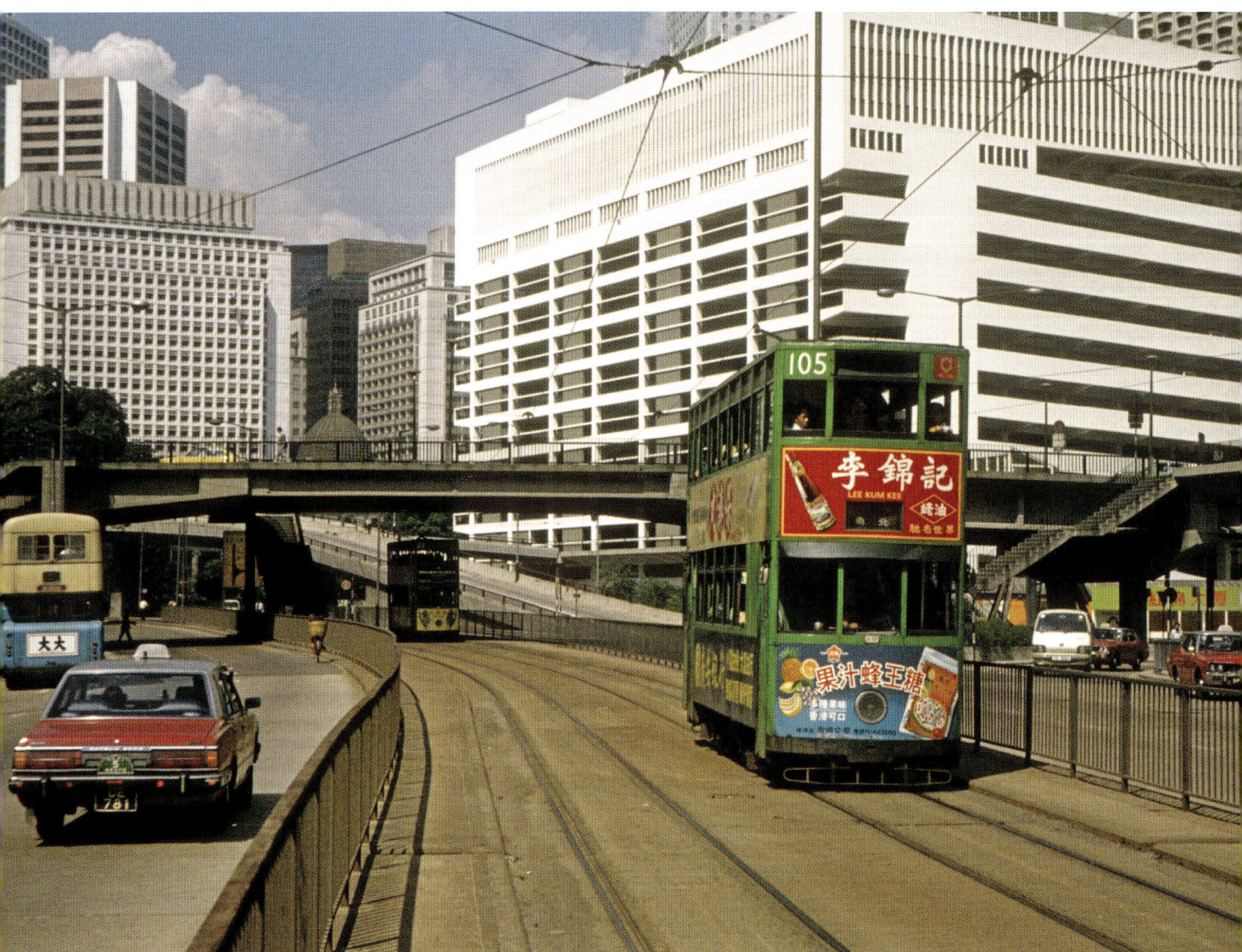

With the dome of the Supreme Court Building just visible amidst the modern office developments, No 105 heads eastbound along Queensway with a service towards North Point on 22 October 1981.
Alan Murray-Rust/Online Transport Archive

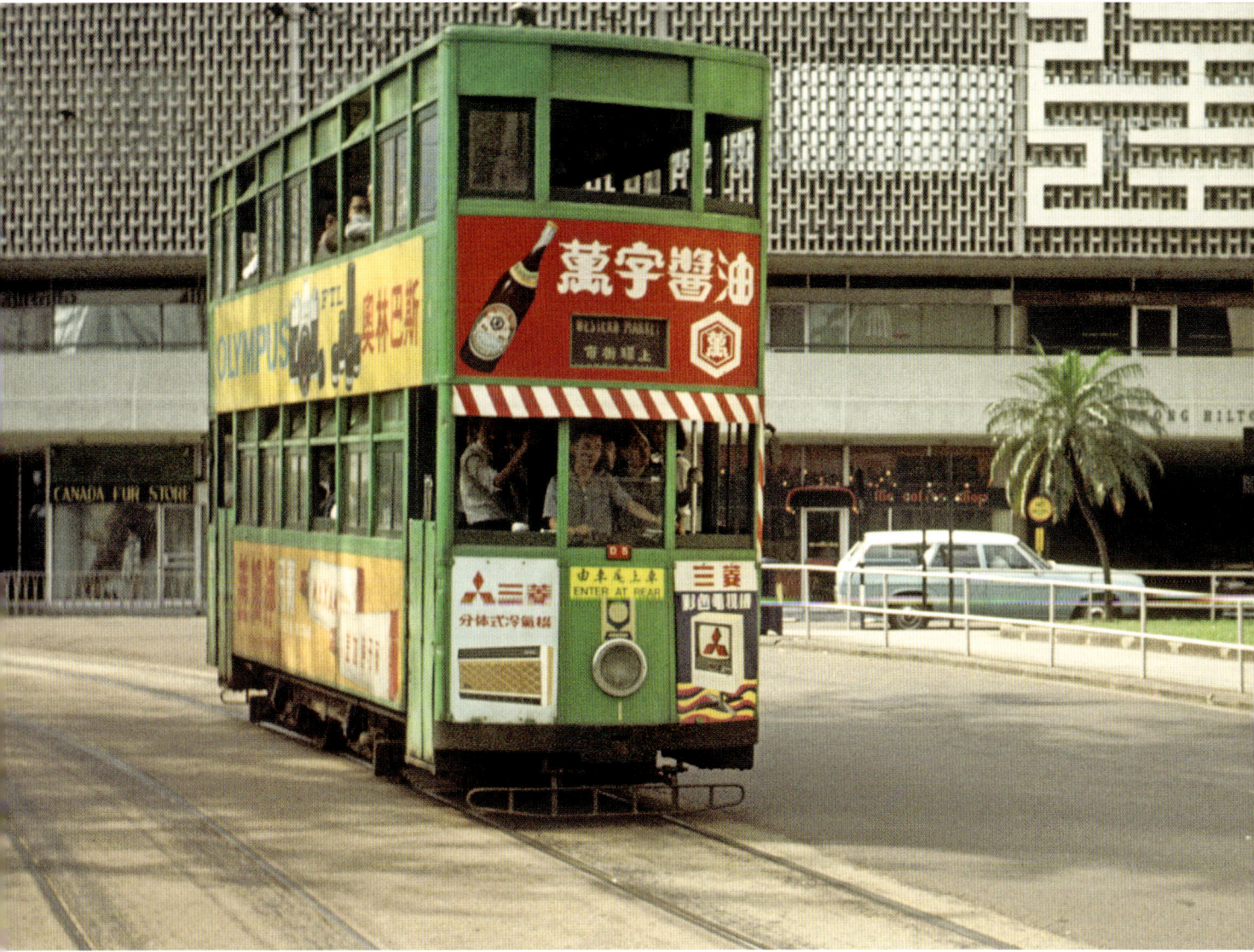

With the old Hilton Hotel in the background, No 1 heads from Queen's Road Central into Des Voeux Road Central with a service towards Western Market during the summer of 1973. No 1 was built by the Taikoo Dockyard & Engineering Co and entered service in January 1954. The red and white stripes visible on the sunshade over the lower vestibule windows were designed to remind passengers that the tram was rear entrance. The hotel itself was completed in 1963; it was to survive until being demolished in 1995 and replaced by the Cheung Kong Centre.
Paul de Beer/Online Transport Archive

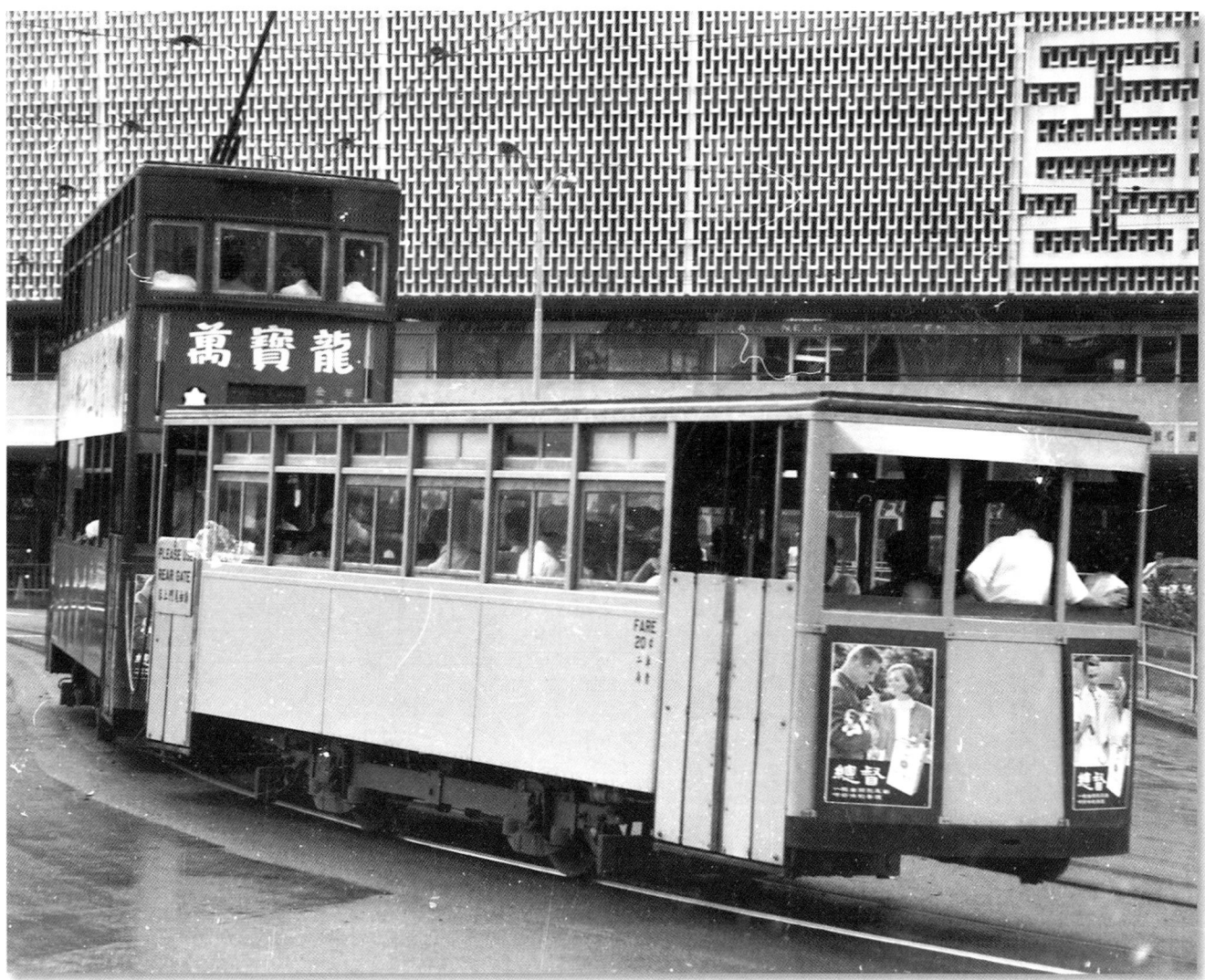

In the early 1960s, as a result of increased competition and traffic congestion, the tramways suffered a loss of passenger traffic and the company decided to experiment in the use of a tram with trailer operation. As a result, the Taikoo Dockyard & Engineering Co was commissioned to produce an experimental trailer car. No 1 entered service in August 1964, operating behind a modified No 161. The trailer, with its own conductor, provided additional capacity for first class passengers. The use of the two entrances proved a problem with the result that, as shown in this June 1965 view taken in front of the old Hilton Hotel, the forward entrance was blocked out with a notice telling passengers 'Please use the rear gate'. Following withdrawal, No 1 was rebuilt as double-deck car No 163, which entered service in March 1991; it was the only one of the ex-trailer cars to receive this treatment.

Douglas Beath/Online Transport Archive

A busy scene during the summer of 1973 sees No 99 head westbound whilst Nos 122 and 58 head past the then Supreme Court Building en route towards Shau Kei Wan. The Supreme Court Building was designed by then consulting architects to the Crown Agents to the Colonies, E. Ingress Bell and Aston Webb, with work commencing on the building in 1900. It was formally opened by then Governor, Sir Frederick Lugard, on 15 January 1912. In 1983, it was decided that the building be adapted to accommodate the Legislative Council and the conversion work for the structure – now known as the Legco Building – was completed two years later. The Council relocated from the Supreme Court Building to new premises in 2011.
Paul de Beer/Online Transport Archive

Above: Heading westbound outside the Legco building in 1995 with a service towards Western Market is No 65. This tram had been rebuilt from the original 1954 car during 1988 and re-entered service on 17 October of that year.
Alan Pearce/Online Transport Archive

Right: With the then virtually new Bank of China building in the background, No 56, a product of Hongkong & Whampoa (Kowloon) Docks and new in April 1951, heads eastbound towards North Point during 1956. The Bank of China building, situated at the eastern end of Des Voeux Road Central, was built on the site of the eastern part of the original City Hall. The City Hall had originally been built in 1869 but its western half was demolished in 1933 to permit the construction of the new headquarters of the Hong Kong & Shanghai Bank whilst the eastern half succumbed 14 years later to permit the construction of this building. Designed by Palmer & Turner and built by Wimpey Construction, work started on the building's construction in 1950 and was completed in November 1951. The building is still extant and remains a branch of the Bank of China, although no longer its headquarters following the completion of a replacement in 1991.
Douglas Beath/Online Transport Archive

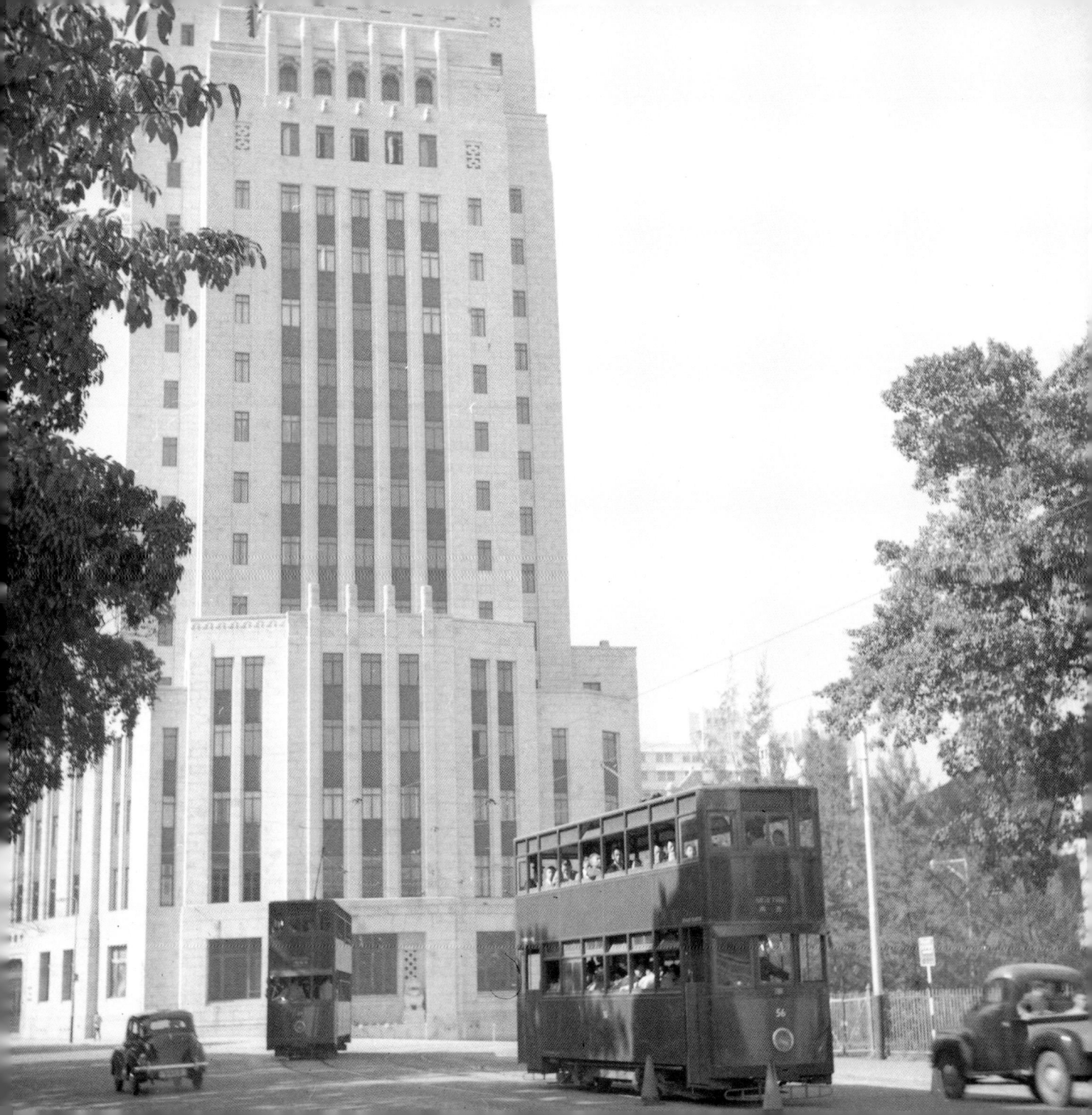

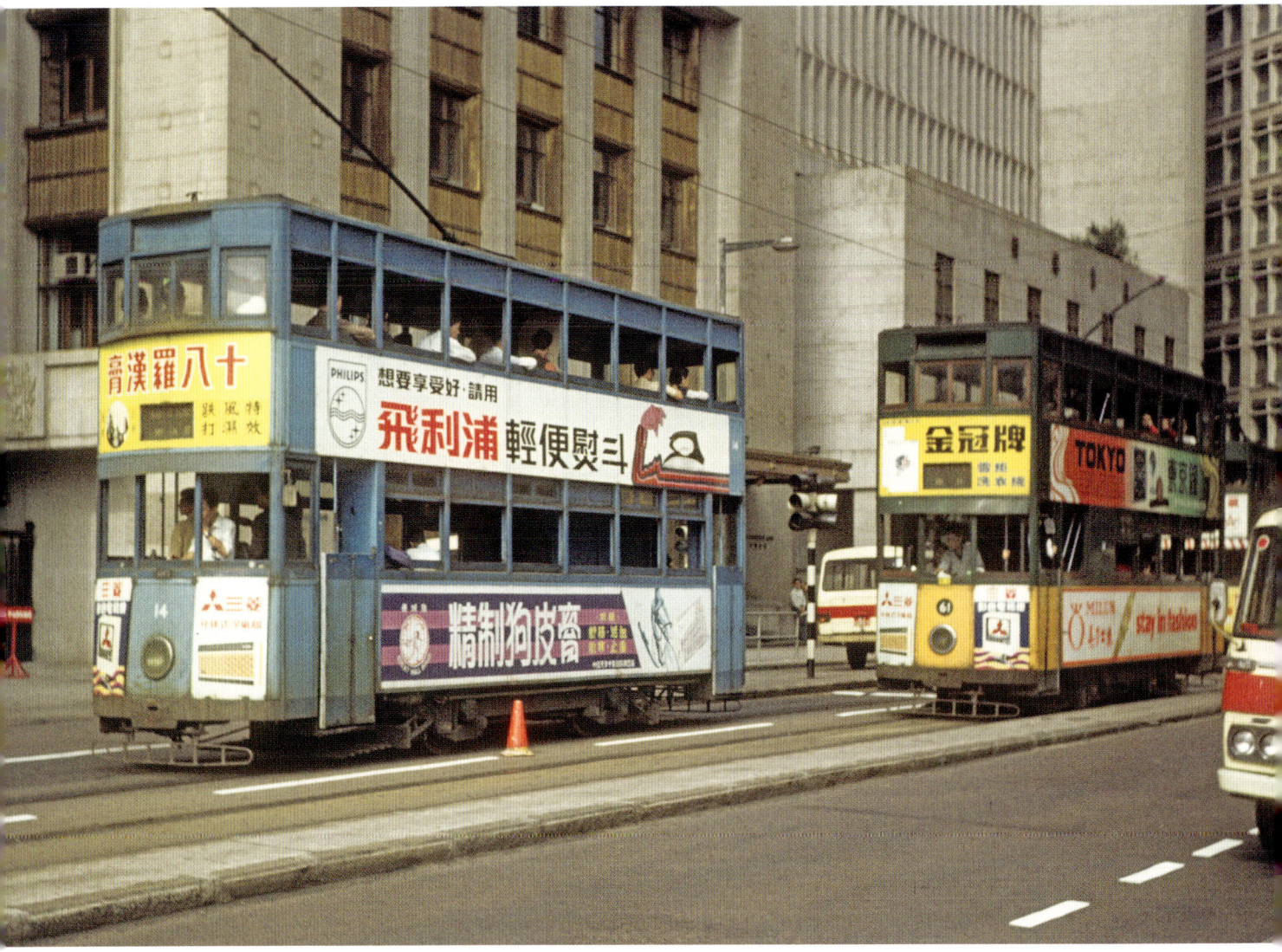

During 1973 Nos 14 and 61 pass in front of the Chartered Bank and Bank of China buildings on Des Voeux Road Central. Both trams were products of the Taikoo Dockyard & Engineering Co and entered service in December 1951 (No 14) and June 1954 (No 61).
Paul de Beer/Online Transport Archive

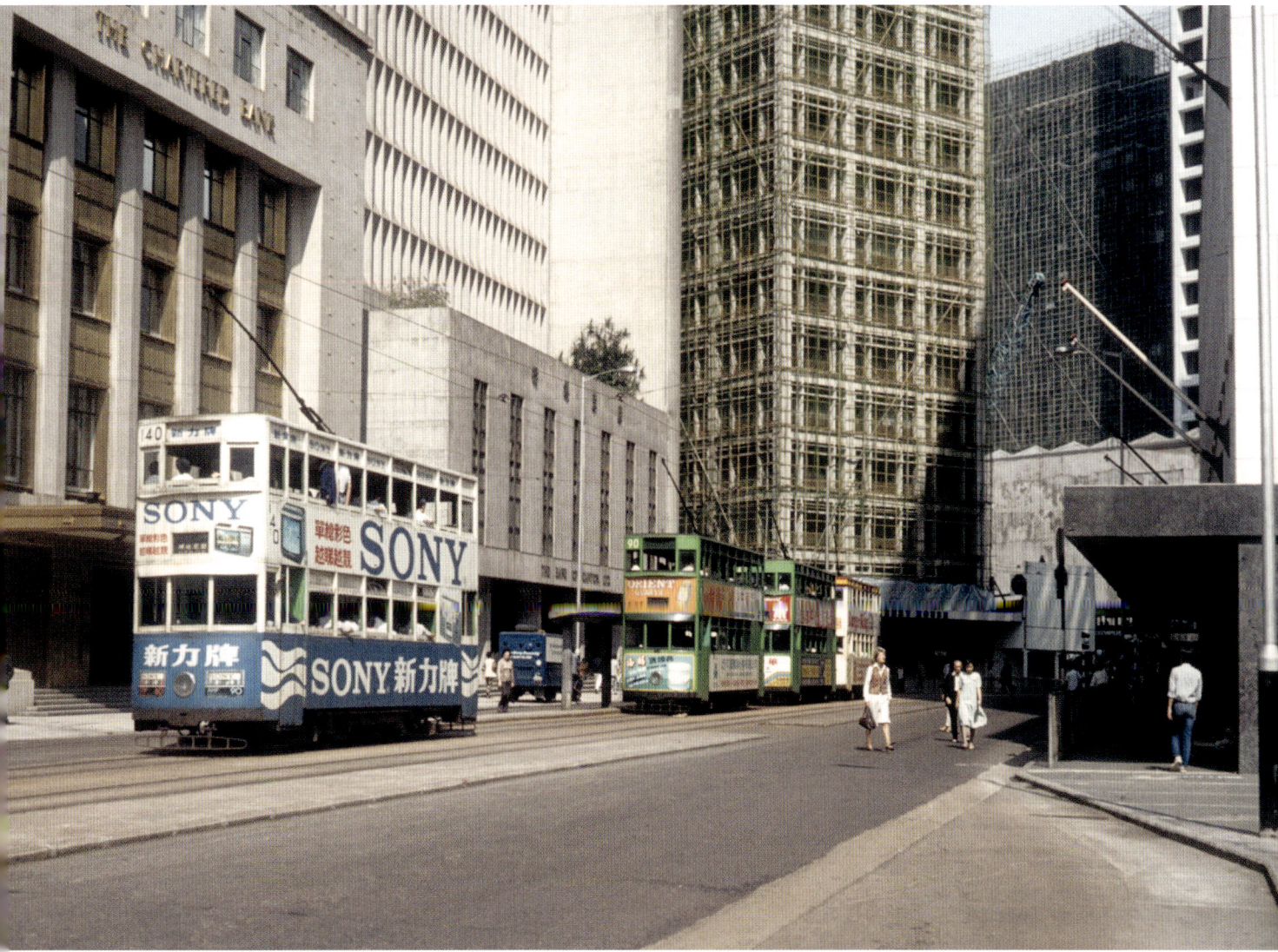

With the rebuilt Prince's Building of 1965 out of view on the right and the Chartered Bank and the Bank of Canton on the left, four trams, with Nos 90 and 40 at the rear, make their way westbound along Des Voeux Road Central. The headquarters of the Standard Chartered Bank dated to 1959 and the 16-storey building was designed by Palmer & Turner. The building was demolished in the late 1980s and replaced by the current structure, designed by the same architectural business, that was officially opened on 30 May 1990. Both Nos 40 and 90 were originally built by the Taikoo Dockyard & Engineering Co, entering service in January 1952 and May 1953 respectively.

Richard Lomas/Online Transport Archive

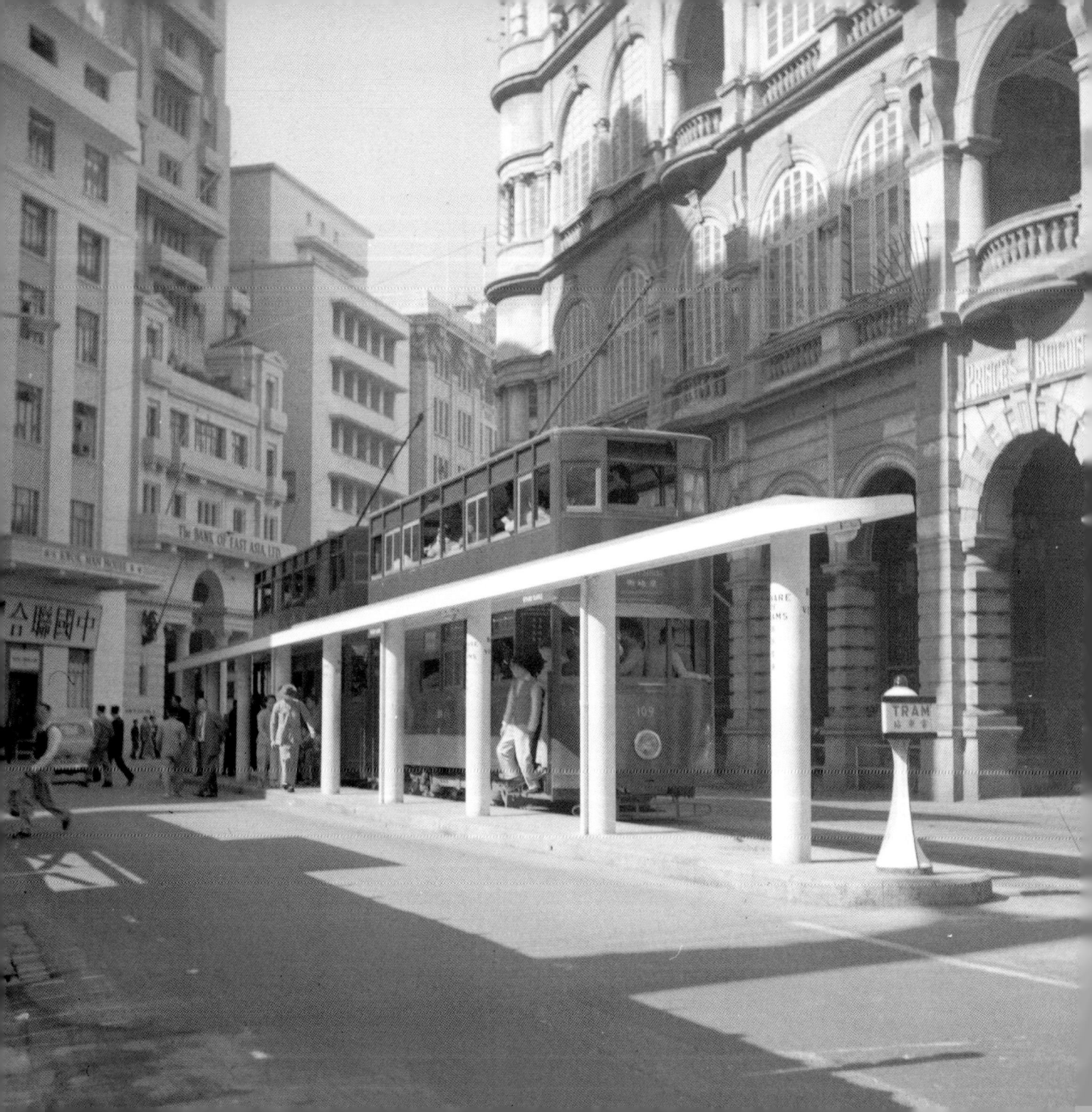

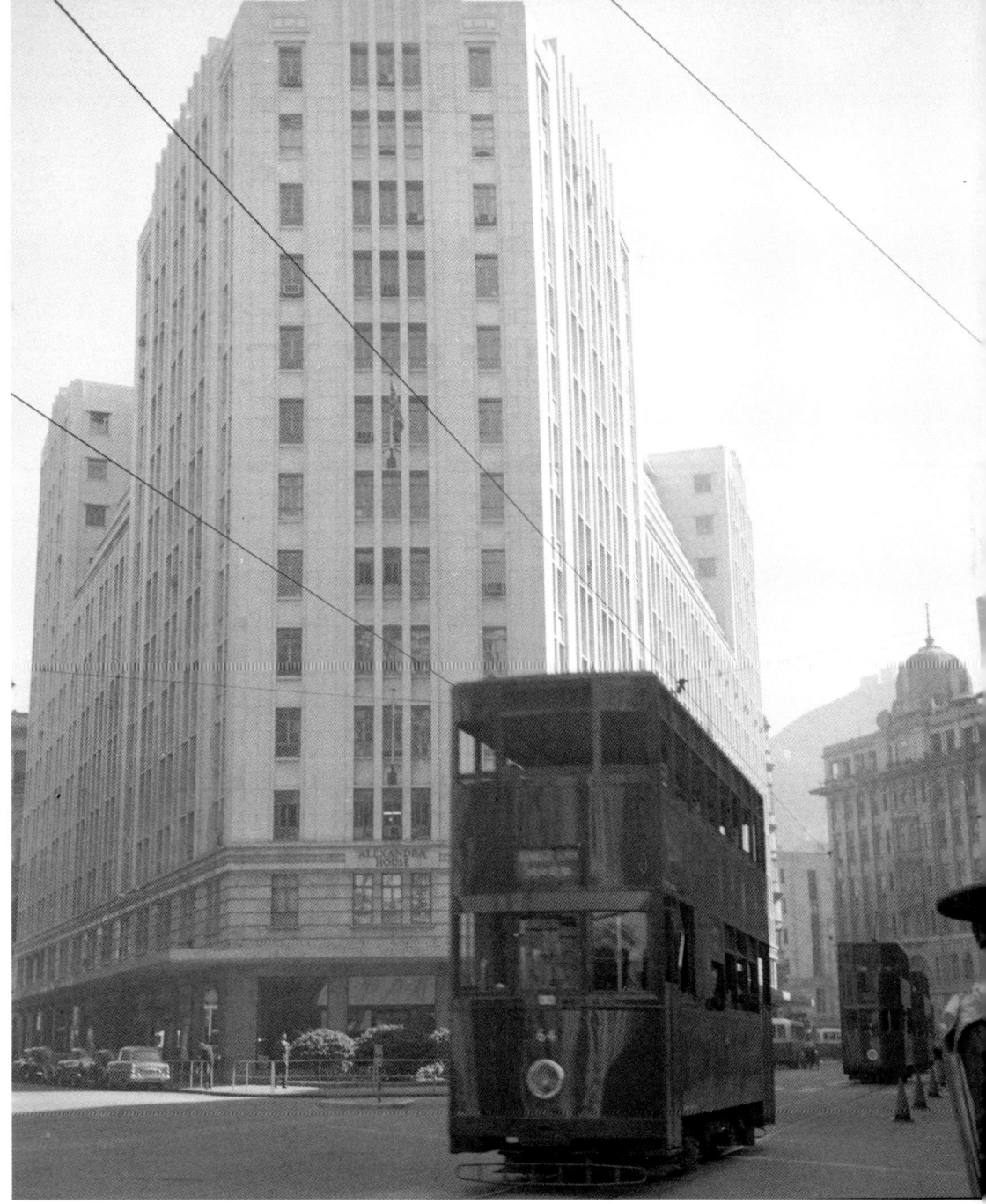

Left: With the old Prince's Building on the right and the Bank of East Asia in the background, No 109 stands at the then-new tram stop on Des Voeux Road Central with a service to Whitty Street. The Bank of East Asia was the second building occupied by the bank on the site; it was completed in July 1935 and was to survive through until demolition during 1980. The Prince's Building was of an older generation; completed in 1904 it was to be demolished during 1963 and replaced by the structure seen in the previous photograph.
Douglas Beath/Online Transport Archive

Right: Following the demolition of the first Alexandra Building in 1952, a new structure – but this time called Alexandra House – was built between then and 1954. Seen here in 1956, the building was to survive until demolition in 1974. Heading westbound past the building is No 64; at this date the tram was virtually brand-new as well, having entered service on 6 September 1954.
Douglas Beath/Online Transport Archive

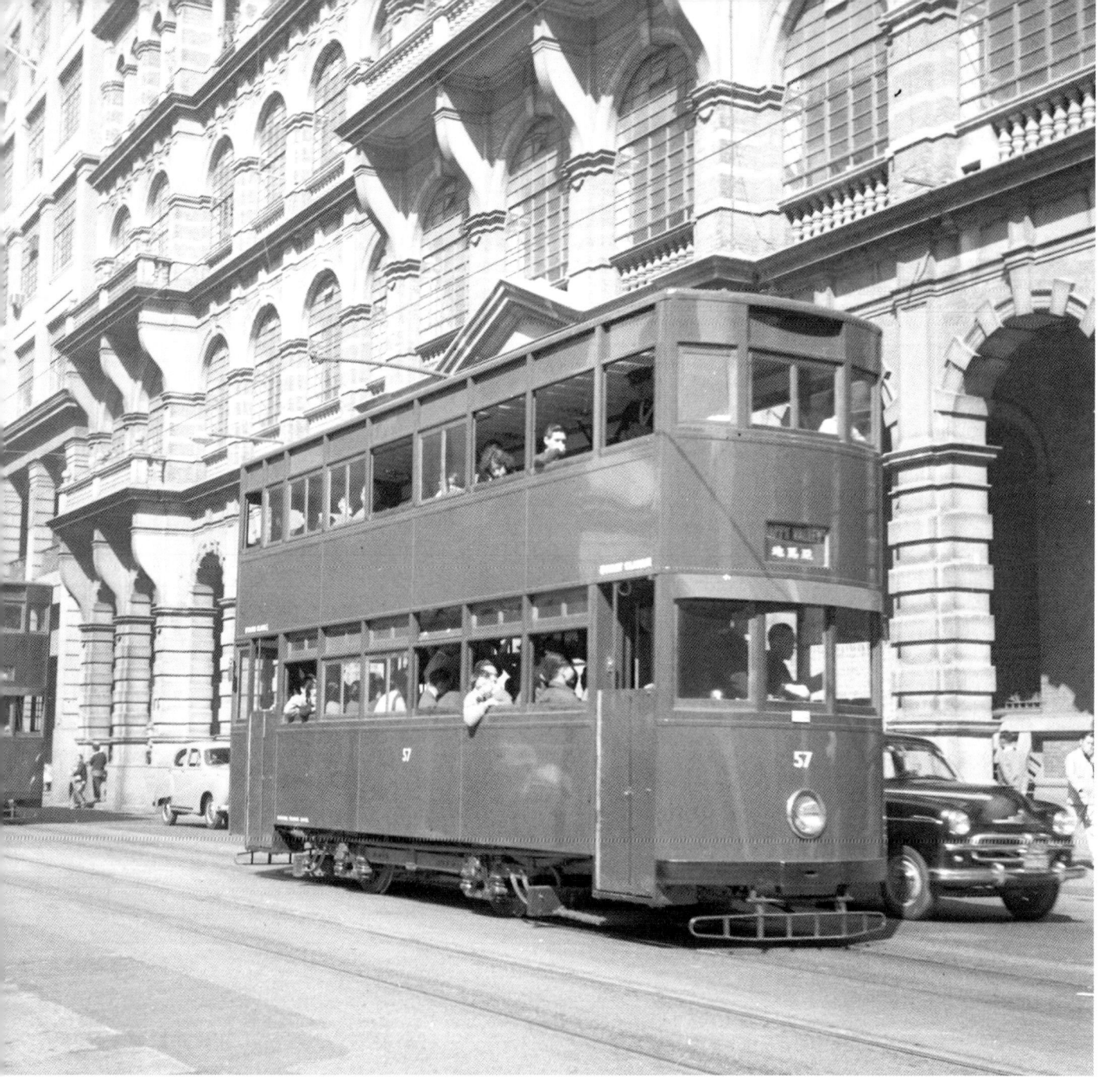

Left: Heading eastbound in 1956 is No 57 – new in April 1951 following construction by Hongkong & Whampoa (Kowloon) Docks – with a service towards Happy Valley along Des Voeux Road Central. Behind the tram is the old General Post Office building. Work on the construction of the building commenced in 1906; built to a design of Messrs Denison, Ram & Gibbs, the building was opened in 1911. The General Post Office was demolished in 1977 and the site is now occupied by World Wide House. More than 40 years on, the replacement GPO, relocated elsewhere, is under threat of demolition although there is a campaign to see it preserved as a building from the brutalist era of architectural design.
Douglas Beath/Online Transport Archive

Right: Having just passed the old General Post Office, No 120 is pictured on Des Voeux Road Central with an eastbound service. No 120 was built by Hong Kong Tramways and entered service in October 1949. It was the prototype car for all those constructed post-war and differed very slightly from the production models in having a greater seating capacity – 68 rather than 63 – with larger windows at each end of the upper deck.
Douglas Beath/Online Transport Archive

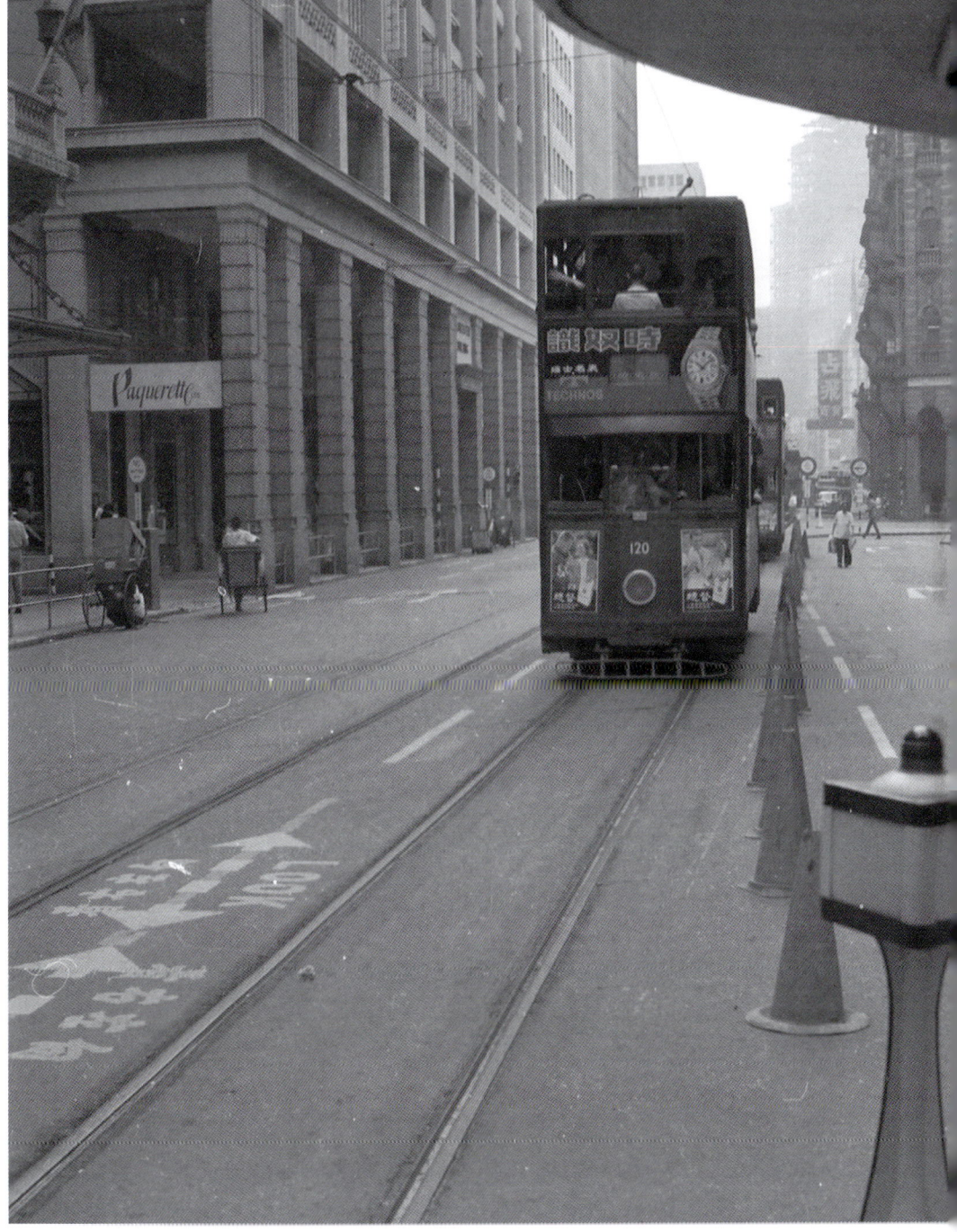

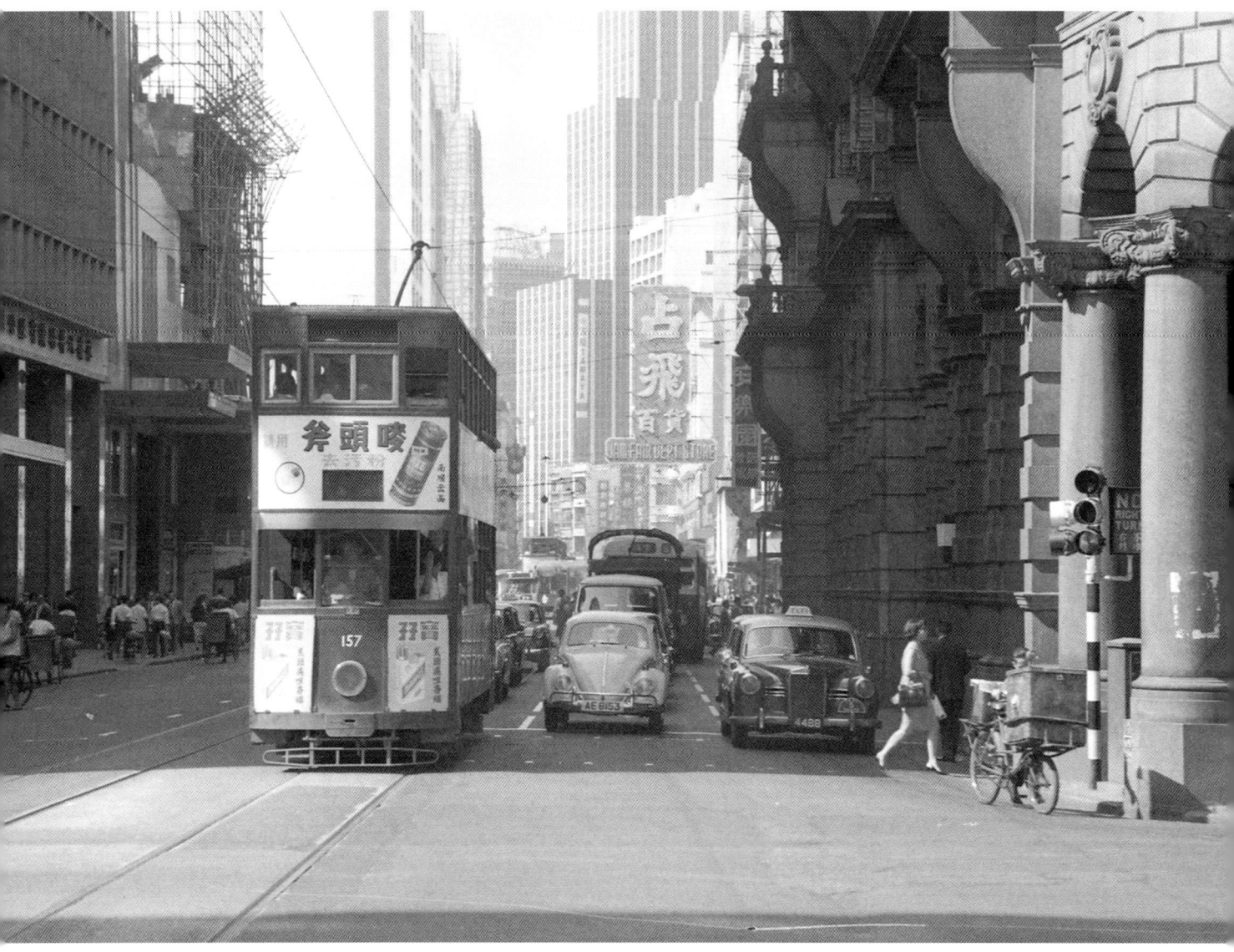

With the old General Post Office on the right, No 157 heads eastbound along Des Voeux Road Central at its intersection with Pedder Street in 1966. No 157 was one of three trams – Nos 157-59 – that entered service in 1963; it was the last of the type, however, to be constructed by Hong Kong Tramways itself.
Douglas Beath/Online Transport Archive

On 19 October 1981 No 37 – built by the Taikoo Dockyard & Engineering Co in 1952 – is seen heading west at the junction of Des Voeux Road West and Western Street with a service heading towards Kennedy Town. The double-deck bus sharing the stage with No 37 is one of China Motor Bus's Guy Arabs, a type long associated with CMB. The change in livery between the earlier maroon and cream single-deckers took place in 1976; it was undertaken to avoid confusion between KMB's own red and cream livery and CMB vehicles after the commencement of the joint services through the then new Cross Harbour Tunnel.
Alan Murray-Rust/Online Transport Archive

In early 1986 a – shortlived – scissors crossover was installed as part of a track reconstruction project at Western Market. This work involved doubling the track from Des Voeux Road Central along Morrison Street to Connaught Road. The crossover was installed to permit eastbound trams from Kennedy Town to reverse at Western Market; the facility was, however, little used and soon replaced by a simple crossover that allowed trams from the east to reverse if required. On 23 September 1992 No 5, originally built by the Taikoo Dockyard & Engineering Co and new in August 1952 and rebuilt 35 years later (it re-entered service in February 1988), heads westbound towards Kennedy Town past the new crossover. This particular tram was never fitted with modern controllers and was to be scrapped in 2002, being replaced by No 63 which was renumbered 5 at the same time.
Author

During June 1966 one of the then relatively new trailer cars, No 5, is seen being towed down the short section of single track along Morrison Street that links Des Voeux Road Central and Connaught Road at Western Market. No 5 had only entered service in January that year.
Douglas Beath/Online Transport Archive

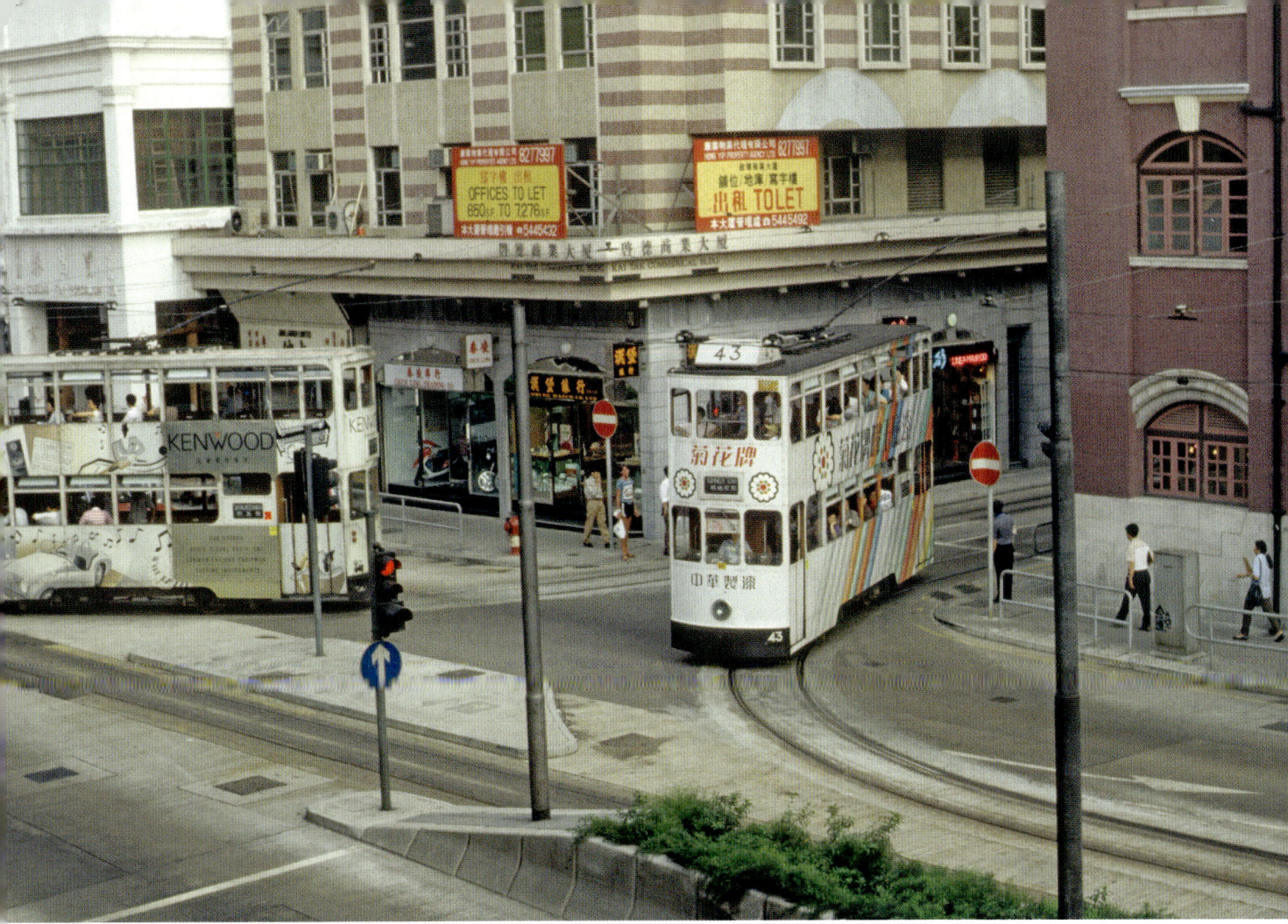

Left During the summer of 1956 No 34 heads into Connaught Road from Morrison Street, Western Market, with a service towards Whitty Street. In the distance a second tram can be seen heading eastbound along Connaught Road prior to turning right into Cleverly Street and then back on Des Voeux Road Central. In the 60 years since this view was taken land reclamation has seen massive redevelopment of this area.
Dennis Beath/Online Transport Archive

Above On 23 September 1992 No 43 emerges from Morrison Street, Western Market, with a service to Kennedy Town whilst a second tram, No 127, uses the curve from Morrison Street into Connaught Road with a service heading back towards Central. This curve had originally been installed in 1927 but the arrangement was modified when the track along Morrison Street was doubled as part of the 1986 reconstruction project. No 43 re-entered service following rebuilding work in June 1991 towards the end of the programme that saw the post-war fleet modernised.
Author

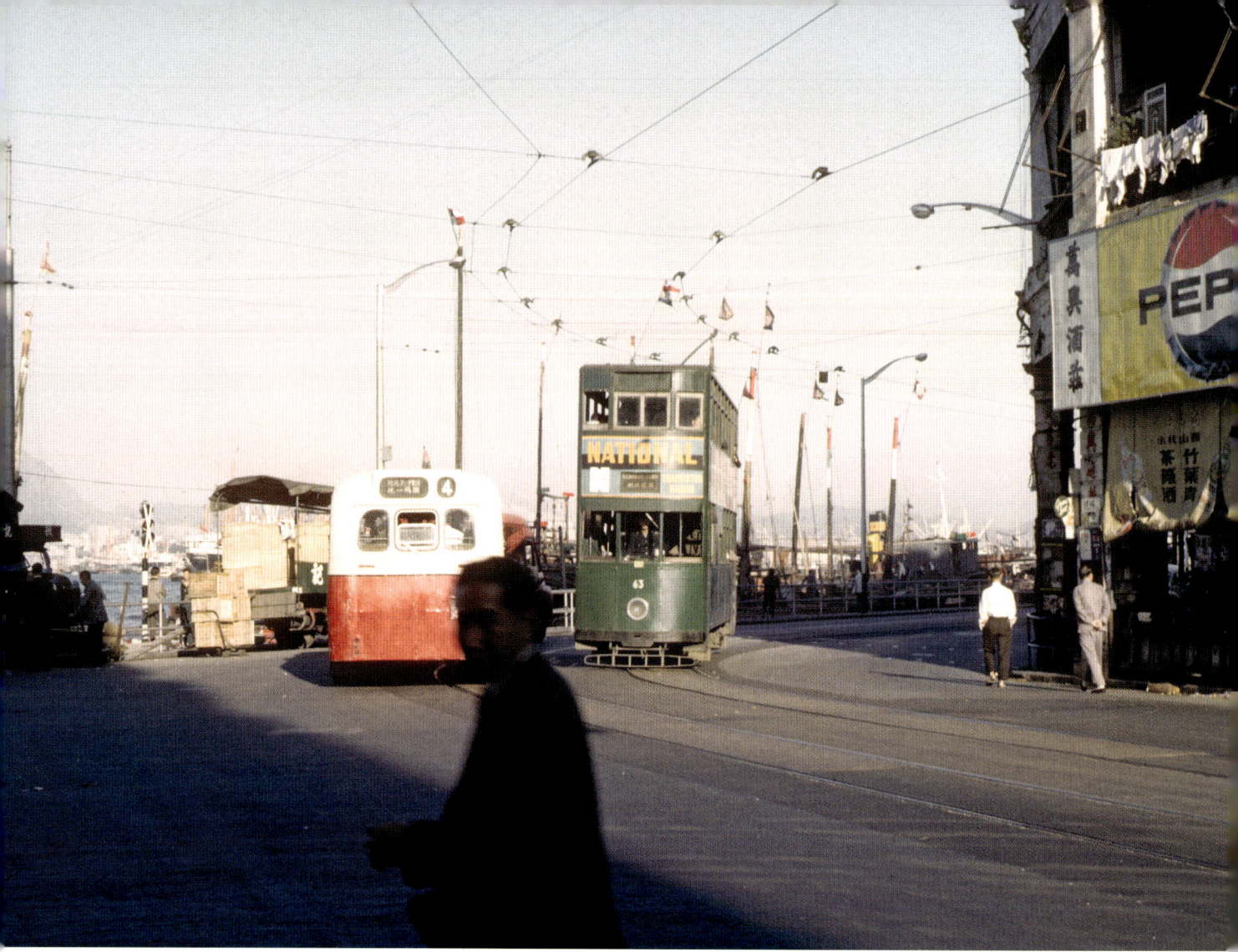

Above: With Wing Lok Wharf in the background – now long vanished under land reclamation – No 63 turns inland from Connaught Road towards Des Voeux Road West and its destination at Kennedy Town in late 1963. No 63 was built by the Taikoo Dockyard & Engineering Co and entered service in February 1953. *Harry Luff/Online Transport Archive*

Opposite: The final short working before the Kennedy Town terminus is situated at Whitty Street. Two trams await departure in 1956 from Whitty Street. In the foreground a tram from Kennedy Town stands on Des Voeux Road West whilst, in the distance, a second tram has made use of the Whitty Street loop and is preparing to leave Hill Road.
Douglas Beath/Online Transport Archive

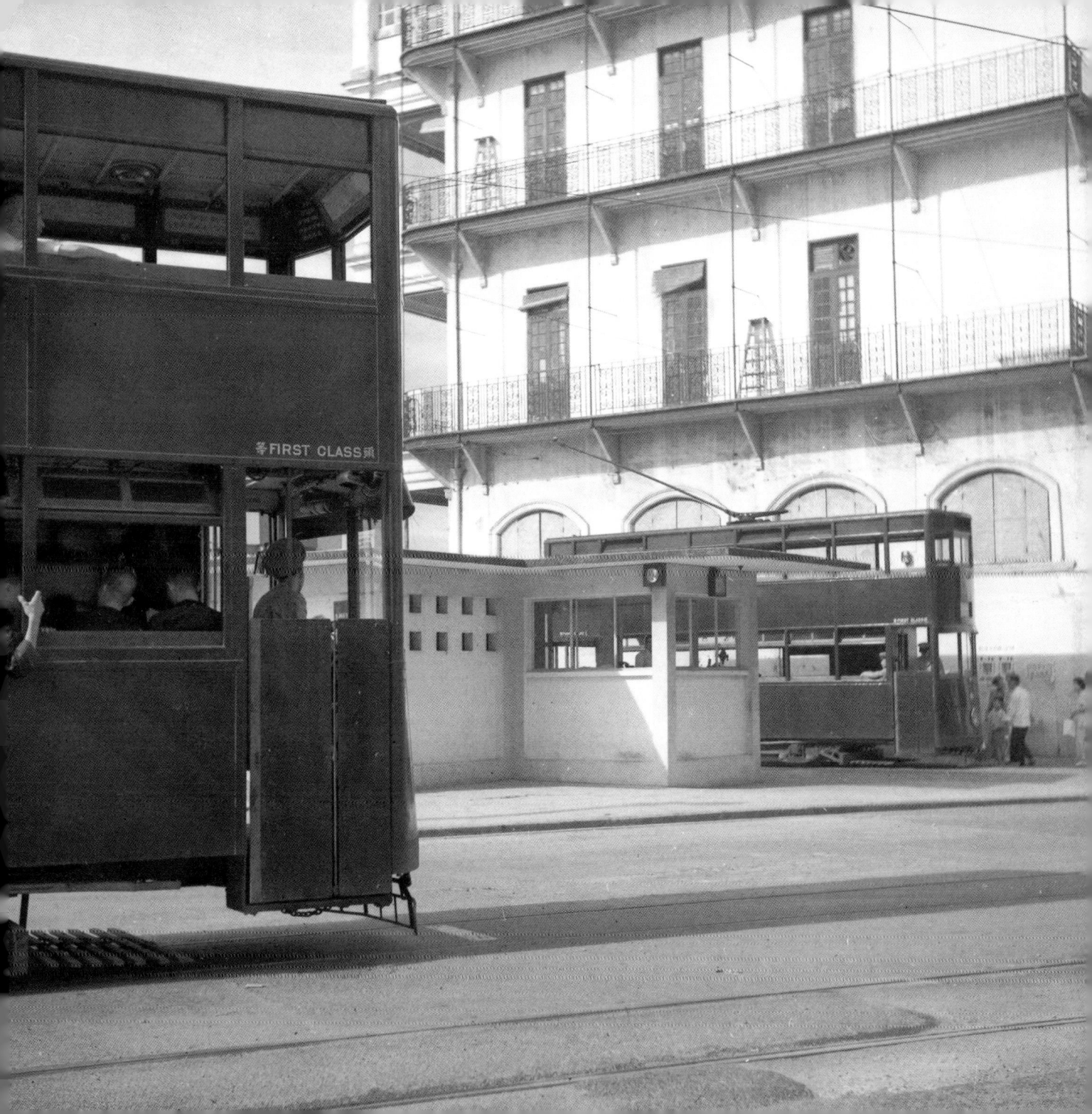

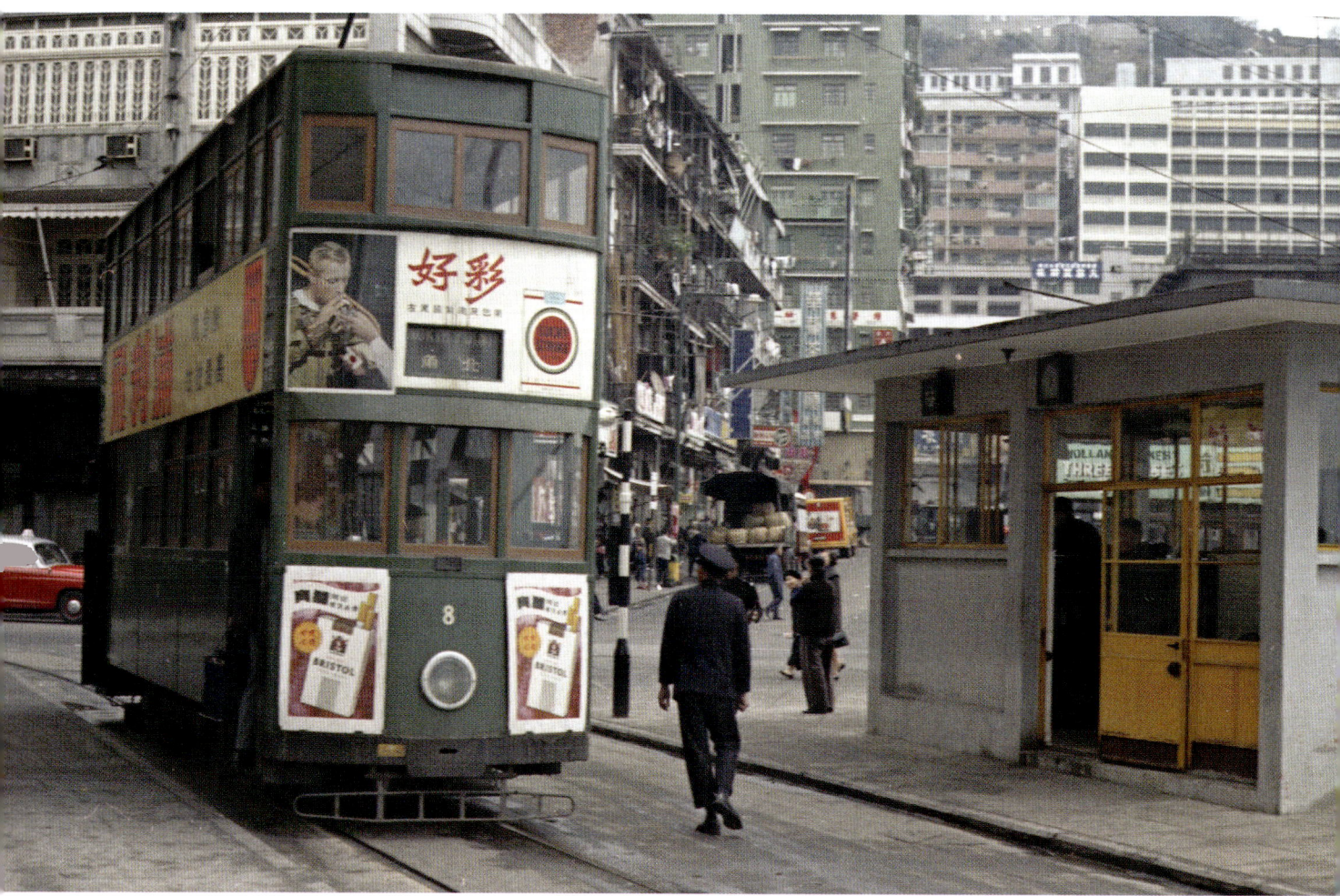

Above: Awaiting departure from Whitty Street with a service to North Point in December 1965 is No 8. This tram was built by the Taikoo Dockyard & Engineering Co and entered service in July 1952.
Douglas Beath/Online Transport Archive

Right: This side view, taken at the Whitty Street loop in 1956, shows to good effect the four-wheel truck in use under 38. The tram was, at that date, relatively new, having been built by the Taikoo Dockyard & Engineering Co entering service in June 1951. The tramway fleet is based around the use of a standard four-wheel truck with an 8ft 6in wheelbase and 33in diameter wheels. The bulk were originally based around Peckham-designed models – either the P22 or the P35 – that were supplied by a number of manufacturers or the later Maley & Taunton version, of which almost 50 were supplied after 1938. A number of locally-built trucks – either by the tramway itself or by the Taikoo Dockyard & Engineering Co – were supplied after 1961. The regular modernisation of the fleet sees the trucks retained and reused with the bodies replaced. No 38 is fitted here with one of the older Peckham-designed trucks.
Douglas Beath/Online Transport Archive

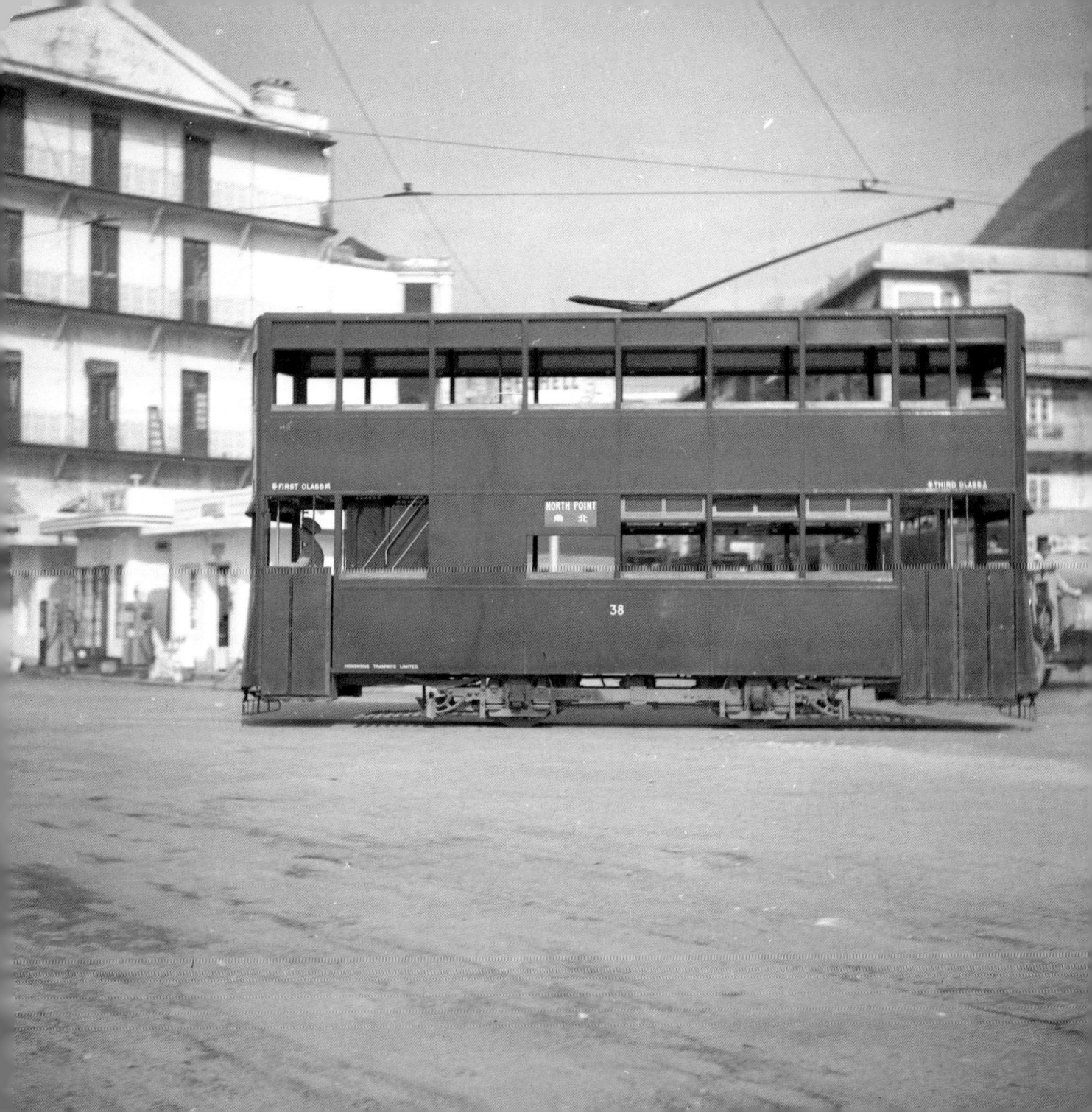

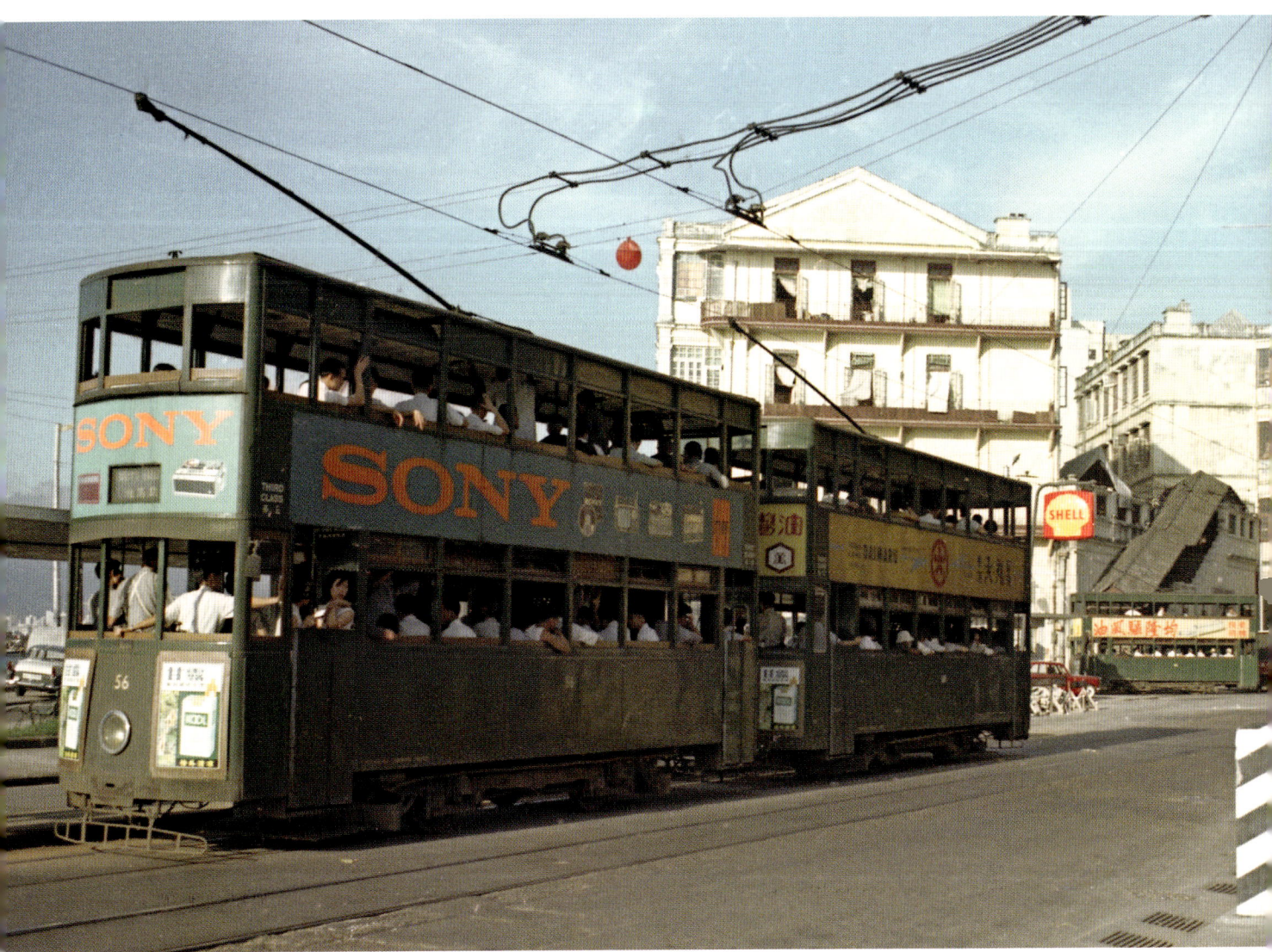

A decade later – in 1966 – two trams stand on Des Voeux Road West awaiting departure whilst a third tram emerges from the Whitty Street loop. Nearest the camera is No 56; this was built by the Hongkong & Whampoa (Kowloon) Docks and new in April 1951.
Douglas Beath/Online Transport Archive

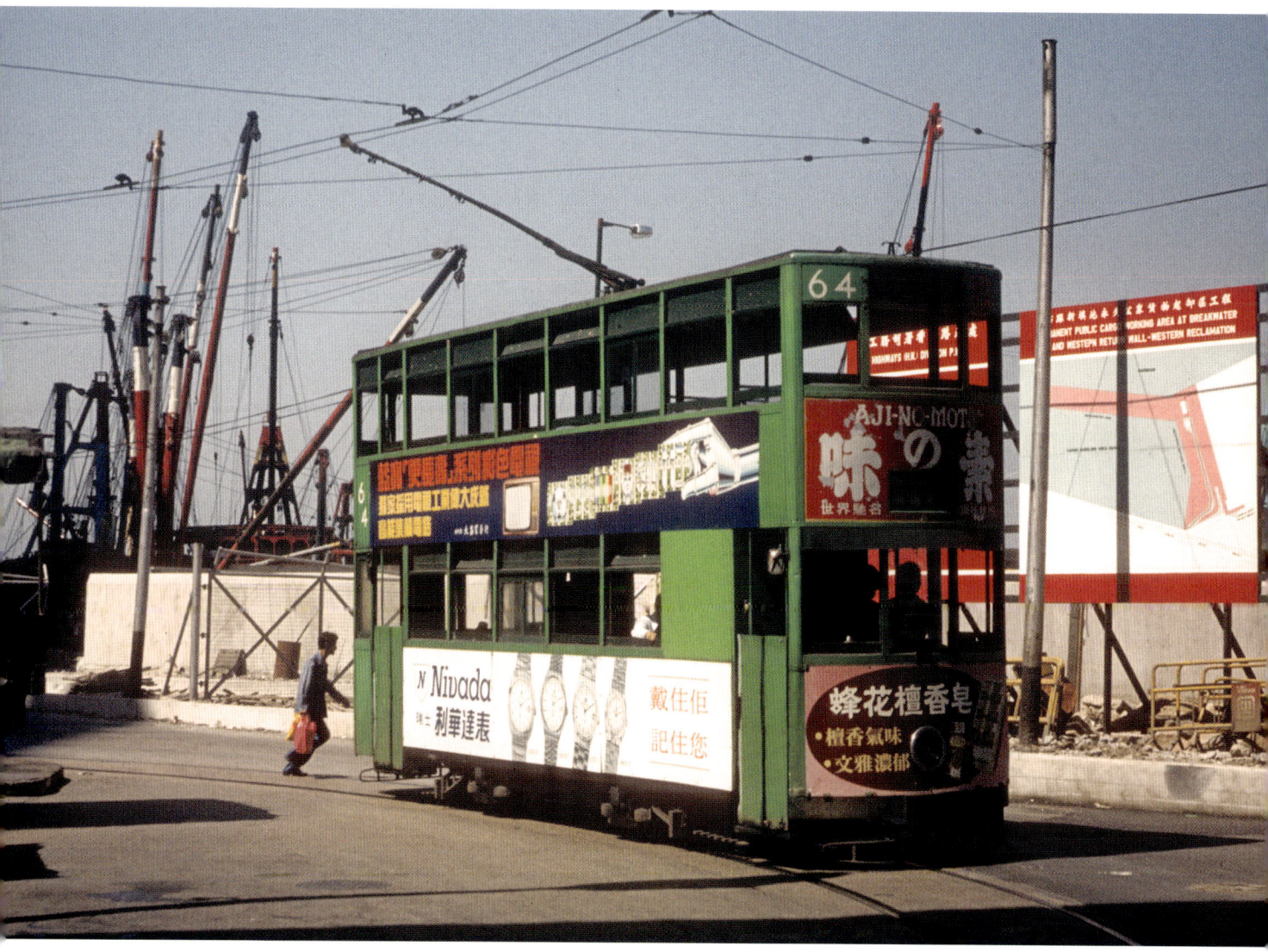

On 27 October 1981 No 64, which was built by the Taikoo Dockyard & Engineering Co and entered service in September 1964, stands on the Whitty Street loop. The track layout at this location has been slightly modified and the backdrop – now dominated by the Route 4 flyover – is unrecognisable.
Alan Murray-Rust/Online Transport Archive

A Journey from East to West • 81

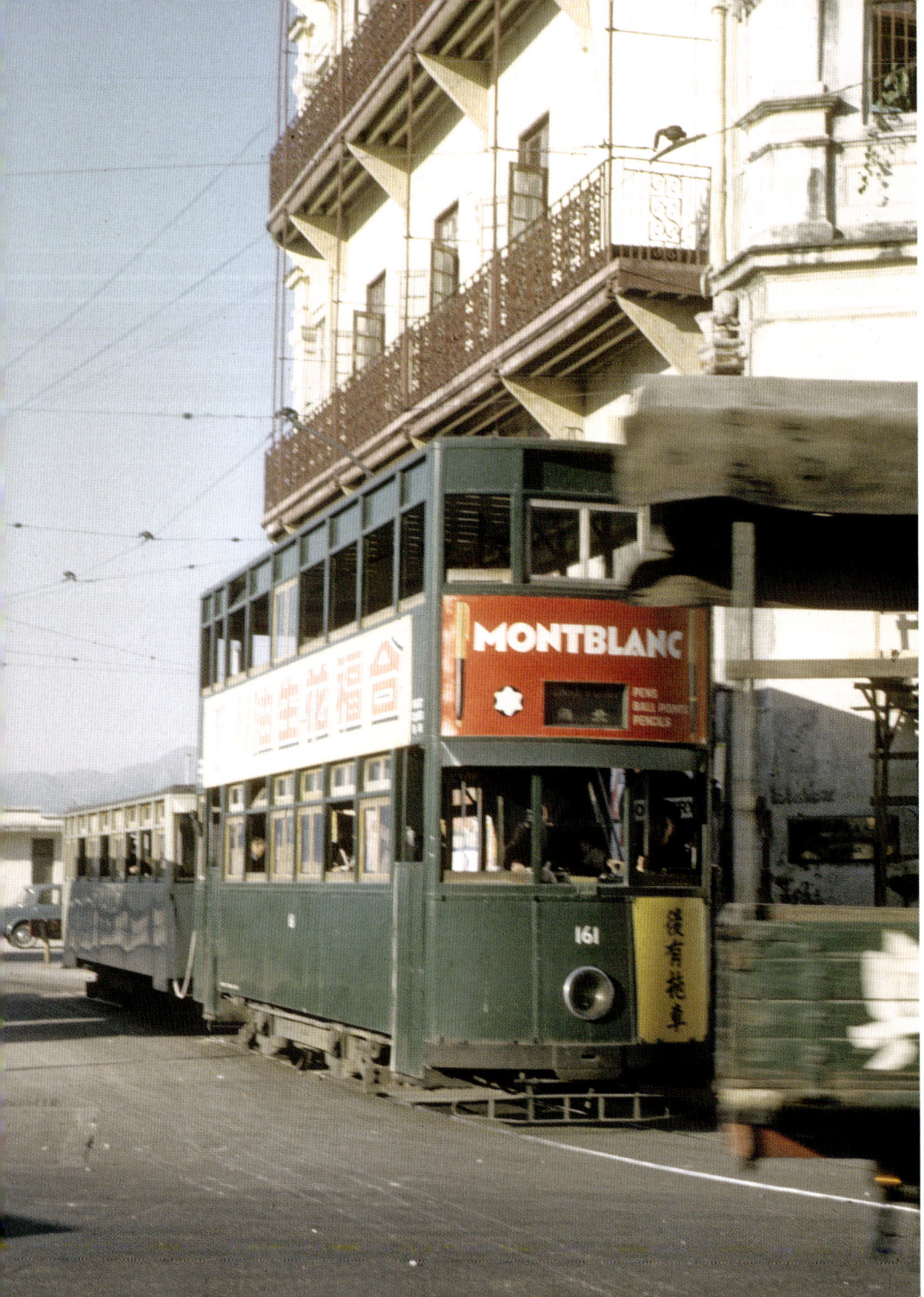

Left: More than a decade earlier, in late 1965, No 161 with a trailer stand in Hill Road, having made use of the Whitty Street loop, with an eastbound service. At this date, No 161 was one of the newest trams in the fleet; it was constructed by the Taikoo Dockyard & Engineering Co and entered service in February 1964.
Harry Luff/Online Transport Archive

Right: It's 27 June 1984 and No 18 is seen entering the loop at Whitty Street. Since the earlier views, the building on Hill Road has been replaced but the Shell garage remained; the latter has also now disappeared with the loop now occupying the site, having been cut back from Connaught Road West in order to accommodate the flyover of Route 4.
Alan Murray-Rust/Online Transport Archive

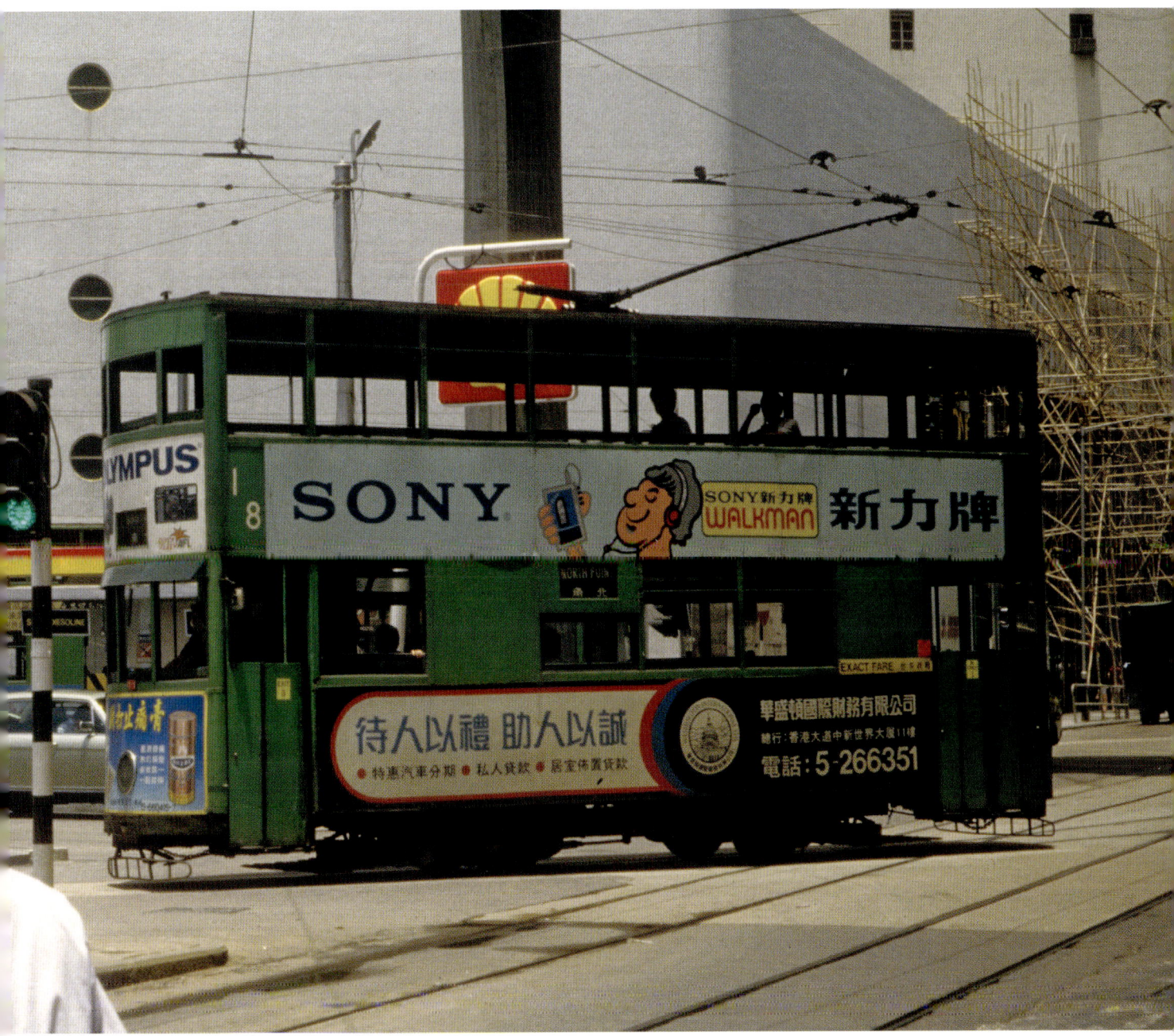

A Journey from East to West

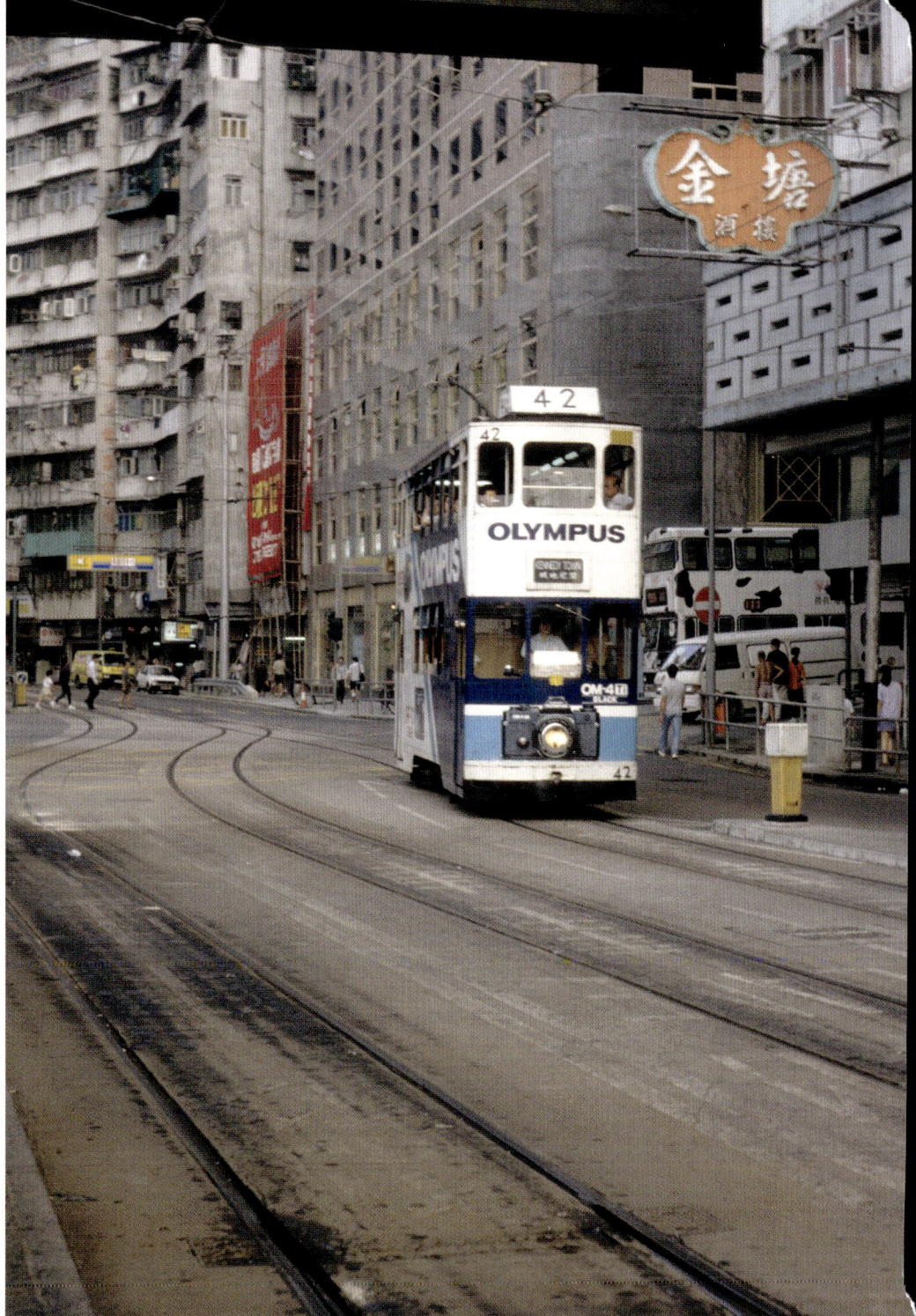

On 23 September 1992 No 42 is pictured at Whitty Street heading westbound along Des Voeux Road West towards Kennedy Town. The trackwork at this location has changed since this view was taken but most of the buildings visible are still extant as is the road overbridge. This particular tram – dating originally to October 1953 – re-entered service following rebuilding in December 1989. Never fitted with modern controllers, No 42 was to be scrapped in March 2014.
Author

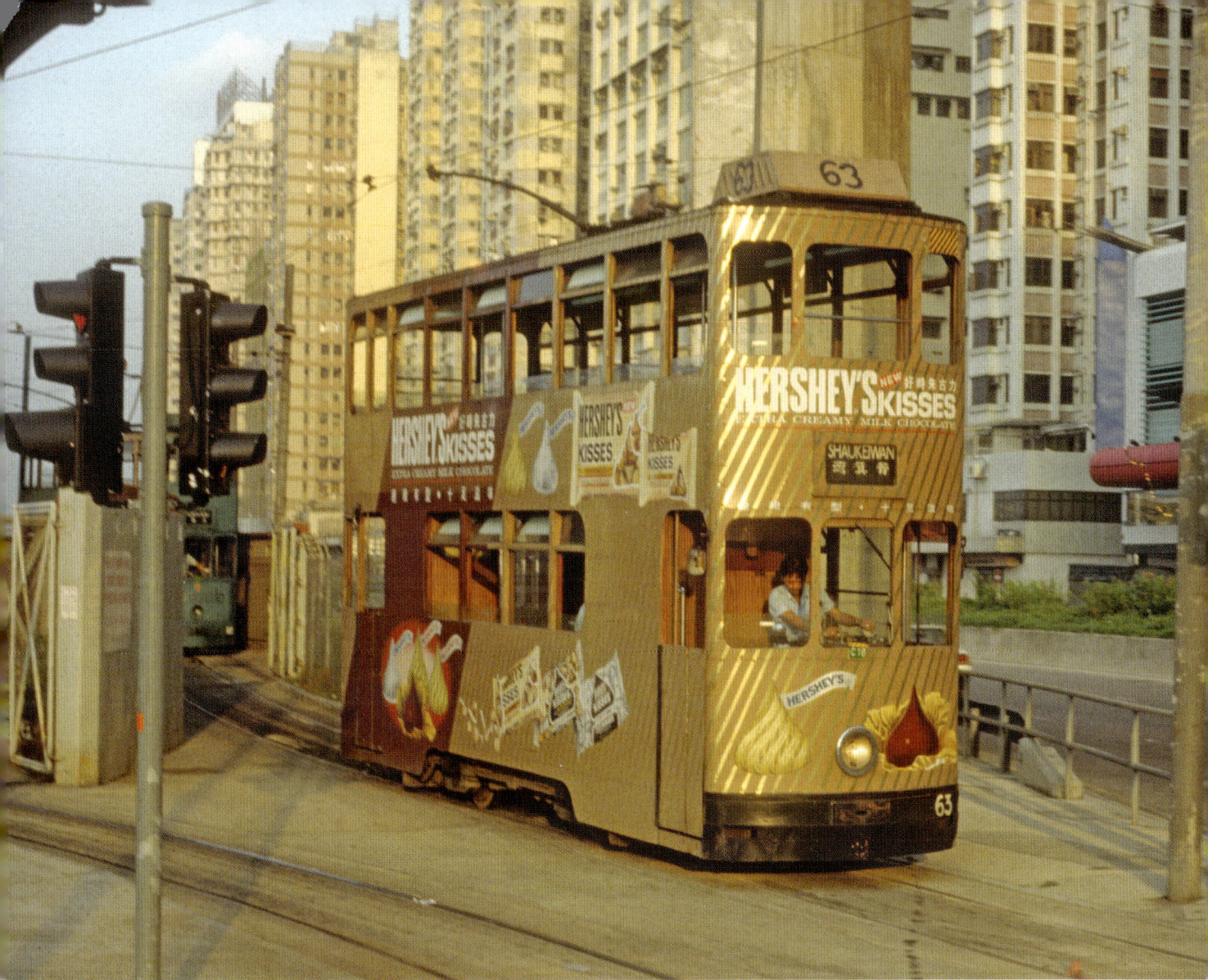

Whitty Street is now the location for the main depot and workshop for the tramways. Following the decision to relocate from Sharp Street, two new depots were constructed – Whitty Street (or West depot) and Sai Wan Ho (or East depot) – as replacements. The Whitty Street depot – an enlargement of the existing workshop facility – was officially opened on 28 April 1989. As well as providing accommodation for some 100 trams, Whitty Street still also accommodates the main workshops. On 22 September 1992 No 63, promoting Hershey chocolate bars, is seen emerging from the depot. *Author*

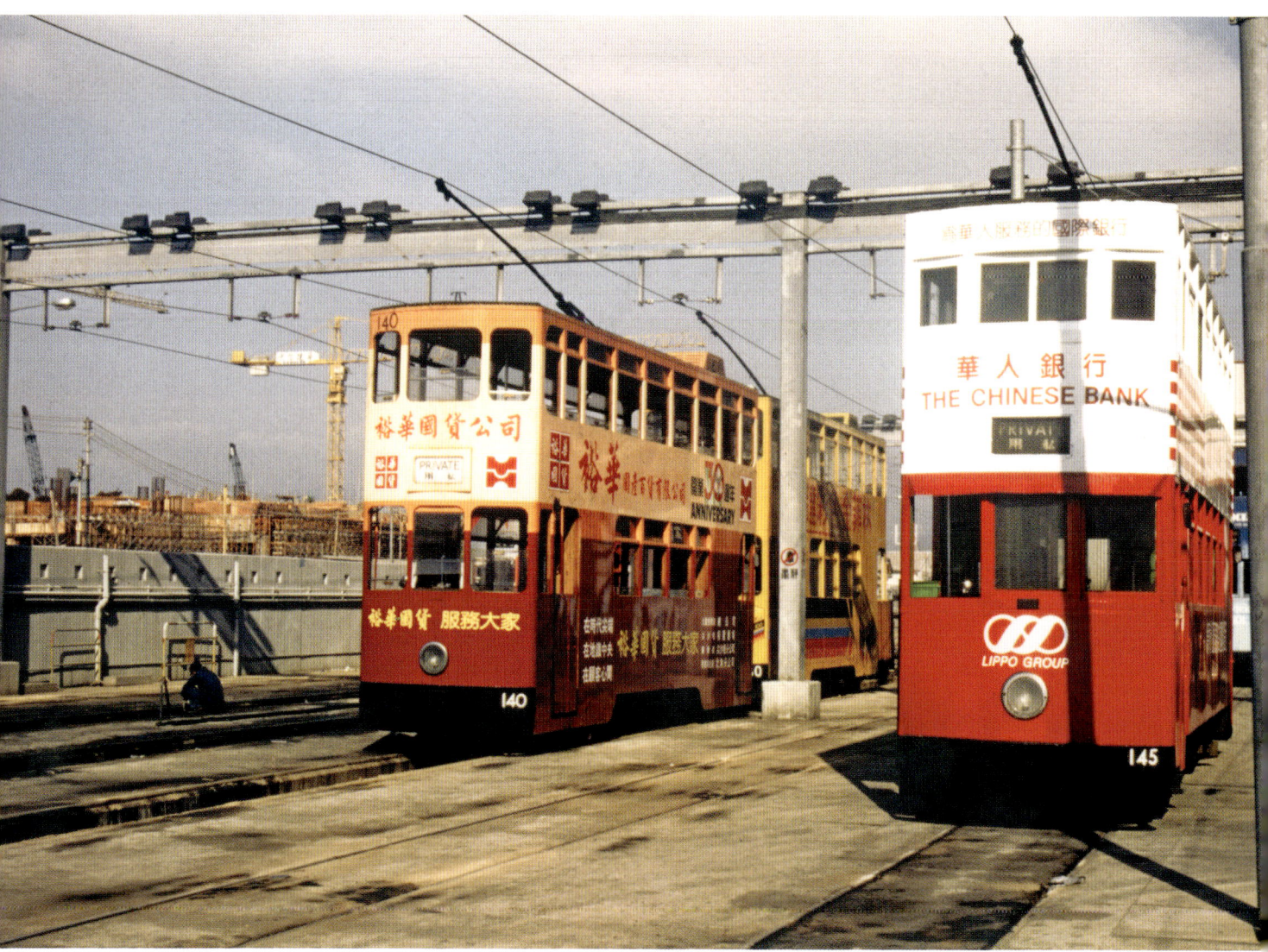

Recorded awaiting their next duties at Whitty Street depot on 14 February 1990 are Nos 140 and 145. The view shows to good effect the differences between the rebuilt tram – No 140 – and the unrebuilt No 145. In the background, construction work on the buildings on the north side of Fung Mat Road can be seen.
Barry Cross/Online Transport Archive

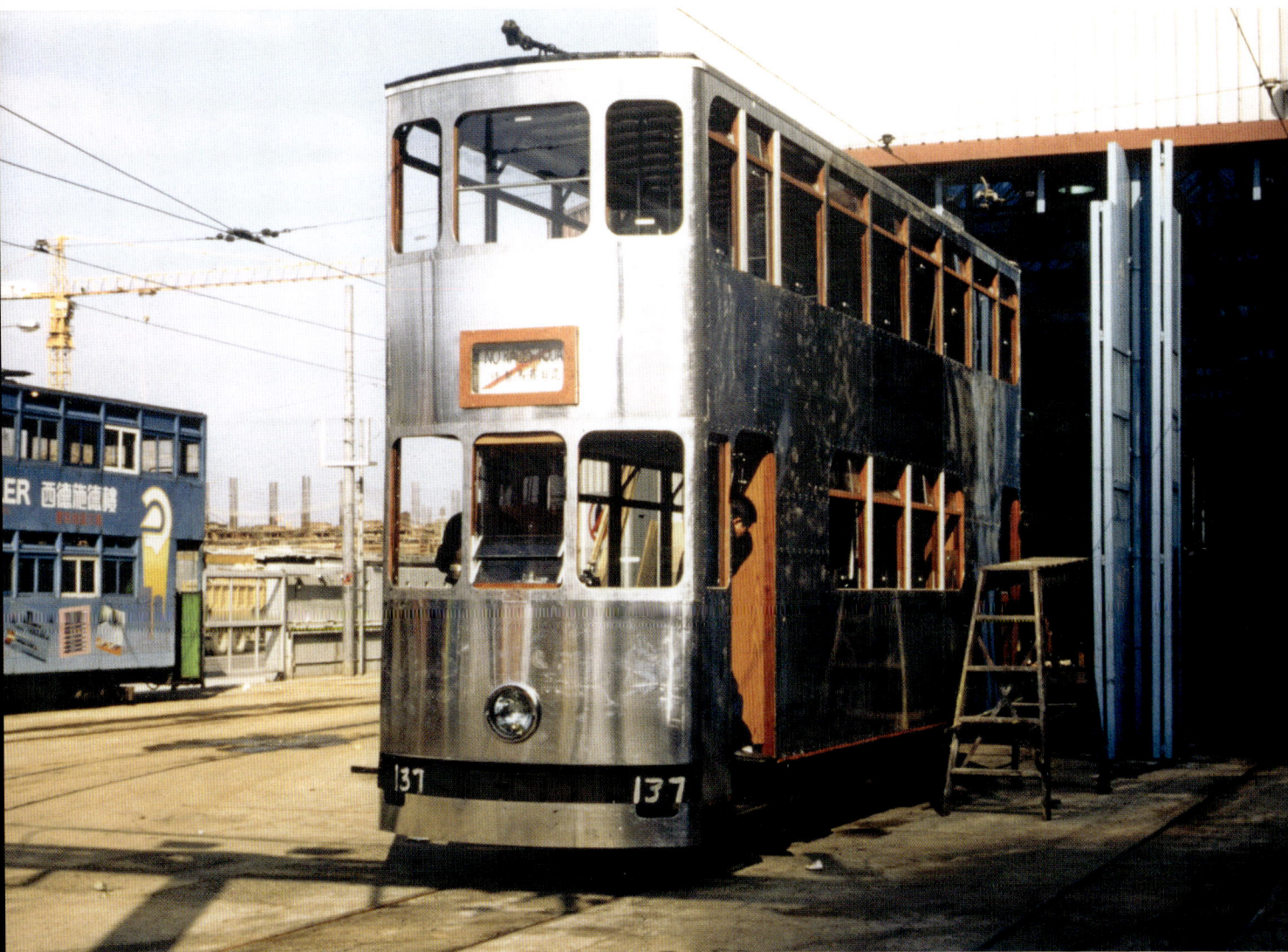

From the mid-1980s, the workshops at Whitty Street were engaged in the rebuilding of the trams delivered to the operator between 1950 and 1964. On 14 February 1990 the new body fitted to No 137 is well advanced.
Barry Cross/Online Transport Archive

In 1994, Hong Kong Tramways constructed a full-size mock-up of a proposed new bogie tram at Whitty Street; it is seen here the following year. At 11.5m in length, the tram – nicknamed the 'metal monster' – would have been significantly longer than the existing fleet. Shortly after this photograph was taken the body was painted into a predominantly yellow livery before appearing two months later in lime green.
Alan Pearce/Online Transport Archive

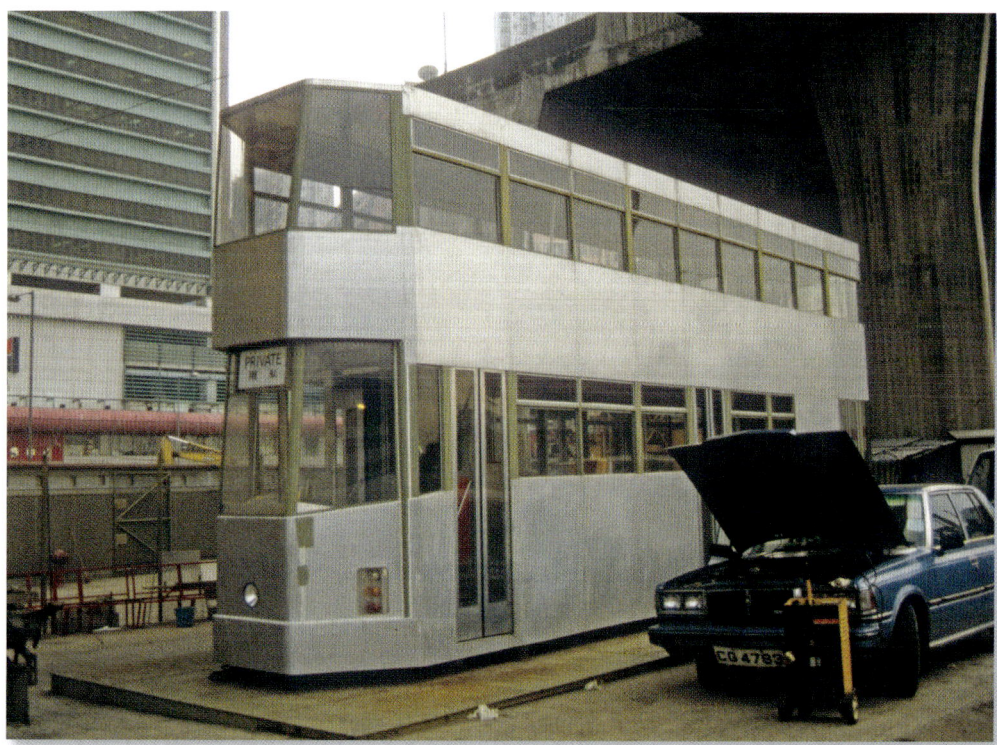

The interior of the upper deck of the 'metal monster'; the body was to have been all-metal and passengers would have benefited from air conditioning. In the event, the project was not progressed – the company was more concerned in trying to maintain its existing fleet – and the body was scrapped in June 1997.
Alan Pearce/Online Transport Archive

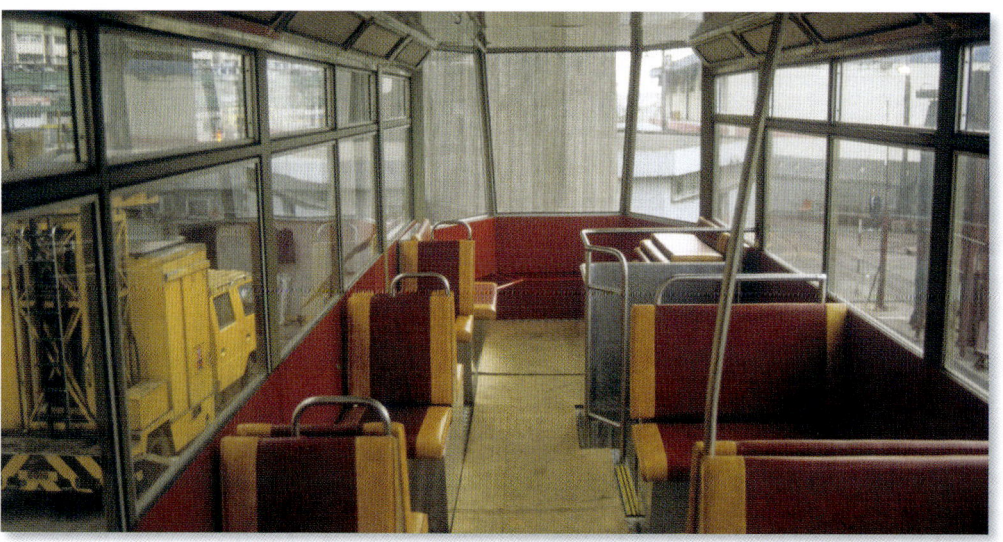

88 • The Tramways of Hong Kong

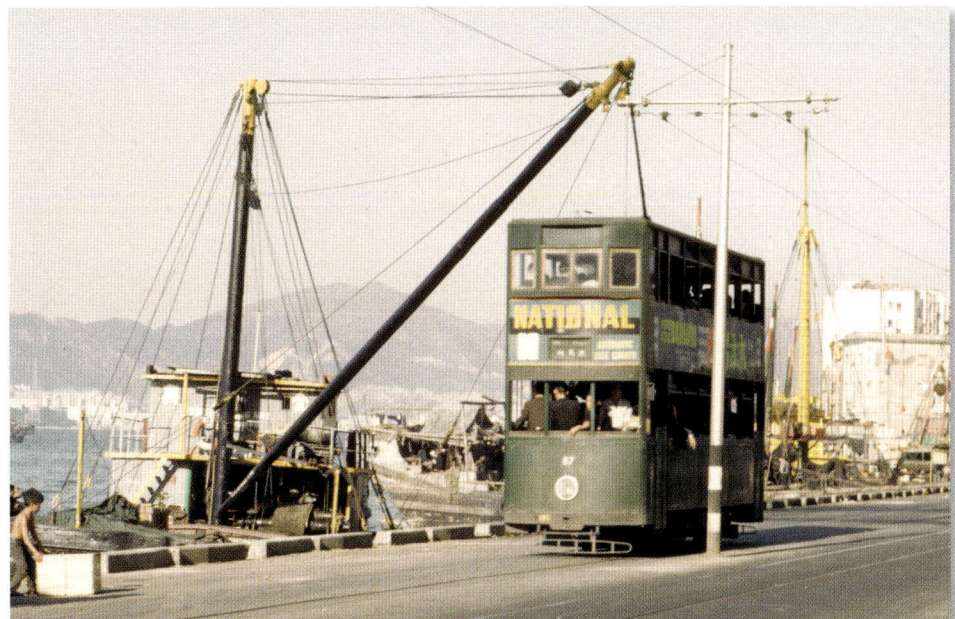

In late 1965 No 87 heads eastbound along Kennedy Town Praya with a view across Victoria Harbour towards the Kowloon peninsula in the background. No 87 was new originally in July 1953.
Harry Luff/Online Transport Archive

In the summer of 1981, No 106, which originally entered service in June 1955, heads westbound along the bustling Kennedy Town Praya as it approaches the terminus. Land reclamation has seen the radical transformation of this scene; indeed the only constant features visible are the tramway and the centrally-placed traction columns between the running lines. The loading and unloading of freight from the roadside quays are now a part of history.
Richard Lomas/Online Transport Archive

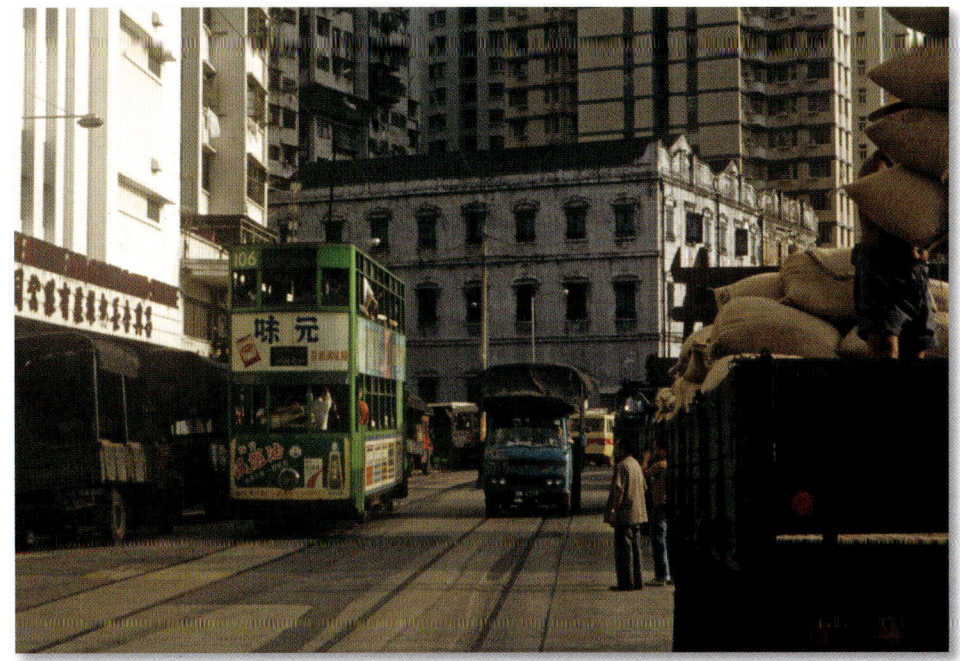

A Journey from East to West • 89

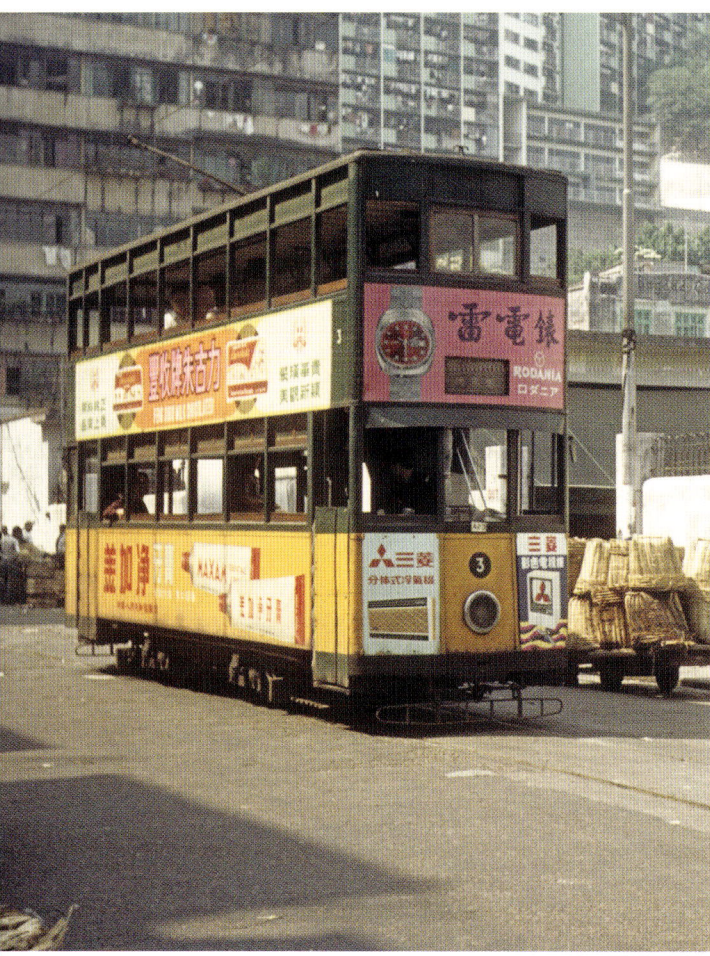 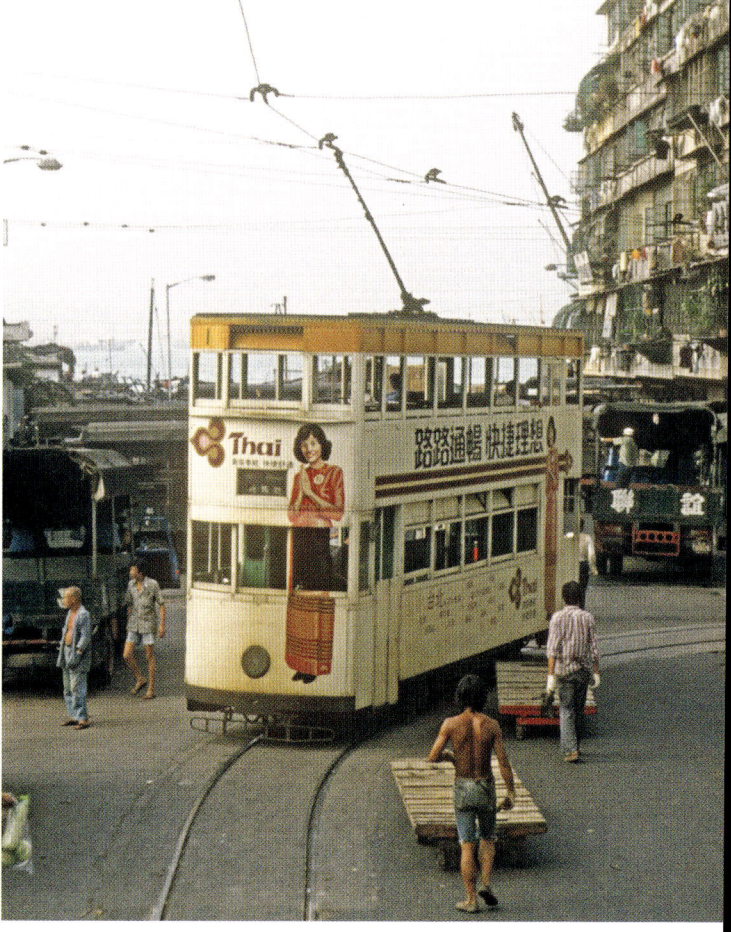

Above left: Recorded during 1973, No 3 stands on Cadogan Street at the terminus in Kennedy Town. The tramway forms a loop around Davis Street, Belcher's Street, Cadogan Street and Catchick Street. No 3 was constructed by Taikoo Dockyard & Engineering Co and entered service on 31 Match 1952.
Paul de Beer/Online Transport Archive

Above right:
A decade later, on 19 October 1981, No 1 is seen turning from Cadogan Street into Catchick Street with a service heading for Happy Valley. This particular tram was completed by the Taikoo Dockyard & Engineering Co and entered service in January 1954. Like all of the trams built between 1949 and 1964, and featured in the pages of this book, No 1 was to be refurbished from 1986 onwards. When work commenced, the first 15 trams treated received new aluminium panelling on existing frames. However, later work saw the complete scrapping of the original bodies and new frames constructed. Following the completion of the refurbishment programme, in 1992, the first 15 treated were rebuilt with new bodies. No 1 re-entered service after rebuilding in May 1989; it was eventually scrapped in July 2012.
Alan Murray-Rust/Online Transport Archive

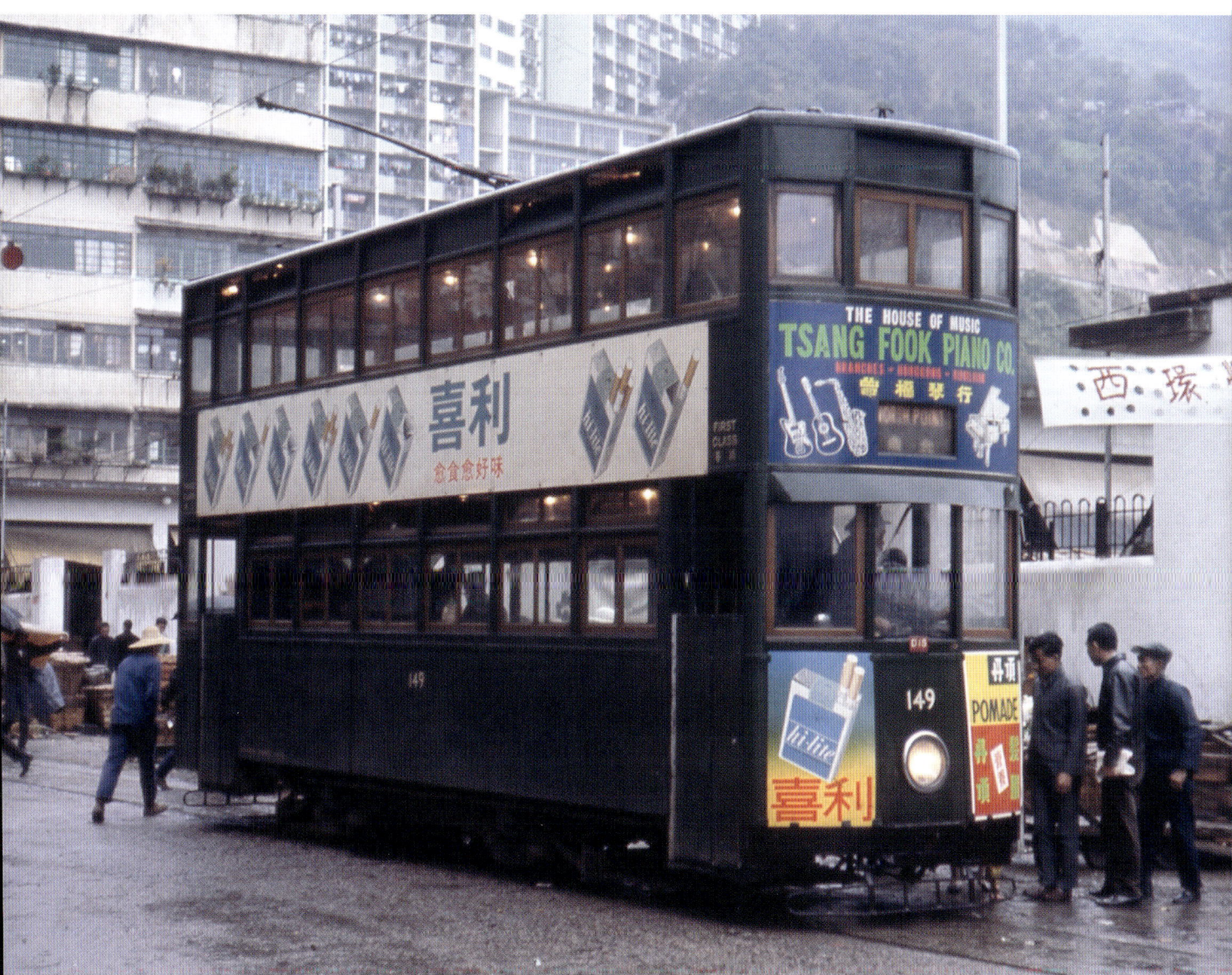

Pictured in the rain at the Kennedy Town terminus during 1969, passengers board the front of No 149 – to access the lower-deck third-class accommodation – as it prepares to depart with a service towards North Point. No 149 was one of 16 trams completed between December 1959 and May 1964 that represented the final batch of the post-war standard trams to be built; all were constructed by the company itself, with No 149 emerging in March 1960.
J. Jordan/Online Transport Archive

THE PEAK TRAMWAY

As detailed in the introduction, the only section of the tramways proposed in the early 1880s to be completed was the funicular from Garden Road to Victoria Gap. Promoted by Alexander Findlay Smith, the 848-yard long line was constructed to the Russian standard gauge of 1,520mm (just under 5ft 0in) and was formally opened, after three years of construction, by the then governor, Sir George William des Voeux, on 28 May 1888. The operator was originally known as the High Level Tramway Co but was retitled as the Peak Tramways Co Ltd. The funicular is 4,475ft in length and ascends a distance of some 1,207ft. At its greatest, the line's maximum gradient is 1 in 2. Today, the line is owned by Hongkong & Shanghai Hotels Ltd.

Nathaniel J. Ede owned a house – Dunheved (which he'd built in 1875) – adjacent to the upper terminus and Smith acquired the house to form the basis of the original Peak Hotel. Following the opening of the tramway Smith sold the hotel and it was rebuilt as a much-enlarged facility in 1890. The building was to be further extended on several occasions but was to close in 1936 and was to be eventually demolished following a fire two years later.

The construction of the line encouraged the residential development of the Mid Levels and Victoria Peak and the line has four intermediate – request – stations.

Originally, power to operate the cable was steam-generated but this was replaced by electricity in 1926. The electricity supply was damaged on 11 December 1941, during the Japanese attack on Hong Kong, with the result that services were suspended on 25 December 1941.

Reopened after the war, a decade later the tramway was modernised, with a new fleet of three cars – two in service and one in reserve – constructed to replace the existing trams. The spare car was accommodated in a small depot located close to Kennedy Road station. These replacement cars were themselves to be replaced in 1989 when the tramway was modernised by Von Roll, of Switzerland. The new two-car units have accommodation for 120 passengers as opposed to the 62 carried by the trams supplied in 1956. Although none of the earlier trams survives (although a replica of the first car is displayed in the Peak Tramway Historical Gallery), one of the 1956-built units is now displayed at the upper terminus.

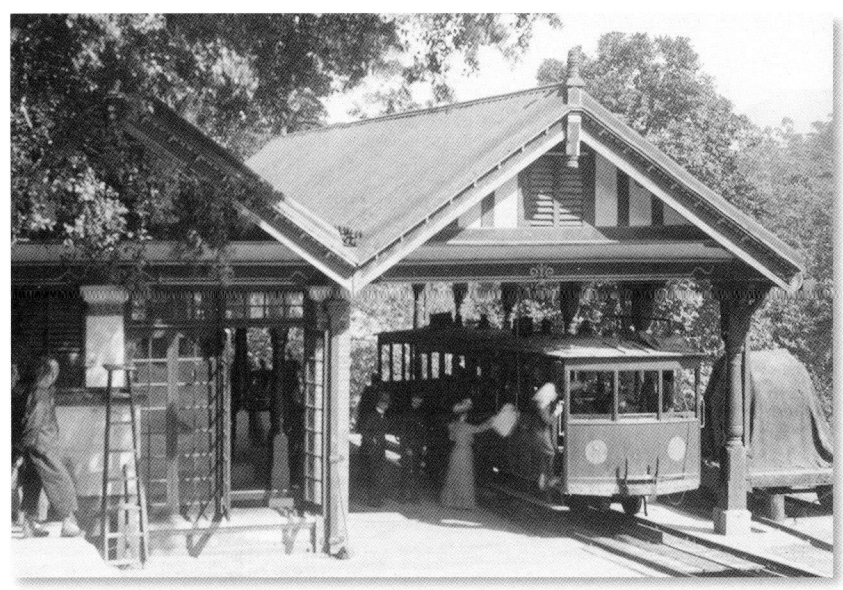

The lower terminus of the Peak Tramway was – and is – situated in Garden Road. This view, taken in the late 19th century, shows one of the original trams at the terminus. From the line's opening in 1888 until 1926, the tram was divided into three classes: First Class comprised British colonial officials and residents of Victoria Peak; Second Class passengers were members of the British armed forces and the Hong Kong police force; Third Class covered all other passengers. In addition, between 1908 and 1949, the front two seats on the tram were reserved for the use of the Governor. This was recorded by a bronze plaque that stated 'This seat is reserved for His Excellency the Governor'. However, if unoccupied by the Governor two minutes prior to departure, they could be used by ordinary passengers.
Barry Cross Collection/Online Transport Archive

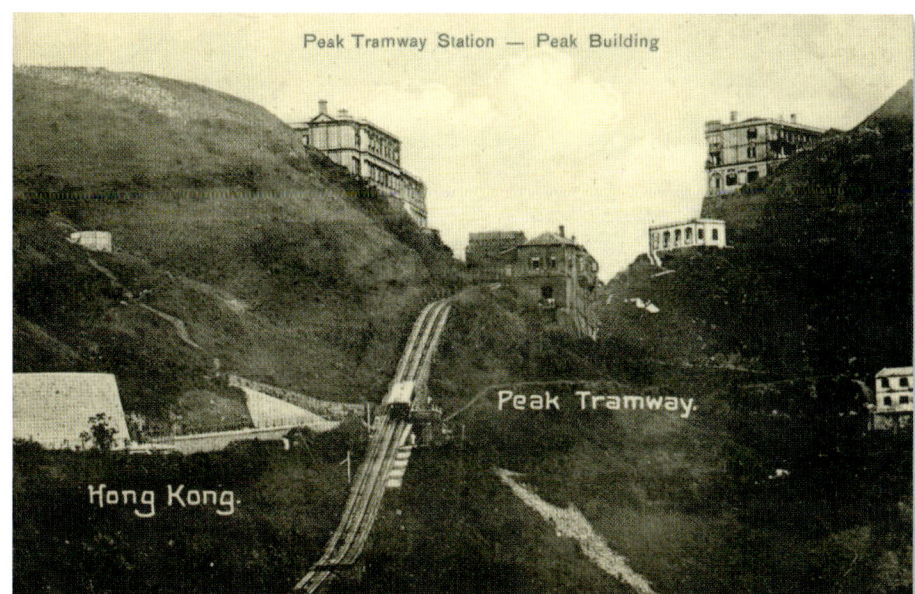

An early view of The Peak terminus from below. The original Peak Hotel was completely rebuilt in 1890 and subsequently extended on several occasions. The hotel was acquired by the Hong Kong Hotel in 1922 but the structure – poorly constructed originally – deteriorated and, in 1936, its owners announced that the hotel was to close on 31 August. Two years later the closed hotel was destroyed by fire and demolished.
Barry Cross Collection/Online Transport Archive

In 1956 the Peak Tramway was provided with three replacement lightweight metal-bodied cars. Only two of these were in use at any one time; the third being held in reserve in a depot – now disused – near Kennedy Road station. This view, taken in late 1965, shows one of the trio ascending towards The Peak terminus with the central area of Hong Kong stretching out in the background.
Harry Luff/Online Transport Collection

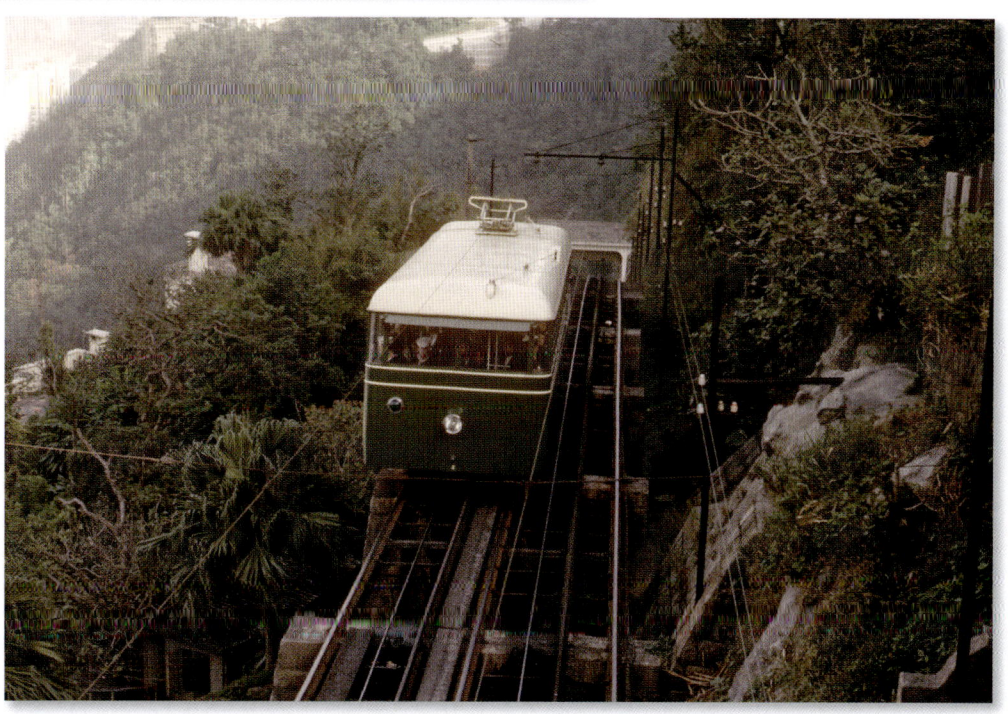

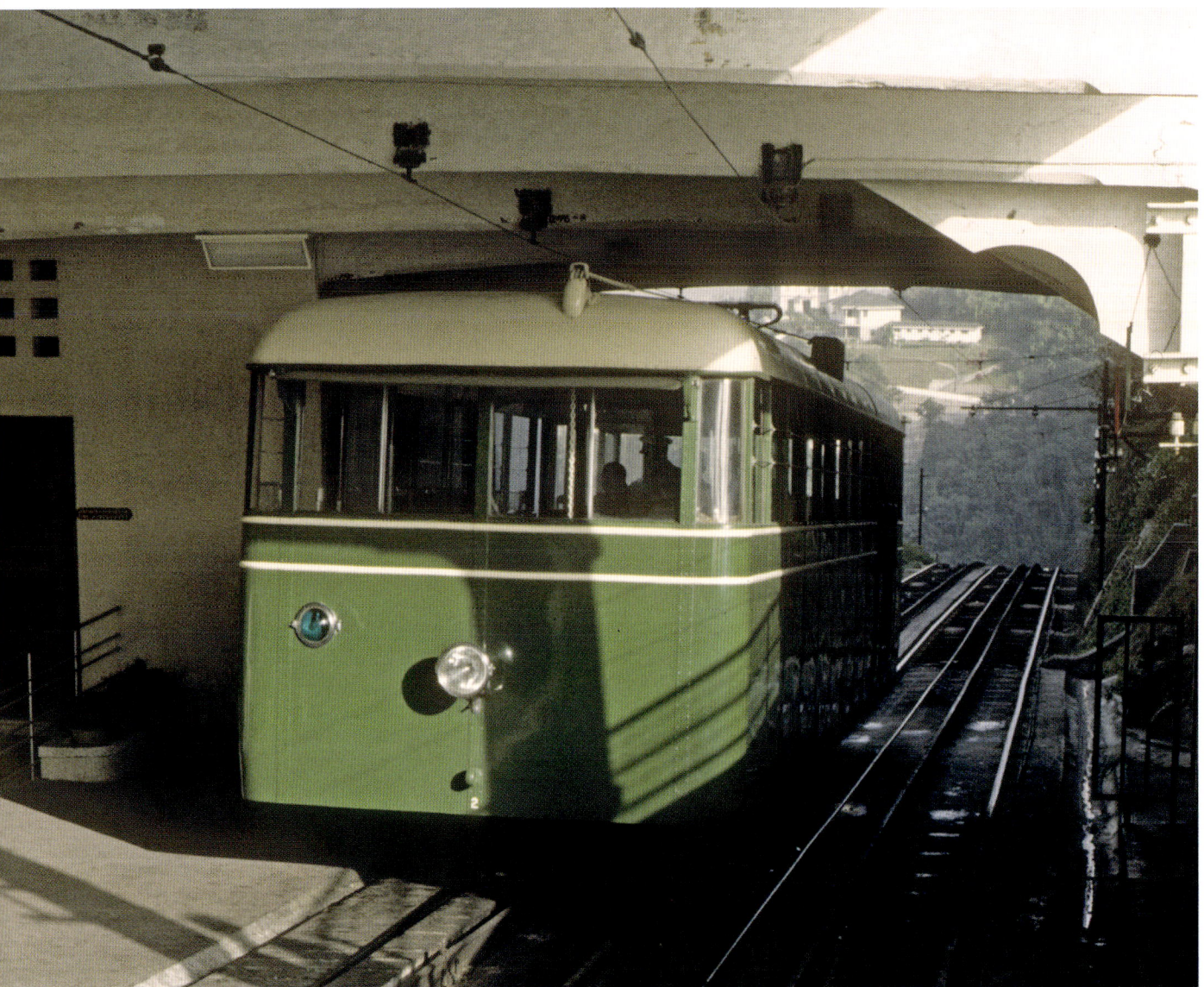

One of the 62-seat cars built in 1956 stands at the platform in The Peak terminus. The precipitous nature of the funicular can be seen in the background as the line disappears downhill; at its maximum, the gradient on the line is almost 1 in 2. The 1956-built cars were withdrawn following the line's modernisation in 1989 and one is now preserved on a plinth at the upper terminal.
Harry Luff/Online Transport Archive

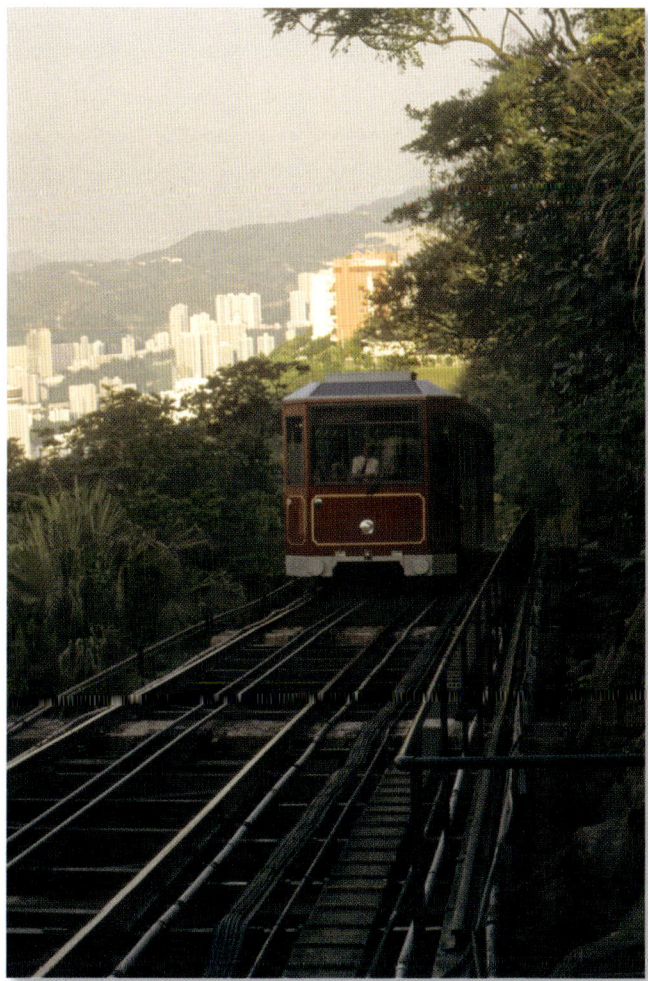

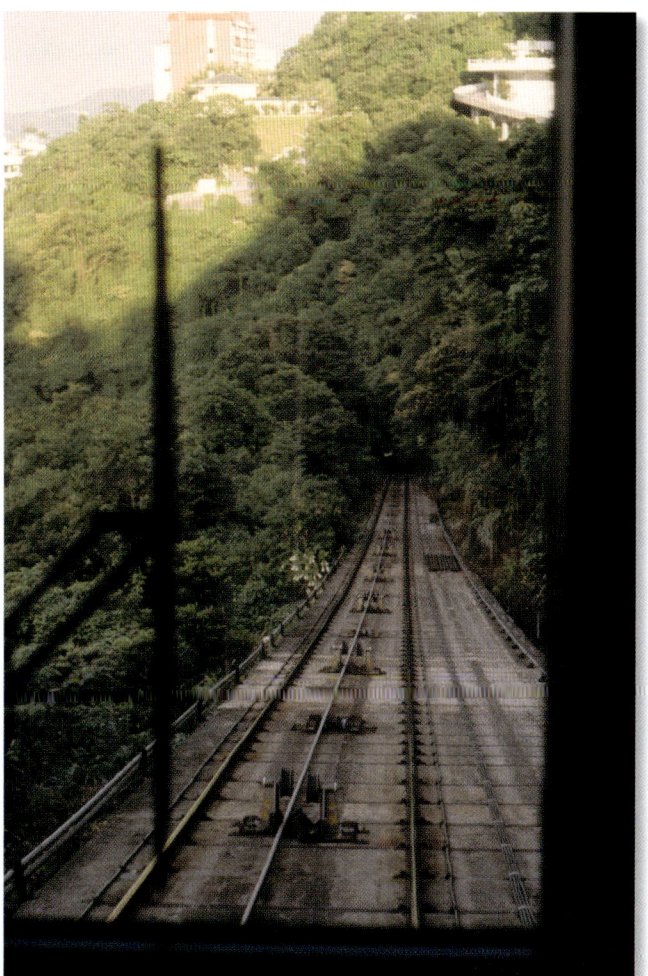

In 1989, after more than a century of use, the Peak Tramway was modernised by the Swiss company Von Roll. Amongst the work was the construction of two new two-car units for the line's operation; these were constructed by a second Swiss company (Gangloff AG). On 15 September one of these two new cars, each of which is capable of carrying 120 passengers, is seen ascending towards The Peak terminus.
Author

The view from the rear of a Peak Tramway two-car unit as it ascends towards the summit. The view shows to good effect the 1,520mm gauge of the line. In all, the tramway is some 1,364m in length and ascends a height of 368m with a maximum gradient of 1 in 2. The usual journey time is almost five minutes.
Author

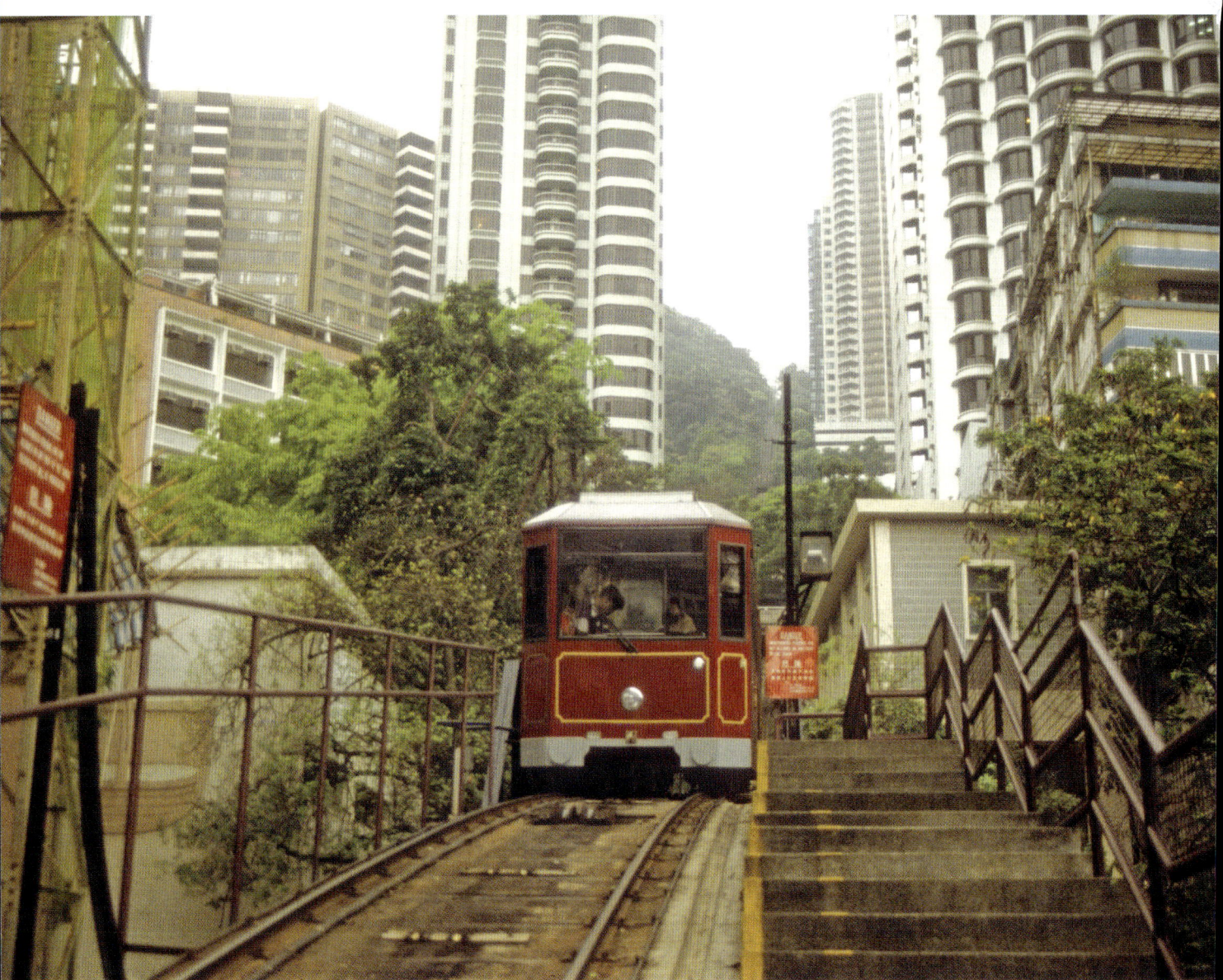

What a difference a century makes; since the opening of the Peak Tramway the Mid Levels have undergone massive development and now represent some of the most desirable residential addresses on the island. In this 1995 view of the Peak Tramway, one of the modern cars can be seen descending towards the Garden Road terminus.
Alan Pearce/Online Transport Archive